Norman Parkinson
Portraits in Fashion

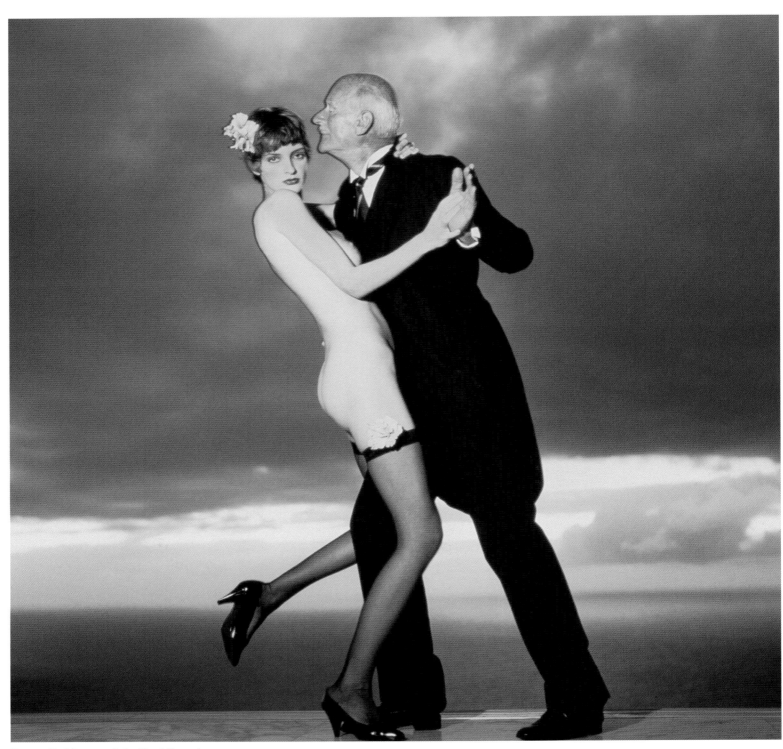

Norman Parkinson, 1985 by Chuck Zuretti

Norman Parkinson
Portraits in Fashion

Robin Muir · *Foreword by Iman*

National Portrait Gallery

Published in Great Britain by
National Portrait Gallery Publications
National Portrait Gallery,
St Martin's Place,
London WC2H OHE

For a complete catalogue of current
publications, please write to the address
above, or visit our website at
www.npg.org.uk/pubs.htm

Created and produced by
Palazzo Editions Limited
15 Gay Street,
Bath BA1 2PH

Designed by Mark Thomson
mt@internationaldesignuk.com

The producers of the book acknowledge
Kerry Foods, the makers of the famous
Porkinson Banger, and their contribution that
has supported the reproduction of Norman
Parkinson's photographs in this book.

ISBN 1-85514-525-1

A catalogue record for this book is available
from the British Library.

Printed in Singapore

Contents

Foreword

Iman

Capturing life – energy, mood and spirit – is a talent reserved for the world's most gifted photographers. No matter how beautiful or photogenic a person may be, their photograph won't shine unless the maestro behind the lens communicates with them, teases them, emotes with them. Photography is a collaborative process – like a dance – and Norman Parkinson was like Fred Astaire. His keen eye and infectious creativity were complemented by his extraordinary sense of humour and wit, and such powers of observation that as a model, I worried not about flaws but about the perfect retort, expressed through my face, body and movement. Norman's most memorable images are marked by the most extraordinary sense of charm and knowing – you can see it in the eyes of the people he immortalized in his photos. Their eyes convey a secret or a sly sentiment shared with Norman sometime during that photo shoot. During my fourteen years as a model, I enjoyed the privilege of working with many of the era's great photographers and image makers. Being a model and standing in front of hot lights, photographers and stylists for hours on end, all in an effort to capture that fleeting, perfect image, is sometimes taxing. Norman's humour always made the search for that image an enjoyable and memorable one. The personality of his best work is the reason those images still speak to us today.

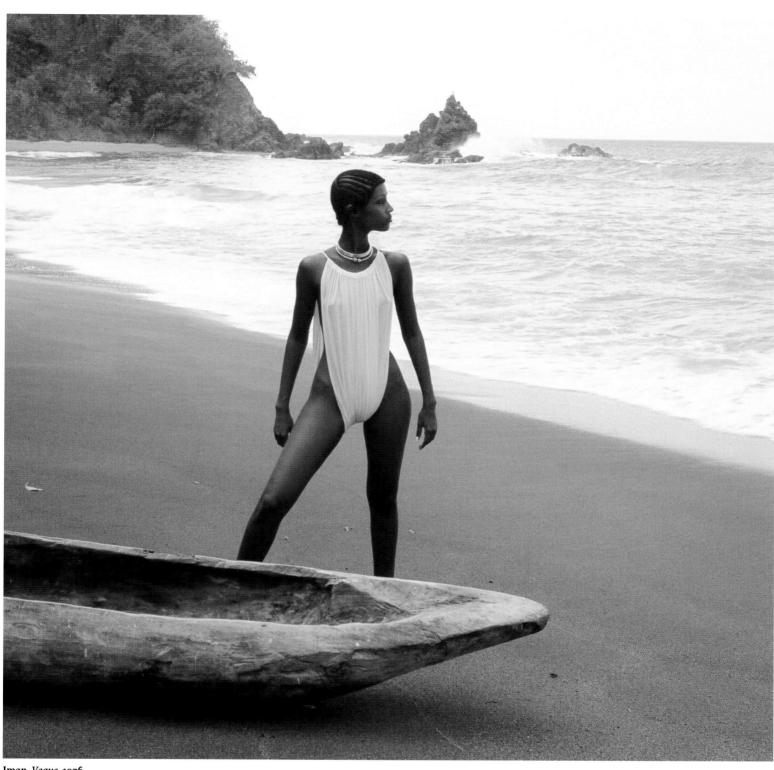

Iman, *Vogue,* 1976

'A Spyhole on the World'
Robin Muir

'I am the World's Most Famous Unknown Photographer', declared Norman Parkinson to *Vogue* in 1973. His comment is characteristically ambiguous: casual self-deprecation underpinning a sure conviction of his own worth. He relished the duality. To one perceptive commentator, Brian Appleyard of the *Sunday Times,* 'Parkinson was at least two men'. He discarded his given name for a professional one; he cultivated a persona at odds with his early background; he spoke of the 'bilateral, diametrically opposed forebears' whose 'unlikely mixture of rustic and urbane genes' informed his photography; he professed to care little about the technical intricacies of photography but revealed himself as a patient and skilled craftsman; he opted for a quiet life on a Caribbean island but appeared to welcome the intrusion of interview requests, magazine profiles, and society page snapshots. He was at once a flamboyant fashion photographer and an enlightening, sometimes incisive, portraitist.

Until he severed ties with *Vogue* in 1978, ending a thirty-seven year alliance, the magazine had made Parkinson's fashion and portrait photographs internationally known. By 1964 *Photography* magazine considered him 'the greatest living English photographer'. In 1989, the year before his death, in an exhibition to mark the 150th anniversary of the invention of photography, the National Portrait Gallery in London noted Parkinson's status as 'the doyen of British fashion photographers'. His name became associated with an ebullient naturalism – almost revisionist for fashion photography in the mid twentieth century – allowing expression to crease unblemished faces and movement to galvanise limbs. Parkinson brought realism to portraiture too, putting his sitters in familiar (and often revealing) milieus, but tempered over-analysis with humour. He achieved his earliest successes in the mid 1930s, as photography emerged as the foremost medium for illustrating fashion, and died, still working and on location, one of the last survivors of a pioneering era.

To his peers he was an original. Richard Avedon maintained that 'there are very few photographers who remember that photography can be an expression of a man's creative instincts. You are among those who have never forgotten'. Terence Donovan considered him 'the first successful English heterosexual fashion photographer', whose 'fluidity of style never deserted him'. Cecil Beaton admired his 'complete mastery of his craft' and his range as 'fresh and unstereotyped'.

In a career that spanned seven decades Parkinson reinvented himself for each or, as Beaton perceived it, changed his style 'according to the necessities of the day': at the outset a West End studio portraitist; by the late 1930s an exponent of *en plein air* naturalism for *Harper's Bazaar*; a neo-romantic photographer-cum-gentleman farmer for wartime *Vogue*; in peace regarded as the finest British portrayer of the 'New Look'; revitalised for the 1960s, he was contracted to the modish *Queen* magazine and in the 1970s, back with the international editions of *Vogue*, a reliable assignee of exotic location work. For his final decade, the 1980s and *Town & Country*, he was a mirror to the sometimes questionable taste of the era, which might become good taste, he mused in his 1984 autobiography *Lifework*, if perpetrated with enough 'persistence, confidence and money'. Beatrix Miller, his editor at *Queen* and later at *Vogue*, observed that '[Parkinson] virtually invented himself, the idiosyncratic layers piling up over the years'.

Parkinson deflected criticism of the multiplicity of his photographic styles – and lack of one identifiably his own – by cultivating an indifferent attitude to the discipline and treating technique in terms of mock awe. 'Colour photography is largely magic', he might say, 'hiding in the bellows

there live dozens of hobgoblins, some good some evil'. Or, of a successful photograph, 'that something extra … comes strolling along. People say, "How did you think of it?" But you didn't, it happened. Something happened in the camera…'. Or again: 'my gremlins are all sort of charming … my pictures turn out kind of charming and beautiful. I don't know why …'. For a photographic yearbook he exhorted readers in a series of lively axioms: 'Don't listen to what they are saying – photography is not an art!' From 1957 onwards, he insisted that his photographs would not come out at all unless he sported a Kashmiri wedding cap (of which he appeared to have an unending supply), a new one perched on top of a worn-out one until it 'had picked up the energy'.

Such nonchalance prompted others to follow his example and Parkinson was often the focus of lightweight magazine and newspaper profiles. This has to a large extent obscured

his considerable inventiveness as a fashion photographer in favour of a 'High-Tory Dandy' persona, a phrase coined by David A. Mellor. Irving Penn considered Parkinson's photographs 'remarkable stills from the film of an interesting life', and Parkinson was meticulous in developing an impulsive and unstructured style, though admitting that 'almost every photograph that is particularly appealing and true has been arranged and rehearsed'.

Before Parkinson's arrival British *Vogue* had relied on imported photographers from Europe and America and, in the infancy of colour photography for magazines, on material lifted from American *Vogue*. Though this would continue out of necessity during the war years, Parkinson's English pastoralism, as much as Cecil Beaton's self-motivated 'recklessness of style', gave British *Vogue* its own identity for the first time. Parkinson appeared, for all too

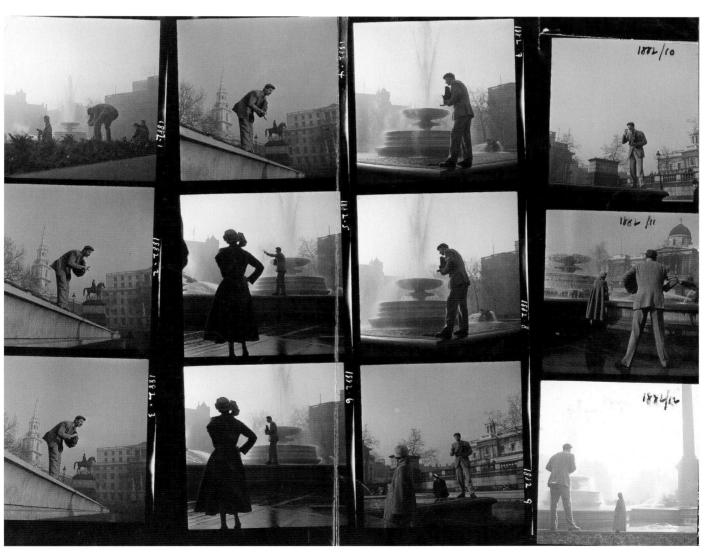

On the Thames Embankment, London, 1949

Aged 14, Putney, 1917 **Westminster School, 1930** **Henley, 1930**

brief a moment, indebted to no previous photographic genre. By the end of his life (he died in 1990 in his seventy-seventh year) he had become, in Britain at least, a household name, a photographer to the royal family, the recipient of a CBE (traditionally the first step to a knighthood), an Honorary Fellow of the Royal Photographic Society, and the subject of a large-scale retrospective at the National Portrait Gallery, London. His death on location in the Far East was reported in every British national newspaper and many American ones. 'Salute to the Last Great Eccentric', ran a typical headline.

His self-invention (and cultivation of eccentricities) started early. Around 1934 at the age of twenty-one he changed his name from Ronald Parkinson Smith to briefly 'Ronald Parkinson' and then 'Norman Parkinson': 'I didn't see how anyone could make a business out of being a high-flying photographer with the name "Smith"'. Standing at 6 feet 5 inches tall since adolescence, he was unable to remain unobtrusive behind the lens and instead created 'Parks', the moustachioed, ostentatiously elegant fashion photographer – as much a personality as those who sat for him (frequently a more flamboyant one).

Like his contemporary Cecil Beaton (who considered Parkinson 'a bit "flash"') he consolidated the popular notion of the mid twentieth-century British fashion photographer as a mondain creature, the worlds in which he moved rarefied and exotic, occasionally frivolous and comical, but clearly never dull. The *New Yorker's* Kennedy Fraser was quick to observe that a page of photographs in *The Times*, which was devoted to a retrospective exhibition of Parkinson's work, was all but dominated by an image of the photographer himself: 'He was manifestly a personage in his own right, seen striding through tropic greenery wearing a sort of

Byronic cricketing outfit, a big snow-white, last days of the Empire moustache, and what looked like a Victorian smoking cap'.

Thirty-five years earlier in 1949 another American, the photographer Irving Penn, made a portrait (for American *Vogue*) that stripped Parkinson's Anglomania to its symbolic and stylised representations: a Savile Row suit, a ramrod-straight back, a furled umbrella. He had taken a Noël Coward admonition at least partly to heart: 'Parks will learn that the talented always dress like stockbrokers', but later ignored it to extraordinary sartorial effect. He was, as his tailor, Mr Wyser of Wyser & Bryant, surmised, 'a man who wanted to be noticed'. At least one American, initially his champion, found the effect parodic and mystifying: 'He became such a social dandy', Alexander Liberman, art director of American *Vogue* remarked, 'he got to be an arch snob and a phoney, and I couldn't stand the falseness'. Liberman failed to glimpse what others did: Parkinson's flawless profession-alism, manners, well-rehearsed absurdities and what Brian Appleyard termed 'the confident eccentricity of his clothes' and another critic referred to as the 'decaying colonel act' reassured the uneasy sitter and disarmed the experienced. His colleague at *Vogue*, Siriol Hugh-Jones, recognised these as elements of the conjuror's art, 'with his sitters half-hypnotized before he begins'.

Parkinson's exaggerated personal style and a propensity late in life for unexpected business ventures, such as pig farming and sausage making; for idiosyncratic publications, such as his first book, the provocatively jacketed *Sisters Under the Skin* (1978) or the conceptual *Would You Let your Daughter?* (1985); for surprising public appearances and for photographs that teetered, as he acknowledged himself,

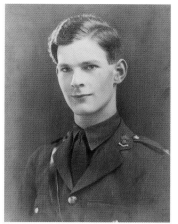
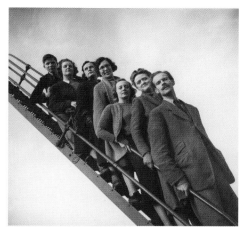

Speaight & Son, 1931　　　　　　With Dover Street Staff, 1938　　　　　　With Wenda, 1949 by Eric

'on the knife edge of bad taste', all conspired, as well his self-effacement, to mask to a wider audience the merits of his fashion and portrait photography. There was every indication too that the public might only think of Parkinson in relation to his successful 'Porkinson Banger' sausage rather than photography. He could be, as his *Vogue* contemporary Cecil Beaton observed, 'acid as well as disarmingly unsure of himself', to which could be added a lifelong uncertainty of the social status of photographers, also shared by Beaton. He would surely have sympathised with Beaton's words: 'When I began, a photographer had no position at all; he was a sort of inferior tradesman, and even the servants used to be surprised at one. And one had to be so terribly polite to everyone …'.

Though he had worked for American *Vogue* in the 1950s, Parkinson found late-flowering success in the United States with the glossy magazine *Town & Country* and in 1983 was awarded a 'Lifetime of Achievement' award from the American Society of Magazine Photographers. Four years later the National Academy of Design, New York, mounted an exhibition of his work, only the second time since 1825 that a photographer had been so honoured. No British institution has held an exhibition of Parkinson's photographs for over fifteen years and despite Martin Harrison's well-received posthumous compilation of photographs, his contribution to the development of fashion and portrait photography in Britain has frequently been overlooked.

Though he would write extensively about his early life in the photographic autobiography *Lifework* (1983), he tended to discourage enquiry into his background, obscuring dates and fudging, for whatever reasons, certain aspects of his personal life. 'The best photographers', he was fond of

remarking, 'are the biggest liars'. The circumstances of his photographing for the first time Wenda Rogerson, the model for his fashion photographs of the 1940s and 1950s (and whom he would marry in 1947), as related in *Lifework*, are misleading. He also suggested that he was first engaged by *Vogue* in 1945, though it was, in truth, four years earlier in 1941. Perhaps he considered this latter fabrication enough to deflect closer scrutiny of his war service, which he tended to gloss over in interviews.

These selective biographical interpretations are harmless enough but add to a prevailing notion of the fashion photographer as poseur, an unfathomable breed apart. Harry Yoxall, *Vogue*'s managing director when Parkinson first worked there, confessed to perplexity over the motivations of 'this curious caste of fashion photographer': '[they] suffer morbid suspicions of their colleagues', he wrote in his autobiography, 'they claim their techniques are plagiarised and demand personal assistants restricted to their private use, so that their "secrets" cannot leak through to other photographers …'. This may be an exaggeration in Parkinson's case, but he was, as he noted himself, occasionally prone to displays of petulance. One such incident at *Vogue* involving him ripping a transparency selected for publication with his teeth because he so loathed it was 'a course of a behaviour of which I am not proud'.

Yoxall's description of Parkinson as resembling 'an officer of the Bengal Lancers', with 'a fancy for wearing curious clothes … one of the diminishing race of English eccentrics', is worth noting. Militaristic descriptions clung to Parkinson, ironical in light of his refusal to enlist during wartime. He cultivated, as already noted, a 'decaying colonel act', his bearing would be described as 'ramrod stiff', his moustaches

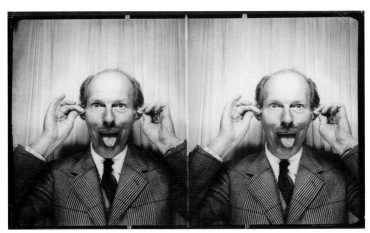

Photo booth, New York, 1949

'formidable', he considered his own demeanour as that of 'a retired army officer', his pre-production like 'mounting a small section of D-Day' and, as Terence Pepper, the curator of his National Portrait Gallery retrospective, put it: 'he will occasionally adopt the air of a faded colonel who has just taken up photography as a pleasant hobby ...'. Cecil Beaton was quick to observe that 'he is in fact not all what he appears to be ...'. Perhaps his polished idiosyncrasies allowed him to escape, as they did Beaton, the restraints of an inflexible middle-class upbringing and pre-empted over-scrutiny into the past.

Ronald William Parkinson Smith was born in 1913 in Roehampton, south London, the second of three children. His father, William James Parkinson Smith practised at the bar with no conspicuous success, 'a quiet countryside bachelor until well after he was forty', as Parkinson remarked in *Lifework*. Most of his career was spent administering the Anglican Church's payment funds and Tithe Redemption in Dean's Yard, Westminster. His mother, Louie, was descended from the great basso profundo Luigi Lablache, who excelled in the title role of Donizetti's *Don Pasquale* and as Bartolo in Rossini's *The Barber of Seville* (he was also a music tutor to Queen Victoria) and one Madame de Meriec, a soprano to the Imperial Court at St Petersburg. This combination of 'rustic and urbane genes', allowed Parkinson to 'feel equally at home waiting patiently ... over a badger's earth or among the marble pillars and gilded ceilings of an Italian palazzo', contributing, he believed, to the diversity of his photographic styles.

He described his paternal grandfather as 'a gardening butter-and-egg merchant from the West Country' and his grandmother Sarah Sealy's rural life in terms so wistful that pre-First World War Wiltshire seems almost a lost Avalon: 'the smithy [at Tetbury] was worked by the Sealy family for as long as records exist and I am very proud of the trickle of hoof-smoked blood that courses through my veins.' Parkinson was himself evacuated to a farm for much of the First World War – 'I remember everything about it, the smells the sounds, the happiness' – and during the Second World War was a successful farmer, which Polly Devlin, writing in *Vogue,* noted years (and two farms) later was 'his real passion in life, not photography'.

Parkinson encouraged this perception of *rus in urbe* as 'part of the secret of why I think and see as I do'. 'When girls are photographed by me in the cow parsley or against dew-hung November cobwebs', he continued, 'you can be certain there are few errors'. The slow pace of English rural cultivation, essentially unchanged despite the advancements of the Industrial Revolution, contrasted with the fast-paced and transient disposition of the fashion world, both providing Parkinson's photography with a delicate equilibrium. He was assiduous in maintaining the balance: 'I have been taking the same pictures for over thirty years. They have got a little bit sharper, a little better, a little more beautiful. I'm not interested in anything Nature has not smiled upon'.

But for most of his childhood Parkinson was brought up in Putney, a middle-class enclave of southwest London. He was conscious, however, that 'it was the underprivileged side towards the river', from where he could make out the 'rather grand' double-fronted house in which his two maternal great-aunts lived with their chauffeur and 'dark green-bodied landaulet by Panhard-Levasseur'. There he would amuse himself with a large kaleidoscope on an ebony stand. 'The magic of this machine never palled ... these

were possibly the first exciting images that my eye ever experienced'. He was also aware that these two ladies – 'the Aunts Cobley' – frequently supported the impecunious Smith family, not least by paying Parkinson's school fees.

He was educated at Westminster where he did not much distinguish himself except at rowing and art. Henry S. Williamson encouraged him in the latter pursuit. Parkinson later wrote of his art master, 'With his spatulate fingers and turpentine smell, he spoke hardly at all and I worshipped him with filial piety.' Parkinson duly won the Henry Luce Art Prize. He was most prominent, however, for his great height – he was already 6 feet 4 inches tall at seventeen – as a school photograph of the tallest and shortest Westminster pupil in March 1930 confirms. A year later, in the absence of a clearer career pattern, he was encouraged to accept an apprenticeship with Speaight & Son, a firm of Bond Street

photographers, whose representative had approached Westminster in search of a suitable candidate for the three-year post. Though Parkinson had by this time enrolled in a bookkeeping course at Clark's College, Putney, his former art master recommended him. Parkinson was taken on, his father paying a premium of £300. From this Parkinson was paid one pound a week and was taught the basic principles of studio portrait photography and allowed to hover over the Speaight printer: 'As his brown-stained hands flipped the next piece of totally clear photographic paper into the developer, I would wait and feel the excitement … at the magic of the slow arrival of the perfect black-and-white picture'.

Speaight & Son had enjoyed popularity with the British royal family, a tradition that continued during Parkinson's brief tenure when Richard Speaight took the first pictures

Vogue studio, 1953

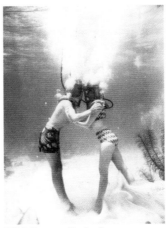
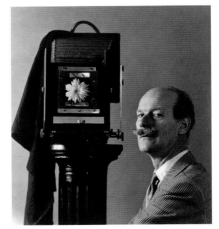

Buckingham Palace, 1955

With Carmen, Barbados, 1959
by Bronson Hartley

At *Queen*, 1960

of the Duke of York's younger daughter, Princess Margaret Rose. He had taken a well-known portrait of the Belgian King, Albert, on the Western Front in 1917, the 'effective dark quality' of which Parkinson found 'most moving, reminiscent of Rembrandt'. But by the time its new apprentice arrived, the reputation of this once fashionable firm of court photographers was beginning to fade – 'a little old fashioned, almost Edwardian', Parkinson recalled, and the company was almost bankrupt, not least because of competition in and around Mayfair and a dwindling clientele for such portraiture. 'Speaight was a court photographer, not a society photographer', Parkinson explained to the *New Yorker*, '"society" was about as nasty a word as "fashion" in those days'. He maintained that the formal portrait 'had died with the First World War, the death knell of vanity'. The photographs of actresses, minor Russian royalty, debutantes and titled ladies who patronised the studio photographers of Mayfair were almost generic to Parkinson's eyes and could have been made 'by Speaight ... or Bertram Park or Paul Tanqueray or Dorothy Wilding or Yevonde or Bassano ...'. Two years later, Parkinson would set himself up in competition in Dover Street, a few hundred yards to the south of Speaight.

In the meantime, in his first few months, Parkinson's indenture consisted mostly of tedious and unskilled studio tasks but in time he was appointed Speaight's principal studio assistant. 'It was an excellent studio by any standards with handsome late Victorian woodwork', dominated by 'the great ten-by-eight bellows camera which rested on a slightly mobile iron contraption which looked like a coffee grinder'. He was released early from his contract, having hijacked a Speaight sitting for his own creative ends: 'I was an unmitigated menace'. His reference from the firm read in part: 'It is possible that one day he may take a good photograph – he is a very original young man'.

In 1934 at the age of twenty-one Parkinson opened his own studio at 1 Dover Street, Piccadilly, in direct competition not just with his former employers at 157 New Bond Street, but with other established Dover Street studios, those, for example, of Paul Tanqueray, Marcus Adams and the husband and wife team of Bertram Park and Yvonne Gregory. He had assumed a partner for this enterprise – one Norman Kibblewhite, also an alumnus of Speaight & Son, who had gained experience in film lighting – and a staff of five. Combining Kibblewhite's first name with Parkinson's father's third forename, the pair opened for business under the name 'The Norman Parkinson Studio'. 'We try to be two friendly people showing [their sitter] how we have planned her sitting, a background especially prepared for her', Parkinson told an interviewer for *Photography* magazine in 1935, 'the camera does not loom before her like a ghoulish monster waiting to devour her ...'. The partnership did not last long and when Kibblewhite left, the remaining partner continued from then on with the *nom de guerre* 'Norman Parkinson'. He intended to make his living by doing what he then knew best: society portraiture with a bias towards presentation photographs of debutantes (in effect the clientele of Speaight & Son). Apart from a reluctance to retouch prints – 'most of our flattering is done by lighting' – Parkinson had another immediate, if slight, advantage over his more established rivals: he was, in his own words, 'something of a debs' delight', allegedly a former junior waltz champion for England and 'had the first of some very fetching motor cars', including a rare (even then) OM four-seater tourer. 'It seemed that the debs were queuing

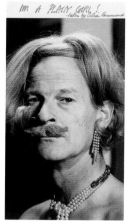

up for a spin or two. Eventually I would spin them into the studio, and, if they agreed, would sell one of the resulting pictures to *The Bystander* for a full page for five pounds'. But with overheads of ten pounds a day and the reluctance of debutantes to settle their accounts 'even a Smart Young Thing each day could not keep me solvent', he recalled.

What did keep his studio solvent from 1935 until he closed it on the eve of war was a monthly cheque from *Harper's Bazaar*, the result of a fortuitous incident at 1 Dover Street. Visiting another photographer, P. Joyce Reynolds, *Harper's* editor, found the lift under repair. On her way upstairs, she paused to look at some black-and-white enlargements – Parkinson's display prints outside his studio. 'I had taken [them] with a friend's camera in Italy. They were very much of the period, rather Germanic lowering skies, silhouetted trees, but they must have impressed her, for later that afternoon I got a call from her art director Alan McPeake ...'. In fact, as the historian Martin Harrison has pointed out, this is a little disingenuous, for Parkinson had already been contributing indifferent studio shots to the magazine. But from then, photographing for the most part outside the studio, he was given more prominence in its pages. His career as a fashion photographer had an inauspicious start: on location in Green Park photographing 'smart ladies in hats', his second-hand camera failed to work. The retaken pictures, this time on a handheld quarter-plate Graflex, were a success and Parkinson found himself regularly commissioned by McPeake. Outdoor location work horrified him at first – 'I only work in my studio!' was his anguished response to McPeake's early overtures. 'I was trying to make moving pictures with a still camera', he explained years later in *Lifework*, 'Many photographers who

attempt this ... have come to realize that if you see on the ground-glass the image you are striving for, and it is a moving or airborne image, you are too late. The secret is to direct the shot and have the luck to anticipate it'. Parkinson's 'Action Realist' approach was augmented to dynamic effect by McPeake's imaginative layouts – he cropped his pictures radically, occasionally tilting them on the vertical axis or overlapping them with text.

'I like to think that I'm a photographer who has not got stuck', Parkinson told Terence Pepper, 'any photographer who surrounds himself with a studio is doomed'. The Norman Parkinson Studio – still specialising in the creatively lit formal portrait in the then-fashionable 'Hollywood' style – continued to run until 1939, but Parkinson could be found mostly on location. For a portrait sitting, this might be the 'crazy, totally messed up' Dorchester suite of the visiting American designer Charles James (he called the finished picture 'Creative Agony') or the 'rarefied ménage in Wimpole Street' of the patron and collector Edward James. For fashion shoots, Parkinson was sent further afield to Le Touquet and the Adriatic Coast, occasionally using hard-to-come-by colour film for his compact, small-format camera.

In addition to regular assignments for *Harper's Bazaar*, Parkinson was also a frequent contributor to *The Bystander* – essentially a society magazine, whose pages Parkinson filled with a steady supply of debutante portraits. Its editor, Reginald Hooper, had an appetite for news pictures. He gave Parkinson *carte blanche* to create elaborate tableaux commenting upon, among other issues, the abdication crisis of 1936 and the beginnings of commercial air travel, the latter in a modernist, geometric representation he called 'Winged

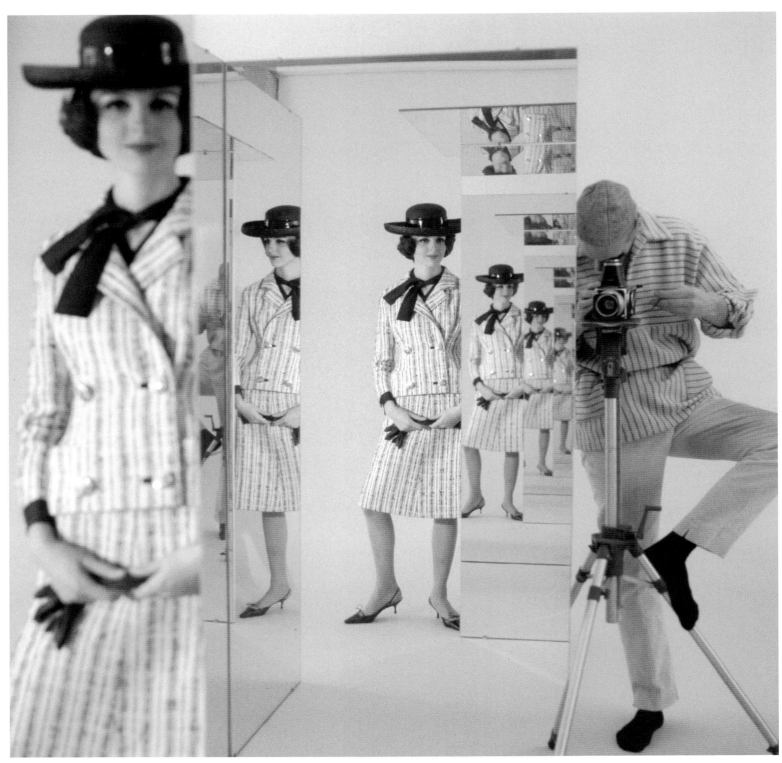

At *Queen*, 1962

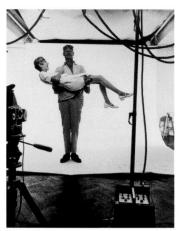

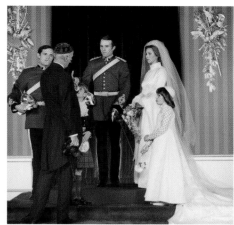

Ravello, Italy, 1969 With Twiggy, 1970 Princess Anne's wedding, 1973 by Tim Jenkins

Leviathan' (1936). Parkinson revealed a considerable – and hitherto untapped – streak of social compassion in a series of documentary pictures of the mining community of Merthyr Tydfil, South Wales. A politically motivated series 'With the Services' documented British re-armament in weekly parts. He was despatched to Paris to report on the Exposition Universelle and also, for a weekend, to New York in 1939 to photograph the World's Fair. In Paris he collaborated with the avant-garde photographer Francis Brugière on a photomural for the British Pavilion by taking portraits of certain generic British 'types'; these could be seen as the antecedents of his neo-romantic oeuvre to come. For *The Sketch*, he contributed reportage portraits of British artistic life, including dramatic if informal snapshots of Noël Coward, and Gertrude Lawrence, John Gielgud and the comedians Robertson Hare and Douglas Byng.

By the eve of war, which his propagandist re-armament photo-essay had presaged, Parkinson was prosperous. In the mid 1930s he had made his first incursion into the advertising world, which customarily paid more than editorial commissions. An advertisement for the fashion house Matita, photographed in 1938, featuring a recumbent Lady Marguerite Strickland, was well received by the industry. It was illustrated in *Art & Industry*, where Parkinson was sufficiently well known to be billed, alongside Shaw Wildman as 'one of Britain's leading photographers', and in *Photography* magazine it earned him 'Advertising Photograph of the Month' with the accompanying accolade: 'it is such a good advertisement photograph ... it compels attention – it has that "different" touch which lifts it from the normal fashion pictures'. Alan McPeake, who had been the art director for Matita in tandem with *Harper's*, may have helped

supply the different touch. The Norman Parkinson studio also held its first exhibition, opened appropriately by a society figure, the Duchess of Leinster. (Virtually all of the negatives from the Norman Parkinson studio were destroyed during the Blitz.) Parkinson had also found time to marry Margaret Banks in November 1935.

By 1940 Parkinson had left *Harper's Bazaar*. There is speculation that he had encountered a lack of sympathy there for his decision not to enlist. He rarely spoke directly of this. 'I was a photographer and a farmer', he told one interviewer, 'most of the officers of the brigade I would have joined were killed at Dunkirk, so perhaps it was just as well ...'. Equally, he seldom mentioned his Territorial Army service as a 2nd Lieutenant in the 92nd field brigade of the Royal Artillery. He mentioned to one interviewer that he had an 'interesting war. I used to do quite a lot of flying, doing reconnaissance, that sort of thing. Quite a lot of stuff I did ended up in magazines for the French resistance.' Perhaps they were better disposed to him at *Vogue*, for by 1941 he had taken his first photograph for the magazine (part of a set of seven images in a fashion story called 'Country Change'), a fashion shot of a utilitarian cycling outfit. Followed swiftly by two spreads entitled 'The Freedom of the Farm', this was the start of an association that would last – with a five-year break in the 1960s – until a dispute over copyright ended it in 1978.

Parkinson acknowledged that at *Vogue* he was part of a brilliant creative regime, whose arrival there preceded Parkinson's by only a matter of months. Audrey Withers, *Vogue*'s editor from 1940 to 1960, headed the team. Parkinson intuited quickly that she had no real interest in fashion (her memoirs reveal further that she had no real interest in editing *Vogue*) and under her tenure, *Vogue*'s features pages glittered.

17

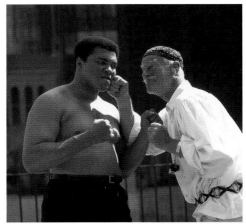
With Muhammad Ali, 1970s

By Cecil Beaton, 1975

On location, 1970s

Parkinson was able to photograph subjects as diverse as the Oxford classicist, Maurice Bowra, Montgomery Clift, a young Petula Clark, Marlene Dietrich and the flamboyant royal dressmaker Norman Hartnell. The variety was due for the most part to the wide-ranging tastes of *Vogue*'s features editor, Siriol Hugh-Jones, whose 'erudition was so complete and impressive that I always felt inadequate in her presence ... we were a great team.'

Though he praised Withers, Hugh-Jones and *Vogue*'s fashion team for guiding his fledgling career, it was art director John Parsons with whom Parkinson had immediate empathy. Having recognised Parkinson's affinity with the English countryside, Parsons was instrumental in developing further the pastoral element that so distinguished Parkinson's fashion work: 'Nervous and desperately sensitive ... he shone for me a penetrating beam on the rustic elegancies of England, which I was almost too close to notice. He was quiet but when he whispered "Zoffany" ... "Devis" ... "Gainsborough" ... "Wyatt" ... "William Kent" ... "Capability Brown", I looked again'. The photographs Parkinson produced were reassuringly idyllic and inward looking as Britain faced the hardship of war. In the years of peace – 'like war', said one wit, 'but without the shooting' – they re-emphasized traditional and unshakeable values.

In fact, Parkinson gave his editor and art director little choice in the matter because his farming commitments – he had acquired a hundred-acre farm at Bushley near Tewkesbury, Worcestershire – made it impossible for him to travel far. Moreover, as he admitted in 'Back to the Land', an article he wrote for *Vogue* in 1944, 'we only get bored away from the country – in London in particular'. Nearby in Gloucestershire was the air base of Little Rissington where

Parkinson carried out assignments for the Air Ministry (for whom he also made photographs for leaflets to be dropped over occupied Europe). He also made several documents of the WELCS (Women's Emergency Land Corps) in action, harvesting and fruit-picking for the war effort. His *Vogue* article introduced readers to his second wife, the former fashion model Thelma Woolley, whom he had married in 1942. His stepdaughter Jennifer took at least one of the accompanying photographs.

Parkinson managed to combine farming with photography for the duration of the war, producing fashion photographs that conspicuously rose above the privations of the period. He was able to explore his bucolic themes further in peacetime. Terence Pepper has identified that Parkinson's women 'have liveliness and warmth as well as elegance. They have a certain breezy independence. They were the kind of women with whom the readers of *Harper's Bazaar* and *Vogue* wished to identify themselves'. In five years, without having to set foot further than Tetbury, Wiltshire, Parkinson had stamped his mark on the magazine. In 1947 he reacquainted himself with the studio and began for *Vogue* a series of dramatically lit fashion pictures. His photographs admitted not only women who 'live ... out there in the fields jumping over the haycocks' but also those of considerable *hauteur*, such as Barbara Goalen and Della Oake who epitomised the feminine ideal for mid century couturiers. The fashion industry had been revitalized by Christian Dior's 'New Look' collections of 1947 and 1948, which, together with a greater allocation of colour pages, rejuvenated *Vogue* in the immediate post-war years.

Parkinson also reacquainted himself with metropolitan life, having given up farming after acquiring a Regency house

 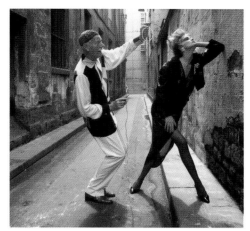

With Andrea Holterhof, 1980 by Chuck Zuretti With Franke, French *Vogue*, 1983

in Twickenham on the outskirts of London. He had eclipsed his colleagues at *Vogue* to become the magazine's leading photographer. His closest rival, Cecil Beaton, had been moved and tired by his war efforts, leaving him with little appetite for fashion in the years afterwards. With characteristic indefatigability, Parkinson sought out fresh challenges.

From 1949 until 1955 he made half-yearly visits to New York and American *Vogue* after making overtures to Alexander Liberman, its art director, to work for his magazine. Liberman recognised that Parkinson's *esprit*, even in its specifically English incarnation and almost exclusively in black-and-white, could be translated into colour onto the streets of post-war Manhattan. And of the Parkinson physiognomy, the 'rustic' genes yielded inevitably to 'the urbane' which had, since 1939, remained comparatively subdued.

Accompanying him was his third wife, the former actress Wenda Rogerson, whom he had married in 1947. With her, he would make some of *Vogue*'s – and post-war fashion photography's – most readily identifiable images: she draped herself over the bonnet of a Rolls-Royce Silver Ghost, leaned over the five-bar gate of a muddy Gloucestershire field, sat in a cashmere twinset and pearls in the public bar of the Hobnails Inn, Little Washbourne, and stood beneath the 365-foot drop of the Howick Falls, Natal. She offered to his camera, in Parkinson's own words, 'a quiet beauty … frozen, permanent, it does not age' and she recognised her strength in his fashion photographs as 'witty underplay'. The impact of their close collaboration (and the parallel example of Irving Penn and Lisa Fonssagrives in New York) prefigured, in Britain at least, in the decades to come, the exclusivity of

Jean Shrimpton with David Bailey and to only a slightly lesser extent, Terence Donovan and Celia Hammond.

Parkinson anticipated abandoning the discomfort of post-war British life. 'When I heard that Penn could use twenty or thirty sheets of 10" × 8" [film] on a still-life sitting, my gaze turned longingly westward'. Cecil Beaton bemoaned the lack of facilities offered by British *Vogue*, identifying Parkinson's partiality for location work as a necessity rather than a preference: 'I think too that it is cashing in on one of our integral assets to photograph people in the Crescent at Bath rather than organize indoor sittings in studios which are poorly equipped', he wrote in a letter to Harry Yoxall. By contrast American *Vogue*'s new studio complex on Lexington Avenue was well appointed. The photographer Horst recalled it consisting of 'several sizeable studios, darkrooms, a dressing room, and an office. The studios were provided with a seemingly unlimited supply of equipment. They were full of lights and props never available before'.

Under the aegis of Bettina Ballard, American fashion editor, Parkinson met with rapid success, his first cover shot an adventurous, reportage-style set up of Wenda on the sidewalk taken through the plate glass window of the Sherry-Netherland Hotel. Apart from the studio amenities, the ready availability of colour film, the consistency of climate and the spiritedness of his collaborators re-energised Parkinson. He also discovered the portable, square-format Rolleiflex camera with a natural low angle, which suited his tall frame. In New York he also acquired one of the first Hasselblads and later the earliest motor-driven Nikon, both of which in time became his preferred camera.

For four to five years Parkinson's contributions to the pages of American *Vogue* were dynamic and conspicuous,

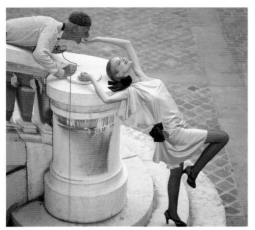

With Franke, French *Vogue*, 1983 For Alexon, 1984 by Chuck Zuretti

confirming his international reputation. He had been determined to 'try my hand alongside the great photographers working there' but discovered that in New York, fashion photography was a burgeoning and cut-throat profession. As the war in Europe had escalated, there were European exiles, such as Horst and Erwin Blumenfeld, Constantin Joffé and Serge Balkin vying with younger home-grown photographers for fewer magazine assignments. This competitiveness manifested itself as soon as his first fashion stories appeared. 'My pride in the Ballard patronage', he recalled, was dampened by an awareness that he was being received with 'marked coolness'. Despite Liberman considering Parkinson 'a very good photographer', admiring his 'wonderful sense of integrating fashion and landscape', they parted on bad terms. He ordered Parkinson to leave his office and did not commission him again. 'I can't even remember why I got so furious at him that day', he told his biographers, 'it was probably a sitting he refused to take. I just said, "Get out" and he did'. By 1954, Parkinson had realised that the more prestigious assignments were being offered to colleagues and it is perhaps understandable that he became disillusioned by magazine photography. He had found time to attend the now-celebrated classes run by Alexey Brodovitch at New York's New School for Social Research. Brodovitch was Liberman's keenest rival. As Martin Harrison has pointed out 'in view of Parkinson's long-term relationship with *Vogue*, it is interesting that he set so much store by the teaching of the legendary art director of *Harper's Bazaar*'. This interlude, brief though it was, would not have further endeared Parkinson to the art director who had brought him to New York. Parkinson's last such visit occurred in 1955.

Before that, in 1950, the second year of their association, Liberman commissioned Parkinson to photograph the Paris collections for British and American *Vogues*, considered then the supreme accolade for a fashion photographer. Subsequently, Liberman included a portfolio of Parkinson's colour photographs for his mid century survey of colour fashion work *The Art and Technique of Color Photography* (1951). His colour photography would be further celebrated in British *Vogue* with a twelve-page portrait portfolio of Britain's leading couturiers.

In 1947, Parkinson was assigned a fashion story, 'Weekend in Brussels', that acknowledged the rebirth of commercial air travel barely two years after the end of a conflict that had redrawn the map of continental Europe. It anticipated the golden age of jet travel, which Parkinson and *Vogue* would both profit from in the years to come. Liberman was not alone in recognising Parkinson's spectacular success with fashion in unfamiliar environments and, four years after his turbulent ninety-minute trip to Brussels, he was despatched to South Africa for a special issue of British *Vogue*. The exotic locations in Zululand, Natal and at the Victoria and Howick falls culminated, as Parkinson told it, in Wenda's positioning herself astride an ostrich, which then moved off into the bush at considerable speed. Ringing in her ears, as Mrs Parkinson relished telling, was genuine concern – for the success of the picture: 'More Profile, Wenda! More profile!' This kind of fashion photograph, colourful, quirky and unanticipated, set a formula for Parkinson's travel and location work. 'I think I started the trend for trips to impossible places', he commented when interviewed for BBC Radio's 'Desert Island Discs' in 1978.

By the turn of the decade, Parkinson had had an exclusive

arrangement with *Vogue*, unbroken for nearly twenty years. His contract was altered to allow him greater freedom of choice in advertising commissions (previously these had been filtered through the agency of Vogue Studios). By the mid 1950s he was considered *Vogue*'s top fashion photographer, eclipsing for the first time his admired rival Cecil Beaton in fashion and portrait coverage. The magazine still valued his pictures greatly for their lyrical qualities: 'pastoral, fresh, loving, an essentially English romanticism, a quintessence of all that is strong yet delicate, traditional yet young, unhectic yet vigorous in our way of life'. He found much of this personified in the model Susan Abraham, who by 1957 had all but supplanted Wenda as his chief collaborator: 'without doubt', he claimed, 'she is the most beautiful model of the 1950s'. But younger fashion photographers such as William Klein had exploded onto *Vogue*'s pages. Klein's witty surrealist vignettes on the streets of Paris, New York and Rome, outplayed his contemporaries in originality and spirit. Despite the exoticism of the locations (between 1951 and 1956, Parkinson was despatched to Jamaica, Spain, the South of France, Haiti, Italy, Scandinavia, Yugoslavia, India and Tobago), Parkinson's models in comparison to Klein's appeared suddenly staid and awkward. His humour too, by contrast, seemed wan. Klein's models refused to jump across rivers or bestride ostriches, but stood defiantly still in urban vignettes, like showroom mannequins abandoned in the heavy traffic. He made them hold mirrors to accentuate the ludicrousness of their situation and on one occasion in Rome, posed them and, at a distance, recorded on his telephoto lens the reactions of passers-by to his set-ups: 'they seemed to think they were whores, because before we stopped they started to goose the models.'

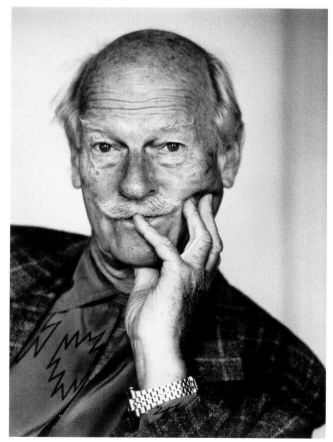

By Jill Kennington, 1987

21

Anti-pornography, 1983

Though he had previously experimented with mirrors and reflections, this was a mise-en-scène utterly at odds with Parkinson's sensibilities. 'Don't destroy them and make them look hideous for the sole purpose of inflating your own photographic ego', he admonished photographers, though later he would try to reproduce just such elaborate and absurd tableaux.

A little outmoded, Parkinson concentrated on his features work for Siriol Hugh-Jones, producing his bleakest portraits. Composers Ralph Vaughan Williams and Constant Lambert, the novelist Charles Morgan and the short story writer Algernon Blackwood were all then in old age and Parkinson caught something of their approaching infirmity and emphasised the consequent discomforts and frailties. In his own old age, he remarked that he had been 'fascinated with the arrival of decrepitude'. Penelope Gilliatt succeeded Hugh-Jones as features editor. Her four-year association with Parkinson at the end of the 1950s produced portraits of a far more glamorous nature. With peace, British *Vogue* had shed its insular, neo-romantic inclinations and in sympathy with its more outward-looking, international and better-travelled readership, its pages were filled with Hollywood actresses, Italian opera singers, Australian ballet dancers, irrepressible French fashion designers and British pop stars on the cusp of celebrity. With subjects such as Audrey Hepburn, Montgomery Clift, Jean Seberg and Cliff Richard, taken in flattering light or posed (as befitted their nascent iconographic status), Parkinson appeared to be in no real danger of eclipse. Further, judiciously casting himself in his own mise-en-scène, thus eroding the customary pictorial anonymity of *Vogue*'s picture makers, he was becoming familiar to its readers as a personality in his own right.

But in a memo from Gilliatt to her editor (Audrey Withers), she emphasized her enthusiasm for a neophyte, the photographer Tony Armstrong-Jones, who 'has something to contribute which, though different from Parkinson's style will, I think, be just as good'. Parkinson sensed displacement in the air and offered his resignation in 1958. He was talked out of it by Withers, whose own tenure at *Vogue* was nearing its end. However, at the dawn of a new decade and mirroring his unease at the start of the previous, Parkinson sought a new challenge.

In 1959 he did not renew his *Vogue* contract and in response to approaches from Jocelyn Stevens, proprietor of *Queen*, he joined the rival magazine as 'associate editor'. With the creative team of art director Mark Boxer, editor Beatrix Miller (later his editor at *Vogue*), and Ann Trehearne, fashion editor, Parkinson intended to try out new approaches to the fashion picture, not least in imposing further upon it his own personality and humour. In a directive to his staff, Parkinson summed up his new colleagues thus: 'Stevens: impulsive and very important; Miller: charming and intellectual; Trehearne: scatty and nutty'. It is in the spirit of Parkinson's desire for an abrupt change of tone that he regarded the latter's attributes as essential. *Queen* heralded him as 'irreverent' and 'The Enemy of Deadpan Pretension', and with Trehearne he made his most spectacular tableaux yet, anticipating by two decades his unrestrained assignments for *Town & Country*.

He invested in a panoramic Widelux camera, which, with its ultra-wide-angled lens, allowed him to take photographs with almost a 180-degree angle to dramatic and unusual effect. He surmised later that this dazzling approach might not have found favour at staid *Vogue* but he had already

experimented there with spatial recession, double-exposure and an occasional reliance on the 'accidental' image.

Mark Boxer had tried to encourage home-grown talent and, with *Picture Post*'s topicality ebbing (it ceased publication in 1957), he was successful in re-introducing the photo-essay to a readership that did not necessarily expect it, part of a strategy that aimed to mix seriousness with what was later termed 'the aggressively ephemeral'. He was less successful in attempting to bring reportage photographers to fashion photography and admitted that 'our fashion coverage never really picked up until Norman Parkinson joined us from *Vogue*'. 'The most impossible or improbable requests would receive the most enthusiastic reception', and Parkinson began as he hoped to continue by hiring a helicopter to cover the Paris collections with his Widelux from above the city. This resulted in series of double-page spreads sequenced for maximum impact by Boxer. For *Queen*, Parkinson would cover the collections – the high point of the fashion calendar – as an observer as well as photographer for seven consecutive seasons. 'If ever I took memorable pictures during those hectic collections, it would have been because I insisted on seeing the clothes live – walked in, whirled and twirled in.'

Parkinson was fifty by 1963 and even then something of an elder statesman, his rakish moustache and patrician demeanour lending him that appearance. He tried other diversions to keep his photography vivid, not least photographing the Paris collections on identical triplets, the Dee sisters. And to an extent he met with success. Diana Vreeland, editor of American *Vogue*, considered Parkinson's coverage of the spring collections of 1963 'the most beautiful fashion story' she had ever seen.

But he was conscious of the immediacy being brought to fashion magazines by new names, particularly at *Vogue*, such as Helmut Newton, David Bailey, Terence Donovan and Brian Duffy. The last three he christened the 'Black Trinity'. He dismissed them airily as 'those fellows so passionate with the idea that they'd invented sex'.

At *Queen* Parkinson was able to work with younger models, which for a time provided his fashion photographs with the dynamism he had sought quarter of a century earlier at *Harper's Bazaar*. One of them, Celia Hammond, who had never been photographed before Parkinson discovered her, was put under exclusive contract with *Queen* on the strength of his first pictures. 'I used her on every possible occasion', recalled Parkinson, not least because she was 'punctual and hard-working'.

He held a successful exhibition at the headquarters of Jaeger, the fashionable British clothing manufacturers in the West End of London, in 1960, noted for double life-size representations of his favourite models. In a precursor, perhaps, to fashion events and 'happenings' later in the decade, live models danced in Jaeger's windows to music audible inside and outside the store. The catalogue included an impressive list of the agencies that regularly employed him. He was now 'one of the best and most productive advertising photographers in the world'.

And it was largely to avoid taxation on his considerable advertising earnings that Parkinson and Wenda decided to relocate in 1963 to Tobago in the West Indies. After nearly thirty years of work and travel, he admitted to fatigue. 'I feel in a way that I have been a photographer and I want to see if there is anything else I can do. What I want is to have a pause in the whole thing; to cut it off dead', adding, 'since I am lucky

enough to have a house in Tobago I would like to go there for six to eight months and do nothing but try to discover who I am …'.

By 1964 and his return to *Vogue*, Parkinson was considered by *Photography* magazine as being responsible more than any other photographer 'for reshaping and re-seeing creative photography here'. He was a natural choice, therefore, to document for *Life* magazine the London fashions currently defining the 'Swinging Sixties'. As something also of a style arbiter, his opinion on current trends was often sought: 'Fashion depends on young people … not only young in age but young in thought. You know I call them the x people'. He had already photographed The Beatles in a hotel suite in Russell Square, London, and later in the studio recording *With The Beatles*. The results were compiled into *The Beatles Book*, a forty-page booklet aimed at the American market, where the eruption of 'Beatlemania' on the eve of their first tour, was imminent.

From Tobago Parkinson made frequent trips for American, French and Italian *Vogues*, as well as for the British edition. His celebrity increased as he accepted well-paid portrait commissions offered by wealthy American patrons. With his impeccable manners and exaggerated *style anglais* he radiated a certain glamour, which his *Vogue* credentials did much to augment. In 1966 his cachet increased at home and abroad after he undertook his first royal sitting, a portrait for American *Vogue* of the Queen's consort, the Duke of Edinburgh. In 1968 his contribution to British photography was recognised with the award of Honorary Fellow of the Royal Photographic Society. This followed a year and a half of almost feverish publicity, some of it self-initiated, but much of it engendered by the editors of the colour supplements of British newspapers. To them 'Parks' was a witty observer of the cultural climate in general and of his fellow photographers in particular. He made his first documentary for television, *Stay, Baby, Stay* (1967), which emphasized his larger-than-life persona with behind-the-scenes glimpses of magazine shoots with, among others, Celia Hammond and Raquel Welch. A series of royal commissions in 1969 kept him in the limelight, most notably the official photographs of Prince Charles at his investiture as Prince of Wales, and of his sister Princess Anne riding in Windsor Great Park in celebration of her nineteenth birthday. Even Cecil Beaton, whom Parkinson had all but deposed as the royal family's photographer of choice, admired his wedding pictures of the Princess, taken in 1973, as 'breakaway photographs which, with a good deal of help from *Vogue*, made her into a beauty'.

In the following decade Parkinson made more exotic fashion photographs, most often with *Vogue*'s Grace Coddington as accomplice, whom years previously he had photographed as a model. Her own force of personality and fashion taste ensured that the photographs were as unmistakably hers as much as extravaganzas by 'Parks'. She observed that with her he honed a 'resolve never to grow old'. In the 1970s, commissions from *Vogue* did not prove elusive but became sparser, treated as 'special assignments' for a grand old man. He travelled 7000 miles across Russia (the first Western fashion team to be allowed access) and to the remote Praslin Island in the Seychelles. Nearer to home, on King Peter's Bay, Tobago, he photographed for the first time Iman Abdul Majid, simply known to him and everyone else as 'Iman'. Though the photographer and naturalist Peter Beard took her first photographs, Parkinson made her into a star. 'She is', he wrote, 'simply the world's most beautiful black woman'.

The terms of Parkinson's *Vogue* contract allowed him to accept invitations from other magazines and in 1971 and 1972 his photographs of Princess Anne at twenty-one and Elizabeth Taylor at forty appeared in *Life*. He was especially proud of inveigling the latter into a specially designed wig to match her favourite pet shih-tzu. In spirit, this was almost a dry run for a set of royal pictures, the now infamous 'Royal Blue Trinity', a triple portrait marking the eightieth birthday of the Queen Mother. Parkinson persuaded the Queen, her mother and her sister Princess Margaret into three identical satin capes he had had designed and made by Hardy Amies, the royal dressmaker. 'I feel it may make a timeless, fashion-free picture which will ensure its place of importance in the future'. It was greeted instead by almost universal media derision.

In 1978 Parkinson finally quit *Vogue*. He quarrelled with the management of the British edition over the copyright in his thirty-five years worth of fashion photographs and portraits. Eventually the dispute was resolved but more immediately he was barred, despite his plaintive entreaties, from photographing the Paris collections for French *Vogue*. The commission went to Cecil Beaton, the forty-four-page portfolio among his last *Vogue* triumphs. It also cost Parkinson representation in the compilation of fashion pictures, *The Vogue History of Fashion Photography*, selected by Alexander Liberman.

But Parkinson, now sixty-five, had no intention of retiring. 'Most photographers after they are sixty-five become half-maimed and blind to boot, shambling off to some distant darkroom to reprint, hopefully for the resale

For *Moda*, 1988

of some of their more memorable pictures'. The debacle with *Vogue* left it open for the editor of *Town & Country* to scoop him up for just the glamorous and fanciful location work he so enjoyed undertaking. The magazine's resources seemed limitless and Parkinson was able to construct his elaborate tableaux again in Columbia, the Yucatan, Sri Lanka and China. 'An entirely new creative instinct was unlocked in my Pandora's box camera'. Though the results cannot be considered highpoints in Parkinson's career, the patronage of the Hearst-owned magazine so soon after becoming an ex-*Vogue* photographer gave Parkinson much satisfaction.

Town & Country, founded in 1846, had remained essentially unchanged for over 150 years: a weekly (later a monthly) compilation of society events and the often larger-than-life personalities who participated in them. As Kathleen Madden, the magazine's biographer, has put it: '*Town & Country* was society's family album, filled with informal news photographs of the rich and the wellborn at play … The Phippses galloped their polo ponies across the magazine's pages; the Biddles gathered at a shooting party; the Vanderbilts put social New York on winter sleds at Lake Placid, in the Adirondacks. At Bailey's beach, Newport, Mrs Havemeyer and Mrs Belmont grandly paraded … The men looked dashing, the women's suitings looked chic'. Parkinson savoured assignments such as 'New York's Treasures', featuring a society line-up of Brooke Astor, Estée Lauder and Suzy Knickerbocker and 'Queen Sofia and the Beautiful People of Spain'. People, in his own words, who 'wore their own jewellery and their own Saint-Laurent dresses and sat in their own drawing rooms under family portraits'. Frank Zachary, *Town & Country*'s editor-in-chief, was grateful to have chanced upon a photographer, 'the sexiest septuagenarian I know', who 'makes our lovely American ladies look like duchesses …'. And it was on assignment for the magazine in the Malaysian jungle that Parkinson suffered a cerebral haemorrhage. Two weeks later, on 14 February 1990, he died in hospital in Singapore.

Parkinson had admitted in *Lifework* to a certain ennui:

'it is clear to anyone in this ephemeral trade … that we are presiding over the dying pangs of style'. His last years had been punctuated by catastrophe. On 24 October 1987, on the eve of his historic retrospective at the National Academy of Design, New York, Wenda, his wife of forty years, died in her sleep in their Twickenham apartment. Four weeks to the day later, their home in Tobago was gutted by fire. 'I feel that my identity', he wrote to the Prime Minister of Trinidad and Tobago, 'has been blown away in smoke'. He revealed in an *Observer* interview following Wenda's death that he had never photographed her unless he was working. 'There's a lot of alchemy if you love someone, and when you point the camera at them, it will always let you down. If you really cherish someone or something and you photograph it, you remove the smell of it, the touch of it, the feel of it …'. For the next three years he took any work he could get to overcome the double tragedy: 'If you work like a lunatic you don't mourn so much'.

Parkinson's frequent and long absences from Britain had made his feelings for the English countryside more passionate and rosy-hued. Fifteen months before he died, he returned to the Thames valley, to Pishill where, as a child, he had been evacuated from the Zeppelin threat. The intrusion of trunk roads and industrial estates made him 'almost sleeplessly apprehensive about this corner of England I had come to love'. At Henley, on the stretch of river he had rowed for Westminster, one of the few triumphs of his school years, he was equally maudlin: 'sadly even this sacred mile-and-a-half is now no longer safe', he wrote in an article for the *Daily Telegraph*.

The critic John Russell Taylor had suggested that Parkinson's portraits 'in colour and composition' bore comparison to those of Sargent, to whom he was 'the logical successor', and that he was the creator of 'time capsules such as were never dreamt of by H.G. Wells'. The photographer was pleased with the evaluation and it featured prominently on the back jackets to at least two of his publications. To a degree it was an apposite one. At the root of his

photography was the simple notion that those ranged before his lens – especially women – should be flattered and glamorised and that their enjoyment of the day should be paramount. 'When I look through the camera, I see an aura about people, a joy and gaiety about it all'. 'The camera', he continued, 'can be the most deadly weapon since the assassin's bullet. Or it can be a lotion of the heart'. The notion of naturalism stayed with Parkinson for his entire career. As late as 1984 he told the painter John Ward that 'I find the thing that excites me about women is the way they move.' Parkinson revealed, again late in life, that among his earliest memories were those of women glimpsed through a fence next to a mulberry tree in his grandfather's garden. From this vantage point, as a 10-year-old, he could spy the girls next door 'with loose dresses and a minimum of underclothes … running fawnlike everywhere. In the summer dog days I could see them lying around on the lawn … the gurgling, throaty laughter. I had a spyhole on the world, which has fuelled my inspiration to this day. I photographed the memory of those well-observed weekend girls'.

Certain of Parkinson's books revealed him to be striving 'to walk down the razor's edge between pornography and a celebration of womanhood', and despite an admiration for Helmut Newton's women 'naked in wheelchairs or martingales' and for Guy Bourdin – 'I long to have that madness but something stops me short' – this came too late in his career to have much impact. Moreover a propensity to titillation mitigated any temptations to blatancy. His amiability masked a zeal for hard work and despite himself, in the years of his greatest success, his assiduously constructed pictures, whether 'urbane' or 'rustic', fashion tableau or portrait sitting, tapped into a prevalent and almost collective nostalgia for a vanishing way of life. *Vogue* did much to foster it. Martin Harrison has discerned it 'as though the "urbane genes" that encouraged his pursuit of the exotic had caused him to neglect his "rustic" roots, the solid foundation which put the ephemeralities of the fashion world into perspective'. But as Parkinson himself intimated, he was no artist,

no matter how fundamentally his crafted pictures reflected his era, though he hoped he might be remembered as 'a tiny Gainsborough or a wretched Reynolds'. He considered himself instead as 'a talented and instantaneous mechanic'. In the 1980s he wished his obituary to read simply thus: 'He took photography out of the embalming trade, and for a time, the open shutter of his camera was a window to the shimmer of a vanishing England'. Shortly before he died, he made a lengthier, more judicious and entirely typical self-assessment: 'I've never had a monumental idea that I'm a great photographer or a brilliant artist … it has pleased me enormously that what I do with this silly gadget – this silent machine-gun of the twentieth century – has gleaned me a lot of respect. But if I should give rein to immodesty … I have opinions which are fresh and I am a fountainhead of ideas. Since ninety-nine per cent of my photographs are taken outside the studios, I shall have recorded the pendulum arc of over seventy years. I hope people will realise when they look through all these hundreds of transparencies and negatives that I recorded a large proportion of the twentieth century. That is not unimportant'.

Parkinson's original black and white prints and colour transparencies were used during the production of this book. This accounts for some slight variation in tone and contrast and, due to their age, some shift in the colour balance of the transparencies.

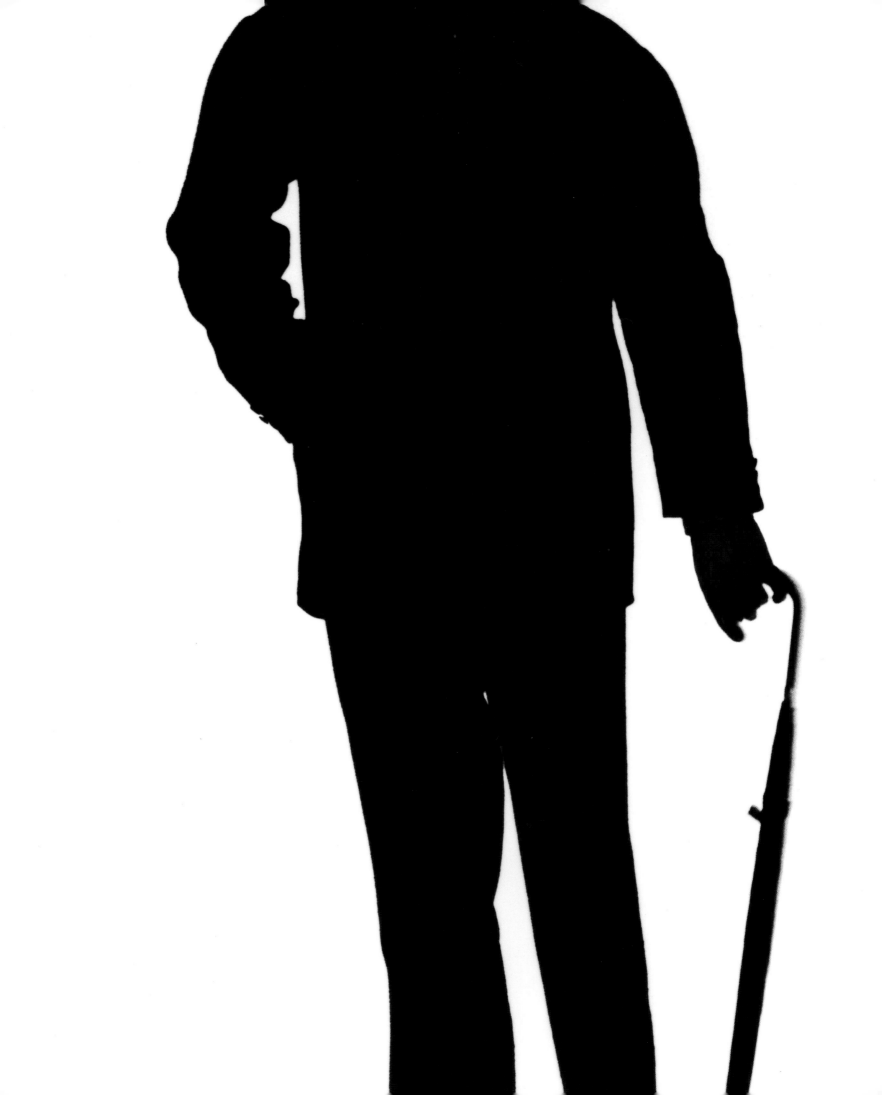

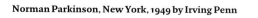

Norman Parkinson, New York, 1949 by Irving Penn

The Thirties

'Norman Parkinson is society's newest photographer – in a few months his striking work has become known throughout the West End. Before finally deciding who shall take your Court photographs Norman Parkinson invites you to visit his studio at Number One Dover Street Piccadilly and see his outstanding portraits. On Court nights the studio is open until one a.m.'
Norman Parkinson Studio brochure, 1935

In *Modern British Photography 1919–39*, David A. Mellor has identified the golden age of studio portraiture as 'interlocked with the customs surrounding high society and its satellite worlds of stage and café culture'. Allied to this, when 'Norman Parkinson' started out, was the pervading influence of another stylistic form, cinema lighting, in the golden age too of film star suffused movie magazines. This necessitated the immaculate presentation of a sitter in what was the infancy of the 'publicity shot'. Parkinson's partner Norman Kibblewhite had extensive experience in the cinema, while Parkinson's training at Speaight had left him with an abiding memory of how not to flatter a sitter with extensive retouching.

Parkinson identified the fashion photographers whose imprimatur underpinned the fashion magazines of the era: George Hoyningen-Huene, the temperamental genius of French *Vogue*, André Durst, its rising star, influenced greatly by nascent Surrealism, and Cecil Beaton the only native star that British *Vogue* could then call its own (Parkinson would become its second). Though Parkinson desired to join these photographers in the first rank, he did not – at least in hindsight – wish to emulate them. 'I wanted to take the scent-laden atmosphere out of photographs', he recalled years later. He did not identify at all with the scenarios their photographs presented, far less the women they depicted: '[they] were a rarefied few, an elitist handful. My women behaved quite differently – they drove cars, went shopping, had children, kicked the dog ...'. He certainly strove to be the antithesis of Beaton: 'there was an effeteness about his work that was suspect. I admired it, but knew it was something I didn't want to do'.

The influence of the much-neglected Peter Rose-Pulham

Pamela Minchin. *Harper's Bazaar*, 1939

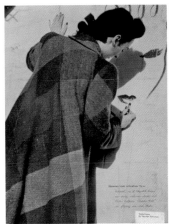

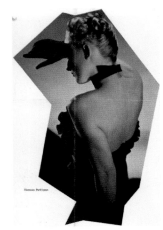

Harper's Bazaar, May 1938 *Harper's Bazaar*, June 1938 *Harper's Bazaar*, October 1938

of *Harper's Bazaar*, three years Parkinson's elder, but whose career flickered only briefly, is more evident in Parkinson's early magazine oeuvre. A *guignol* still life, taken in 1937, of two tailor's mannequins and a pair of open scissors, for the British couturiers the Rahvis sisters, owes much to Pulham's baroque still lifes for the rival house of Victor Stiebel. Parkinson did not fully explore the possibilities afforded by such arrangements, constrained perhaps by imagination and the more conventional requirements of his clients. But Parkinson was in awe of Pulham's vivid imagination. Cecil Beaton was too: 'He was in advance of his time', the latter declared, 'he could make a romance out of cheesecloth, tarlatan and torn paper', before adding, in admiration, that 'Pulham's photographs appear to be developed in a particularly virulent poison, probably violet or viridian coloured; his prints have a mysterious, pernicious and enigmatic quality'. Parkinson admired Pulham for being 'brilliantly creative', while recognising that 'I could never approach his artistry'. Eschewing therefore the extremes of artifice and invention that marked Pulham out, Parkinson focused instead on Pulham's subtle, almost ectoplasmic manipulation of shadow and appropriated his use of unusual vantage points to enhance the bold, geometric patterns of dress design. Curiously, Pulham's greatest gift to Parkinson may be non-photographic. His dandified presence, or frequently absence – 'I discovered regrettably with some glee that despite his undoubted talents, Rose-Pulham was unreliable' – gave Parkinson a role model for the modes and gestures he would later make his own: a detached indifference towards craft and a flair for extravagant sartorial taste. Pulham's explanation of his eagerness to take up photography, for example, betrays much of Parkinson's

subsequent nonchalant tone. 'My first impulse towards taking photographs', Pulham wrote shortly before his death, 'came from seeing those of Cecil Beaton published in *Vogue* ... it seemed to me that the people portrayed and possibly Mr Beaton himself, were having a more amusing time than I ...'.

Pulham gave up photography to concentrate on painting, though there is every indication that *Harper's* had given up on Pulham. 'We were always looking', Alan McPeake of *Harper's* told Martin Harrison, 'for an English Munkacsi' – and in Norman Parkinson he found one. Martin Munkacsi, a Hungarian émigré had brought to fashion photography a naturalism, known as 'Action Realism'. And for magazines of the era, the American edition of *Harper's Bazaar* in particular, such a snapshot aesthetic was a revelation. Though Munkacsi was not the first to photograph fashion out of doors, it was still customary in the early 1930s for 'swimming' and 'sailing' features to be studio-bound, a virtue made of contrivance and stasis. Though Parkinson professed at first to like the environment, (likely motivated by familiarity), he later termed the studio 'the urban snake pit'. McPeake's quest was prompted by his scrutiny of the photographs of the French photographer Jean Moral. A new realism, taken in the streets of Paris, tolled the death knell for the diaphanous, hyper-romantic style first brought to the modern magazine by Baron De Meyer. In McPeake's words, 'the Baron was finished'. Encouraged by McPeake, Parkinson's placing of his models in familiar urban scenarios introduced, in London at least, a new era in the depiction of clothes. Mellor has discerned the part silhouette and focus played in achieving an almost heightened realism in Parkinson's fashion photographs, so too the repertoire of devices associated with the reportage photographer: 'the

notion of seeing past or through spectators or participants onto an event'. This is especially manifest in photographs such as 'News in London', taken in 1938, a contribution to *Harper's Bazaar* which skilfully imitates social documentary, almost detrimental to its success as a fashion picture. It is replicated in later fashion pictures, such as a set for *Vogue* taken through the spokes of a bicycle wheel.

Parkinson quickly brought his action realism out of its specifically British context. His photograph of models in sportswear aboard a 35-foot yacht on the Adriatic coast off Dubrovnik was his first foreign location assignment. He was able to distinguish the women he wanted to capture: he later wrote, 'I wanted them out in the fields jumping over the haycocks – I did not think they need their knees bolted together.'

After his successful debut for *Harper's Bazaar*, Parkinson avoided the studio portraiture that had hitherto secured his reputation, though examples that were conspicuously successful included a shadowy presentation for *The Bystander* of Vivien Leigh (1935) and a portrait of Noël Coward (1936). Coward's effortless charm was matched by a sure knowledge of self-presentation. Parkinson's colleague Horst, who photographed Coward in the same year, admonished his sitter: 'don't pose so much. Look at me'. Parkinson turns debonair posture almost into parody. Coward's refined nonchalance personified the manner in which Parkinson wished to present himself to the world. To Parkinson, Coward was 'the most memorable person that I met before the war'.

Parkinson's nascent neo-romanticism found early expression in his contribution to the British pavilion at the Paris Exposition Universelle (1937), though he married it to the modernist vision of the experimental photographer Francis Bruguière. Parkinson contributed specially commissioned photographs of typical British characters, ranging from a fisherman to a policeman, which were then superimposed onto pastoral English scenes. The façade of the British pavilion was picked out in red and blue. A long frieze ran its length designed by John Skeaping, the subject of a graphic profile portrait by Parkinson to represent all the principal British industries. Artists, such as Doris Zinkeisen, Albert Rutherford and George Sheringham, most of whom were also photographed by Parkinson, gave visual expression to British national pastimes, such as hunting, shooting and fishing. *Vogue* noted that 'everywhere art and British industry go hand in hand'.

In the mid 1930s Parkinson motivated himself onto location. 'What you have to do is ignite the enthusiasm to get out of the studio', he later recalled. Subsequently, he began a series of portraits of sitters in their own surroundings, with the obvious intention that a familiar environment might shed further light on a subject, apart from making them feel more at ease. Arguably the baroque environment in which he found Edward James, his Wimpole Street house, threatened to overshadow his sitter.

Parkinson's reliance on realism occasionally extended to the transposition of real-life gestures into the studio. His first acknowledged advertising success, a commission for Matita, featuring the bohemian society beauty Lady Marguerite Strickland, earned an endorsement from the agency Robert Sharp & Partners, 'Parkinson believes in realism for this type of advertising but sees that the realism is leavened by dramatic quality and subtle presentation'.

But what most occupied Parkinson in these early stages of his photographic life – and most satisfied him subsequently – were his instinctive *en plein air* fashion photographs taken for *Harper's Bazaar*. Though most likely to have been meticulously rehearsed in the mind's eye of the photographer, they appeared informal and immediate and without a trace of the artifice found in the fashion photographs of his contemporaries. Of his photograph of Pamela Minchin, leaping off a breakwater on the Isle of Wight in 1939: 'when I pulled that picture out of the soup it confirmed to me for the rest of my life that I had to be a photographer'. This celebrated fashion photograph and its sunlit companion from the same year, 'Golfing at Le Touquet', were important landmarks in the development of British fashion photography. Terence Pepper has identified them as 'demonstrating that the fashion photograph could be convincingly and enjoyably spontaneous'.

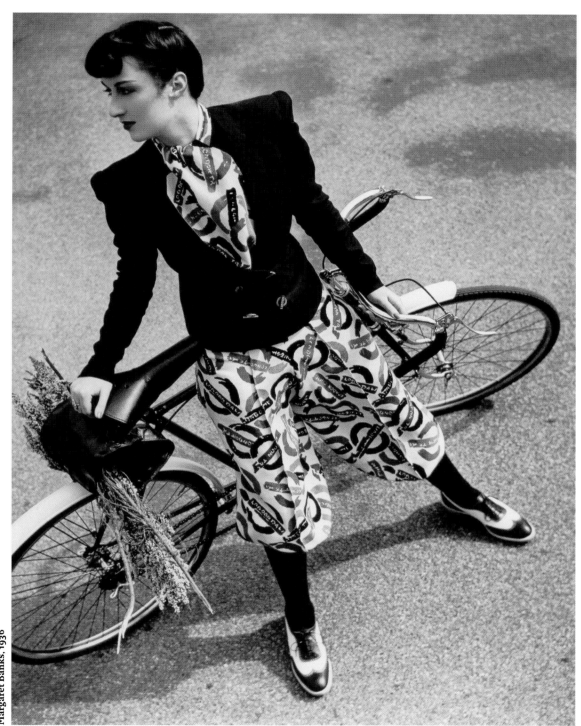

Margaret Banks, 1936

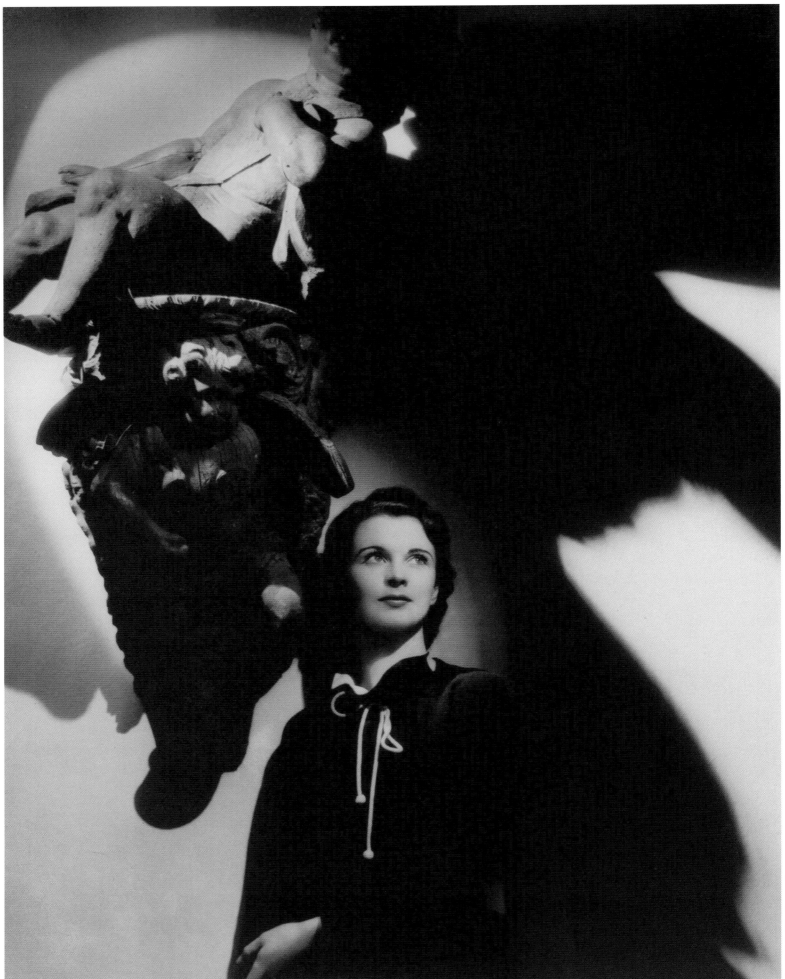

Vivien Leigh, *The Bystander*, 1935

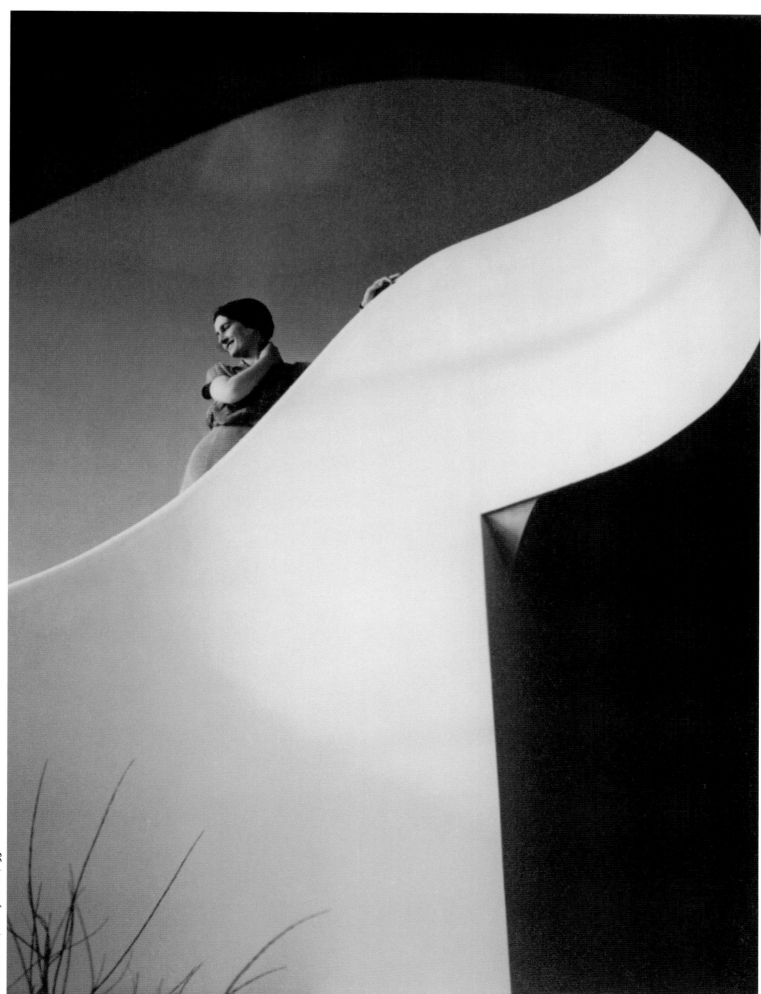

Maxine Miles, *The Bystander*, 1936

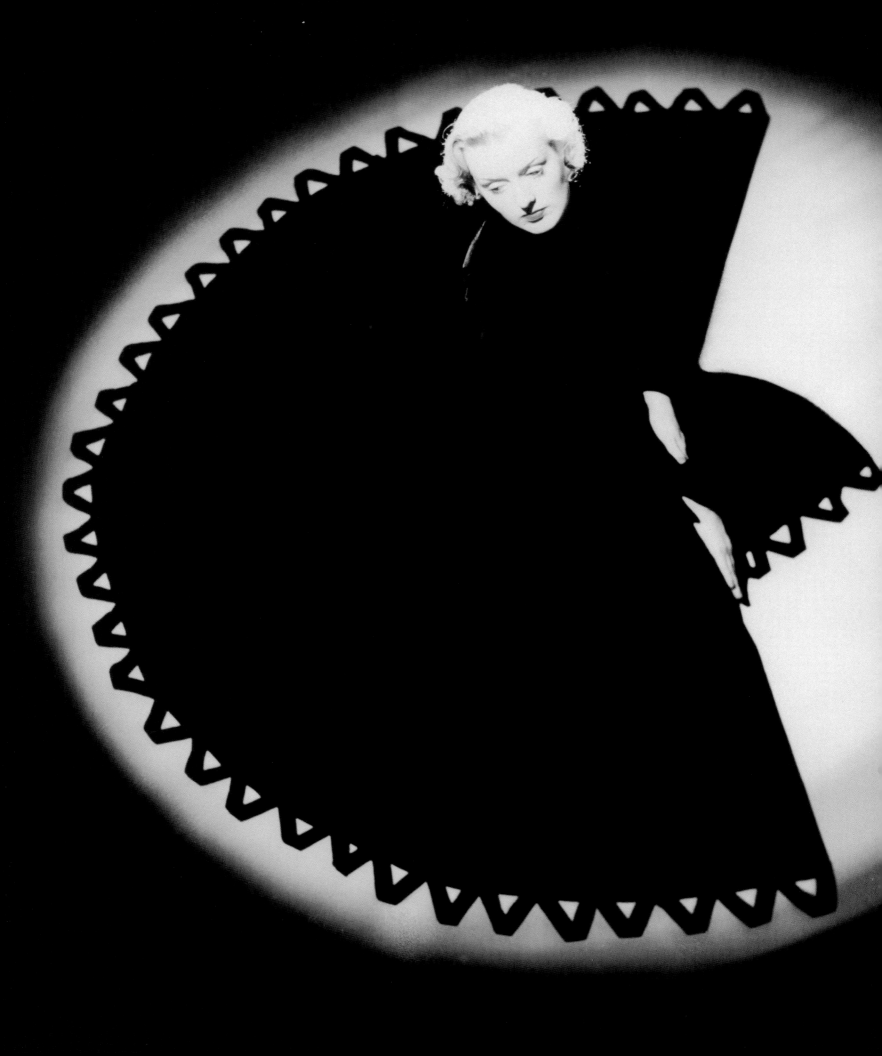

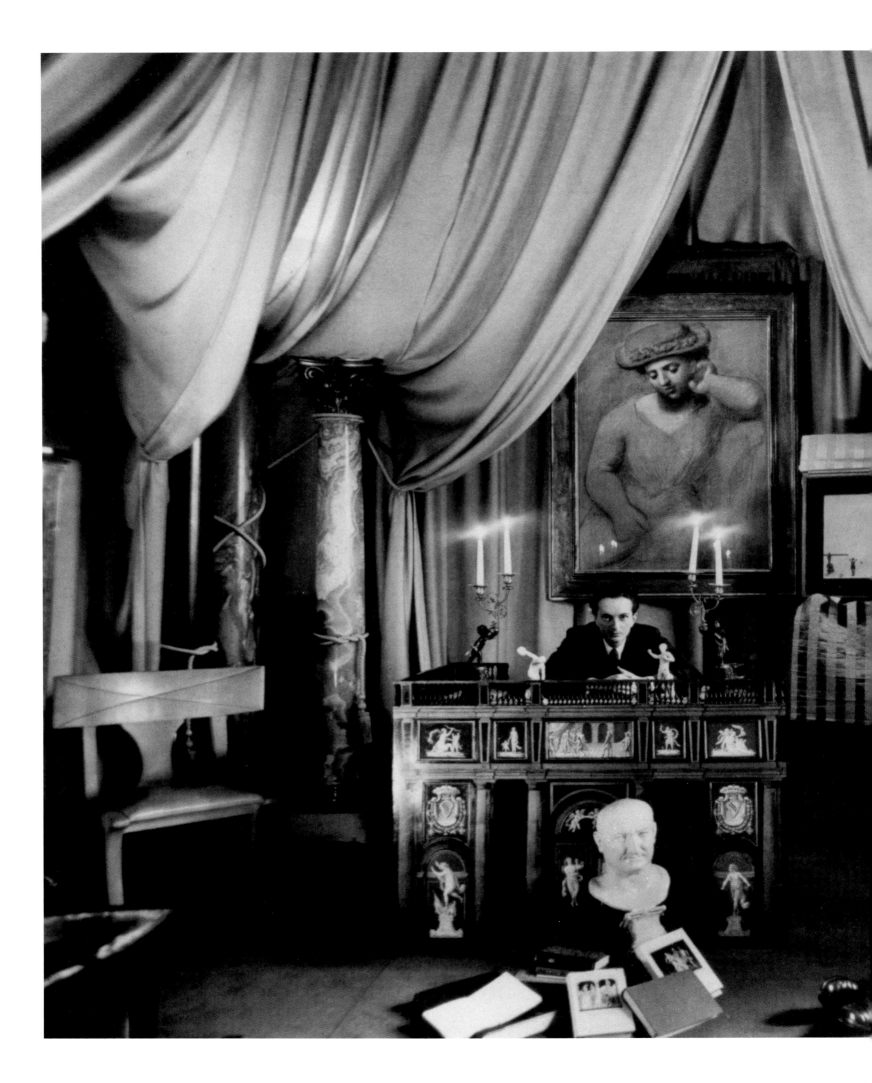

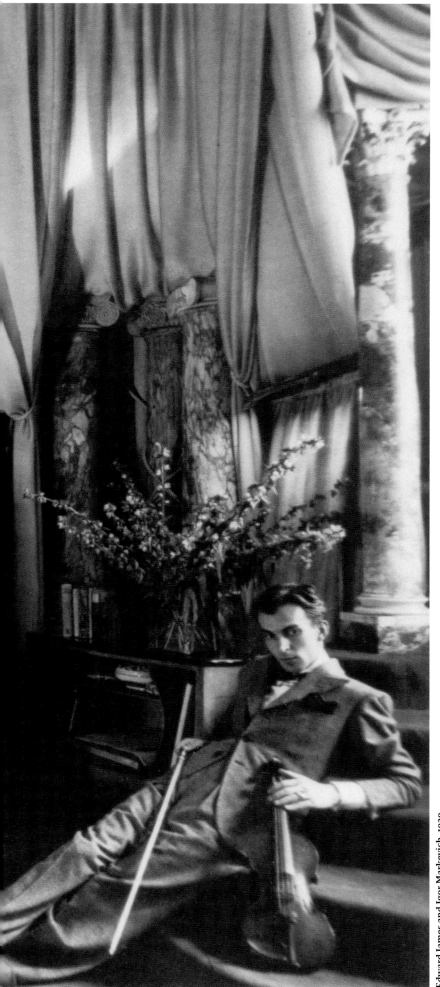

Edward James and Igor Markevich, 1939

The Bystander, 1936

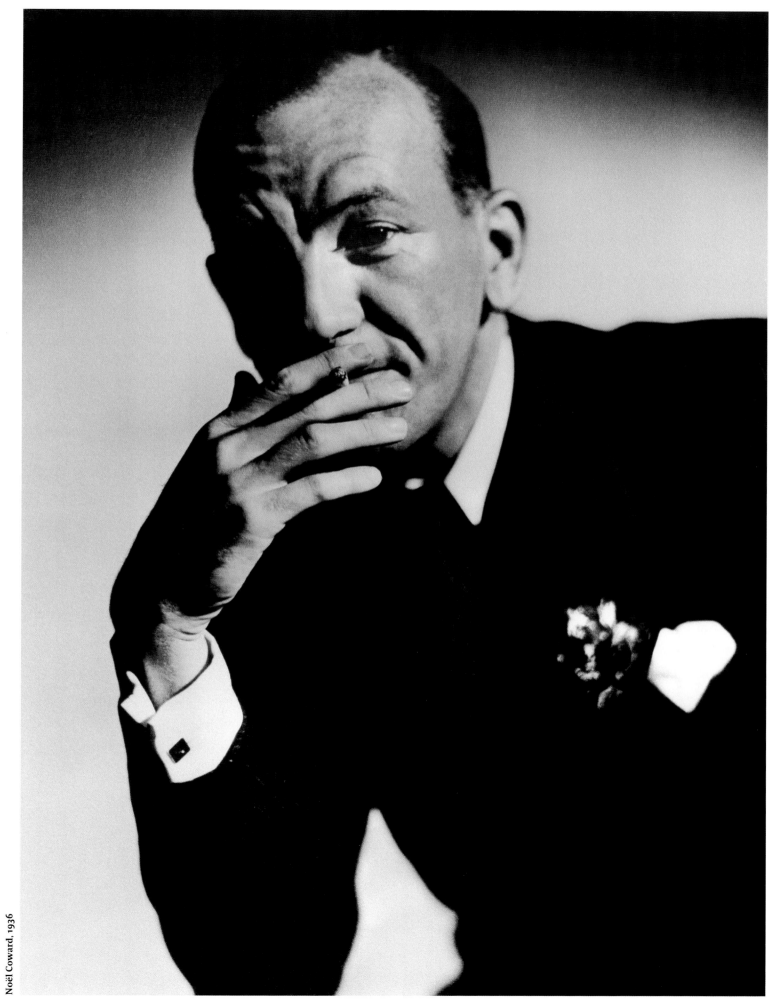

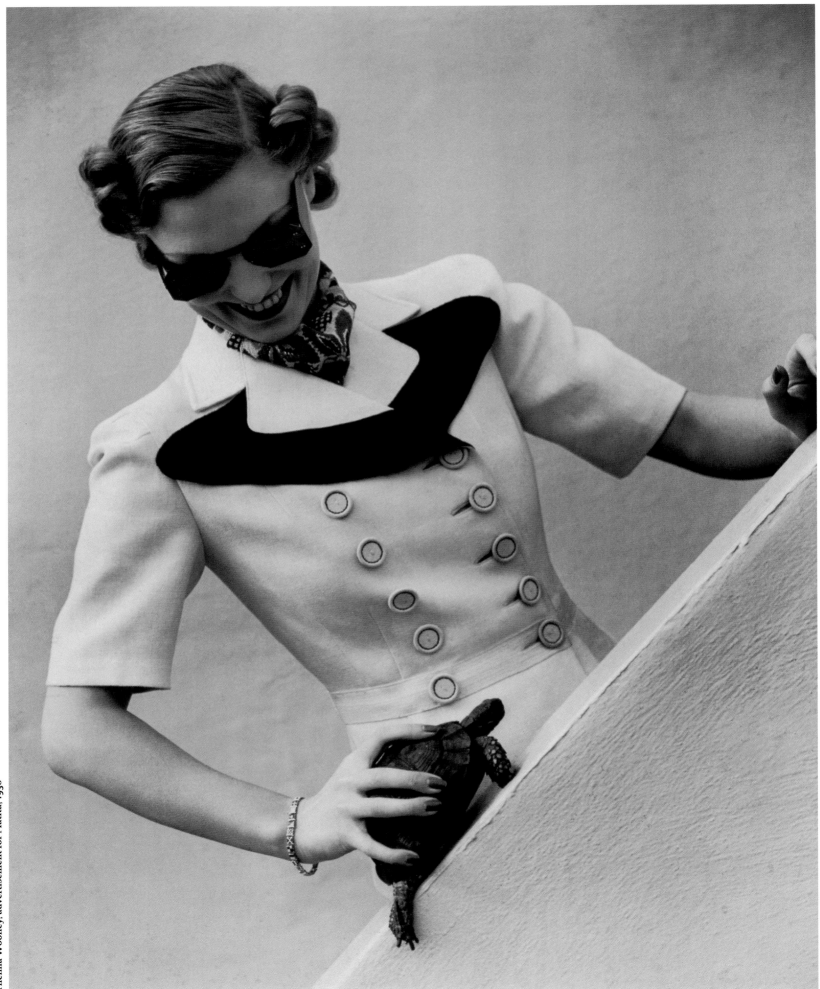

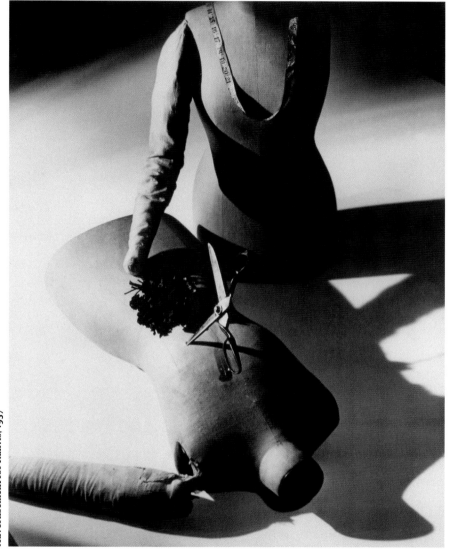

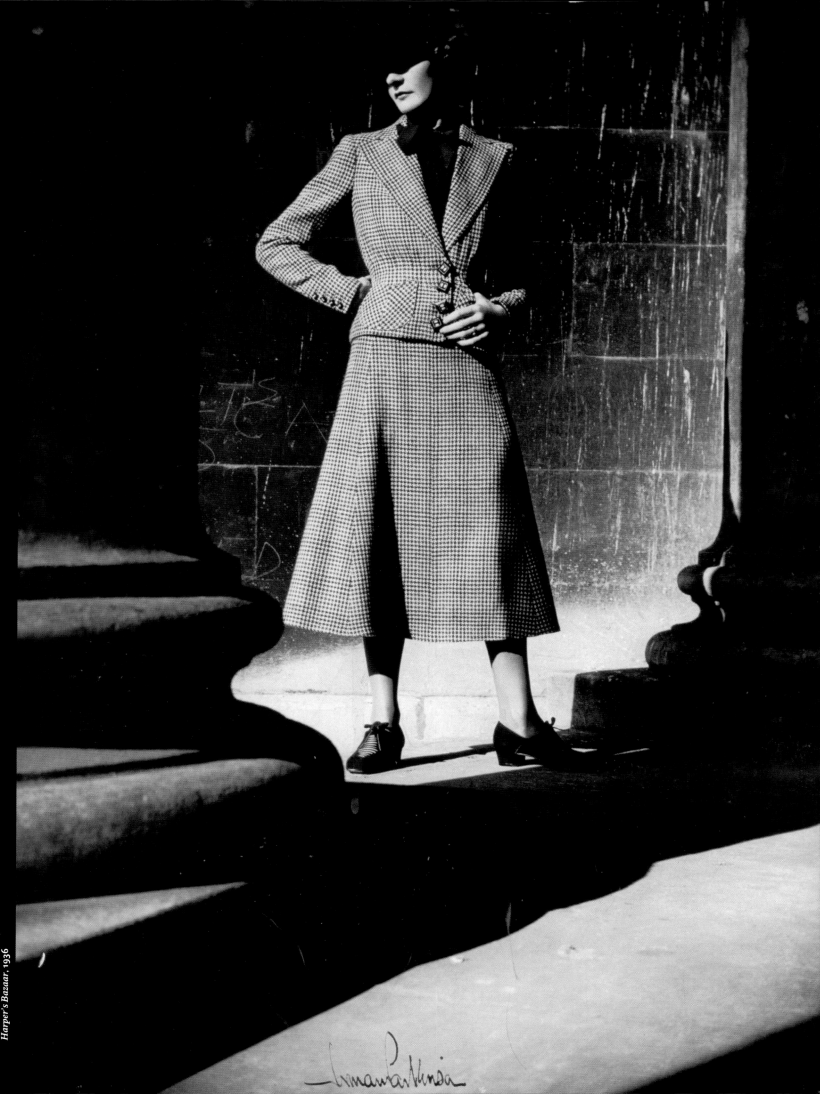

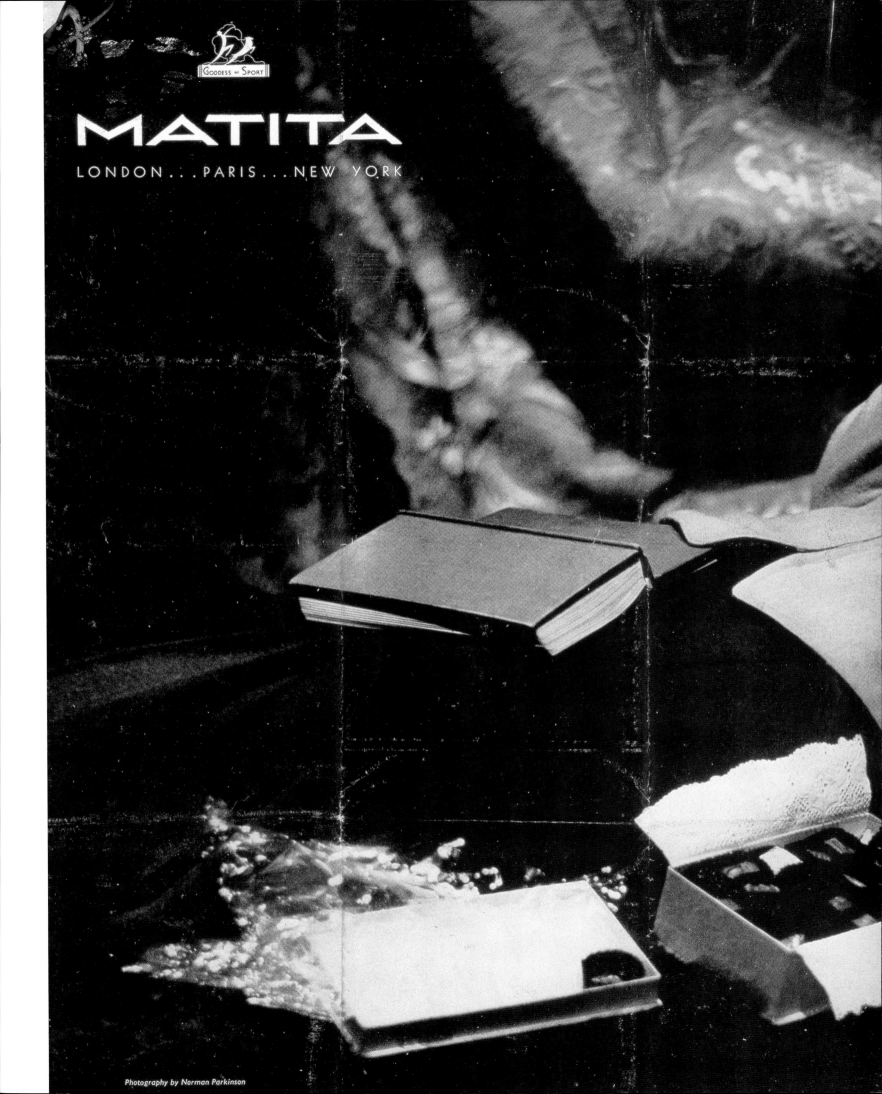

MATITA

LONDON...PARIS...NEW YORK

Photography by Norman Parkinson

My Matita house suit is so useful. I love it!

writes — LADY MARGUERITE STRICKLAND

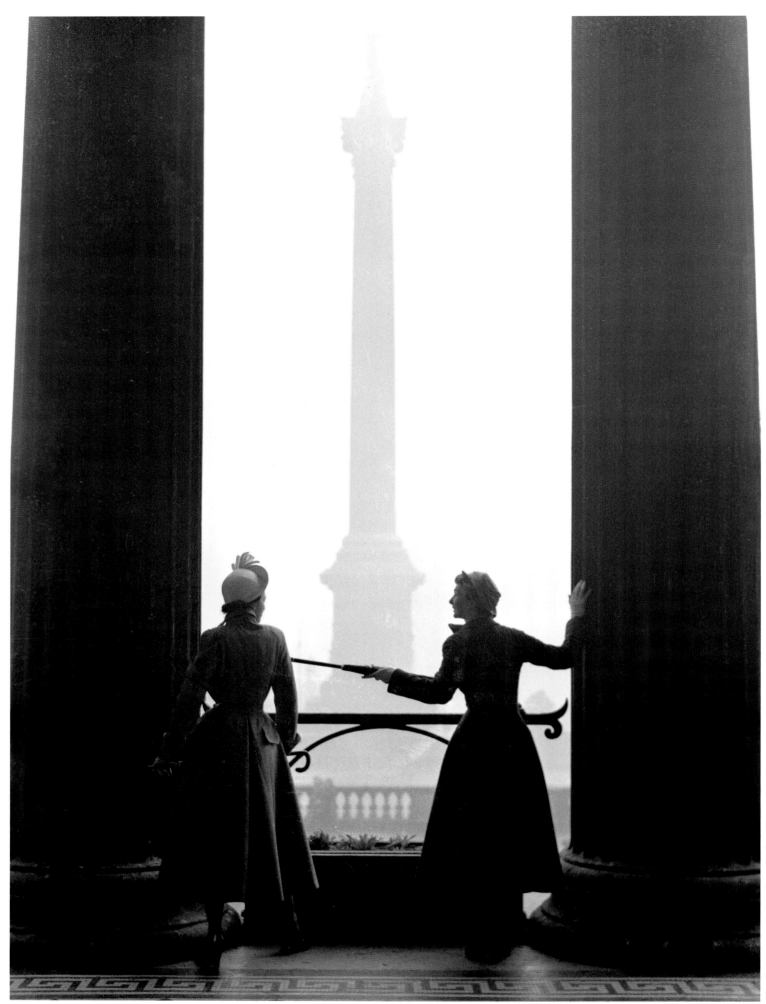

Wenda Rogerson and Barbara Goalen, *Vogue*, 1949

The Forties

'There was always room in a magazine for the scent-laden marble-floored studios with lilies falling out of great bowls of flowers. But there was also room for my sort of photography.'
Norman Parkinson, 1983

Throughout the war, *Vogue* continued publishing, its mixture of movie features, homespun domestic advice and common-sense fashion coverage considered good for the morale of the home front. Though diminished in size and availability – it was said that a subscriber had to die before another subscription could be offered, and it became, out of necessity, a monthly magazine (previously it had been fortnightly) – it did not disappoint its readers or the Ministry of War. The quality of its photographic coverage of the war effort, both domestic and further afield, set it apart from other publications; not least because of Parkinson's tireless 'documentary fashion' pictures taken in and around his Worcestershire farm. Cecil Beaton travelled the world as photographer for the Ministry of Information. But it was the unlikely figure of Lee Miller, a former *Vogue* model, who gave the magazine a dimension unimaginable at the outbreak of the War by becoming, almost by accident, its very own war photographer.

Staff members and photographers enlisted and the magazine relied on an apparently ever-changing roster of less talented individuals. 'Until the arrival of Cecil Beaton and Norman Parkinson', wrote Harry Yoxall in his autobiography, 'our London studio was lamentably short of native aptitude; and even when they arrived they were constantly being whisked off to Paris and New York.'

For *Vogue* Parkinson's arrival at this time, 1941, could not have been more fortuitous. Combining agriculture and photography at what was still considered a 'dark hour' for Britain, he was able to tap into a spirit of neo-romanticism that underscored the virtues of the countryside and its simpler ways of life and traditions. As Martin Harrison has put it, 'It is impossible to over-emphasize the importance of the land for Parkinson, who formed the kind of deep attachment to it that only a city dweller can. It acted as a source of peace, strength and reassurance that counter-balanced the frivolousness of the world of fashion.'

The article and photographs submitted to *Vogue*, 'Back to the Land', centred upon Parkinson's own rural life at a rented farm in Bushley, Worcestershire. The title had, of course, a double meaning for Parkinson: not only was he exhorting readers to nurture and preserve precious British natural resources, but, in a personal context, he was rediscovering the West Country roots of which he was inordinately proud. He attempted to preserve through the lens of the camera something of 'the broad sweep of the landscape with its carefully observed rural intimacies', but admitted in his autobiography that 'fifty years of that sort of work would soon have become a real bore'. When peace came he effortlessly transferred the spirit of neo-romantic pastoralism into a resolutely urban environment. In 1949 Beaton wrote to Yoxall: 'I am convinced, especially in England, that the most interesting photographs are taken outside the studio … What has impressed me most are the Norman Parkinson photographs … those pictures on railway stations where so much of our lives seem to pass'.

Vogue had perceived rapidly where Parkinson might best be placed, and his first personal appearance in the magazine found him wielding his camera on the Embankment of the Thames. It noted that 'his long legs take him to vantage points for the outdoor photographs at which he excels'. His collaborator in these scenarios was Wenda Rogerson. A former actress, she was discovered by Cecil Beaton in a play at the Arts Theatre Club and he suggested that she should model. Beaton did not, however, photograph her himself and it was his colleague Clifford Coffin, an American photographer on loan to British *Vogue*, who took her first photographs in early 1946.

Coffin's first photographs of Rogerson are, for the most part, undistinguished, but he continued the working arrangement with her after her marriage to Parkinson. Perhaps the best known was taken beneath the bomb-damaged staircase of a house in Grosvenor Square, Wenda wraith-like amid the ruins in a Rahvis evening gown. Parkinson's photographs did not accentuate her delicateness but emphasized instead, in photographs of her taken, for example, standing in the forecourt of the Peabody Trust Buildings in a Simpson's suit (1950), a demure and quintessentially English elegance.

British fashion had previously responded to the prevailing mood by continually applauding the virtues of a garment that might be worn from morning till night. The collaborations of Parkinson and Coffin with Wenda Rogerson and Barbara Goalen, and of Parkinson with Anne Chambers and Della Oake brought British *Vogue* out of the isolation of its war years without losing touch with its essential qualities of 'Englishness'.

'I got this zest, this renaissance after the war', Parkinson told an interviewer, in tune with the extravagance of the 'New Look'. The 'New Look' substituted the feminine silhouette for the wartime masculine rectangle. His series of the London Collections in 1949 are a highly stylised and romantic evocation of fashions but anchored to the reality of familiar London locations. His new wife was a vital collaborator in establishing the mood for Parkinson's post-war photographs and she was the star in the romantic narratives he planned. Of pictures such as these, whose qualities Beaton had already noticed, Parkinson himself remarked, 'perhaps there is a vintage quality to beauty, and to mood too, which makes those early attempts to capture that beauty in many ways more successful.' This continuing neo-romantic response to the 'New Look' marked out the parameters of Parkinson's fashion oeuvre to come, reaching an apogee in his vivid colour photographs of the

1950s. But for most of the previous decade, Parkinson's fashion coverage is resolutely monochrome.

Firmly set against a rural background, the narratives Parkinson wove during the early war years, contain at their core an invitation to a more austere and (thus more fulfilling) country life. Fashion, as can be seen from even a cursory glance at his wartime output for *Vogue*, did not preoccupy Parkinson. Instead he documented the war effort as it affected the land: convoys of Auxiliary Training Service (ATS) drivers moving supplies and carrying out repairs; Women's Emergency Land Corps (WELCS), harvesting and fruit-picking and training in the Malvern Hills.

Parkinson's reputation may have soared in Britain and to an extent preceded him in New York, when he started regular trips there in 1949, but his photographs on the Manhattan sidewalks were not innovative. As Martin Harrison has pointed out, the photographs of Frances MacLaughlin-Gill, for example, a protégée of American *Vogue*'s art director Alexander Liberman, covered the same ground with more finesse. However, this may well have been the point. Liberman realised that *Vogue*'s readership did not respond favourably to constant groundbreaking photography and, as his biographers, Dodie Kazjanian and Calvin Tomkins, have put it in relation to the continually inventive William Klein: 'a little Klein went a long way and Alex was careful to surround it with pages and pages of less jarring work by John Rawlings, Frances MacLaughlin, Serge Balkin, Constantin Joffe ... Clifford Coffin and Norman Parkinson'.

Victory had heralded slow and dismal domestic recovery. The national trade deficit was almost incalculable. Food rationing became even harsher than during wartime (finally ending in 1954). That Parkinson's photographs should continue the inward-looking characteristics of his immediate pre-war corpus is unsurprising. He may skirt forever afterwards around his war service and the contribution it made to his departure from *Harper's Bazaar*, but his black-and-white documents from Worcestershire were potent reminders to a large readership of the harmony to be discovered in a return to a simpler way of life. These are Parkinson's war photographs and are no less invaluable or less impactive for his never having seen active service. Their neo-romantic spirit, transferred to an urban setting, informed many of his London-based photographs in the years to come.

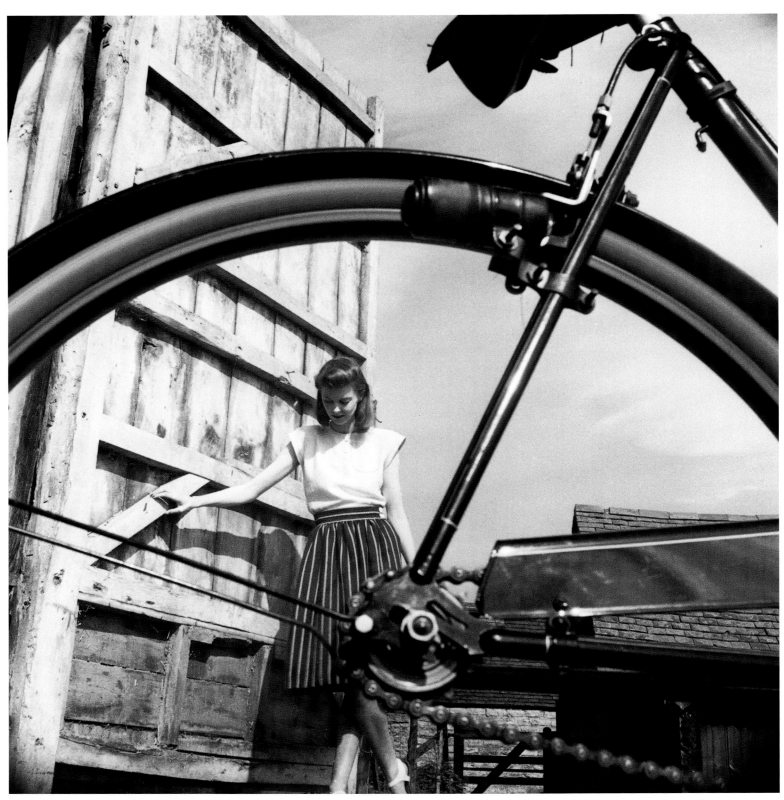

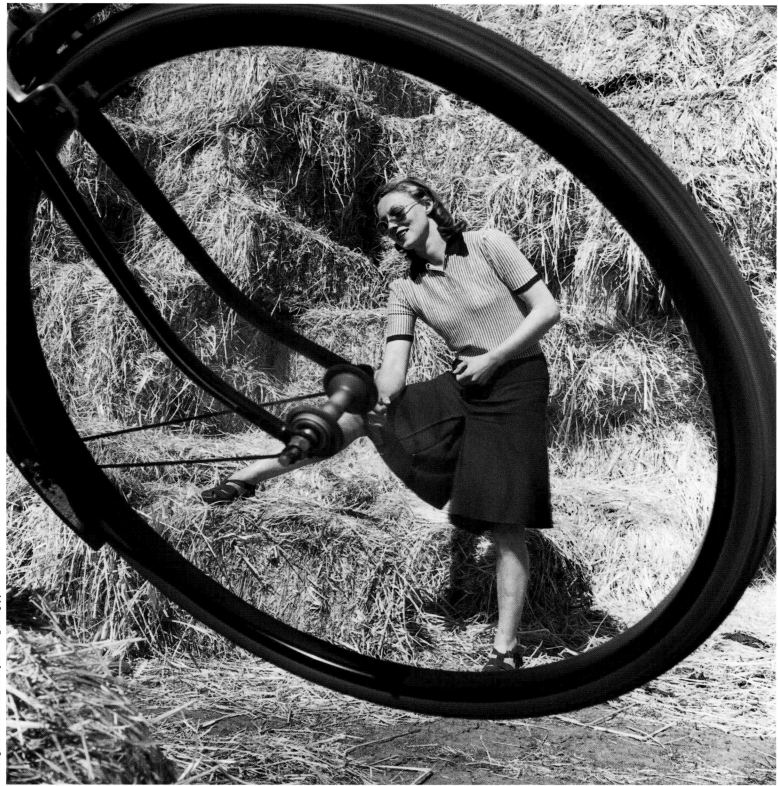

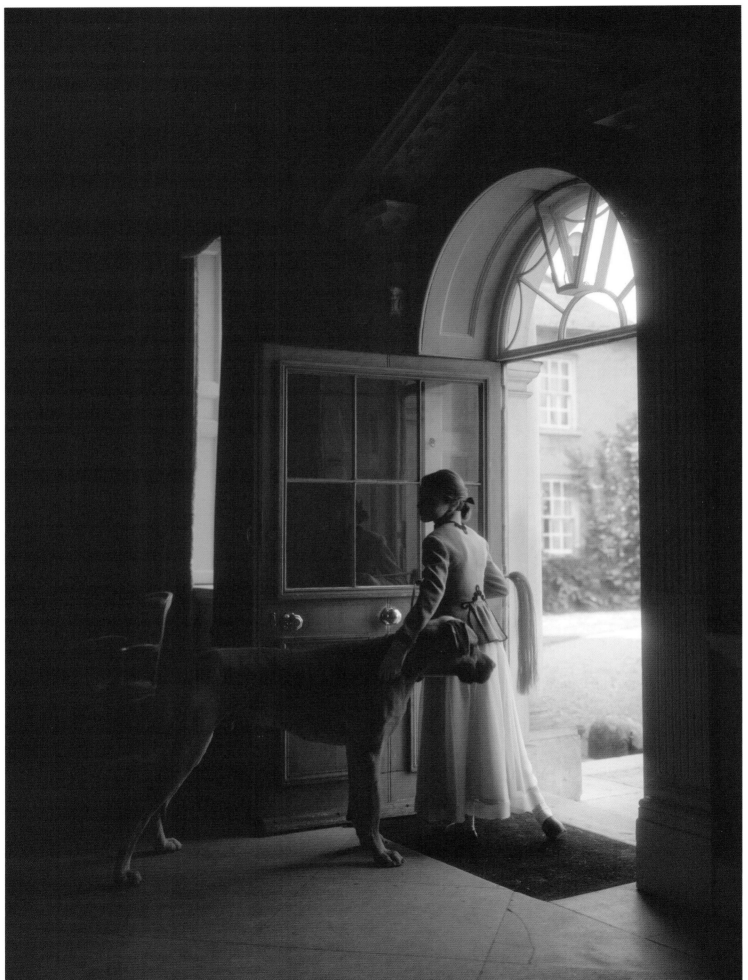

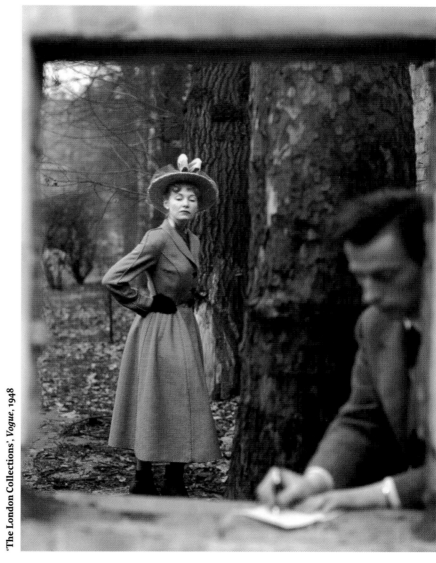

'The London Collections', *Vogue*, 1948

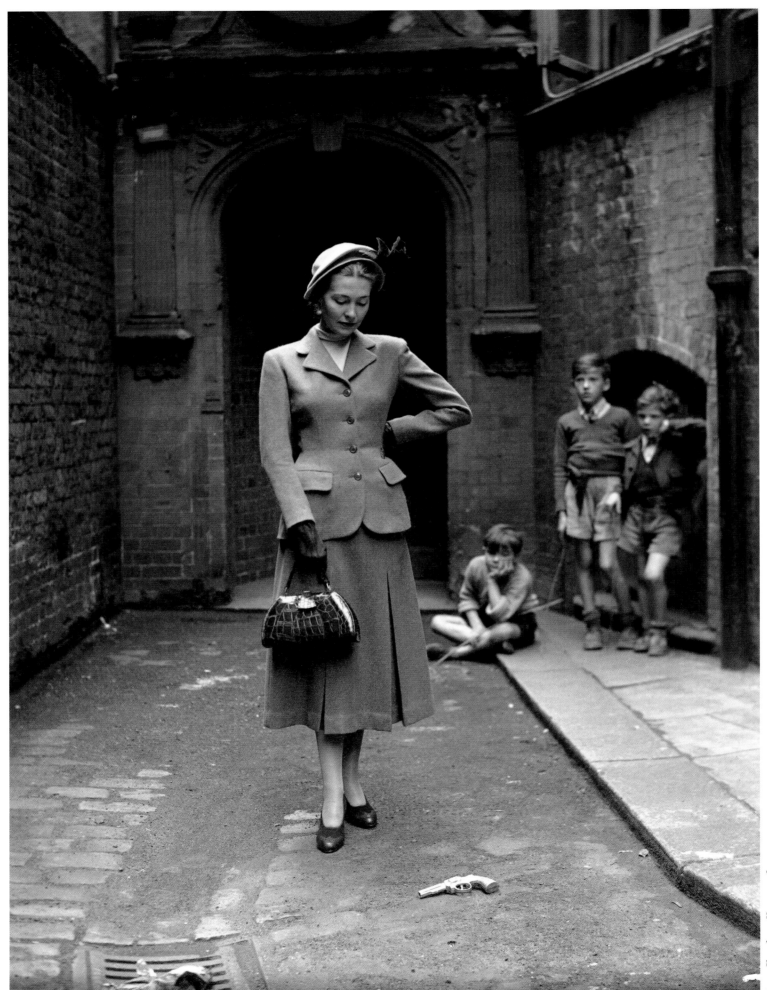

Anne Chambers, *Vogue*, 1948

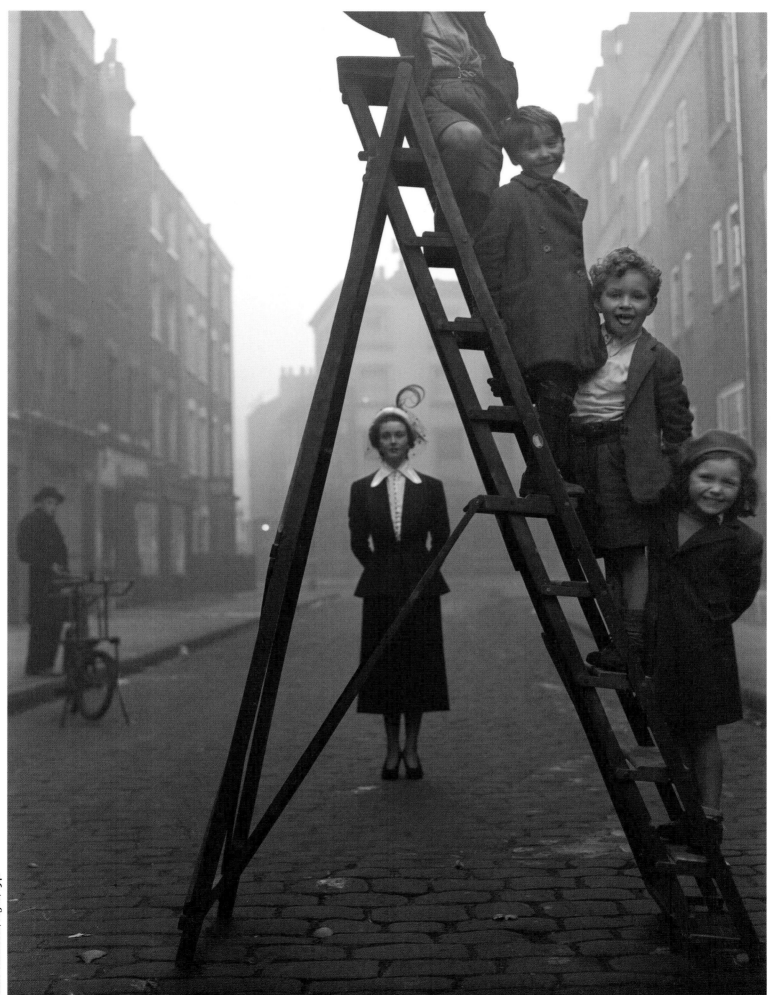

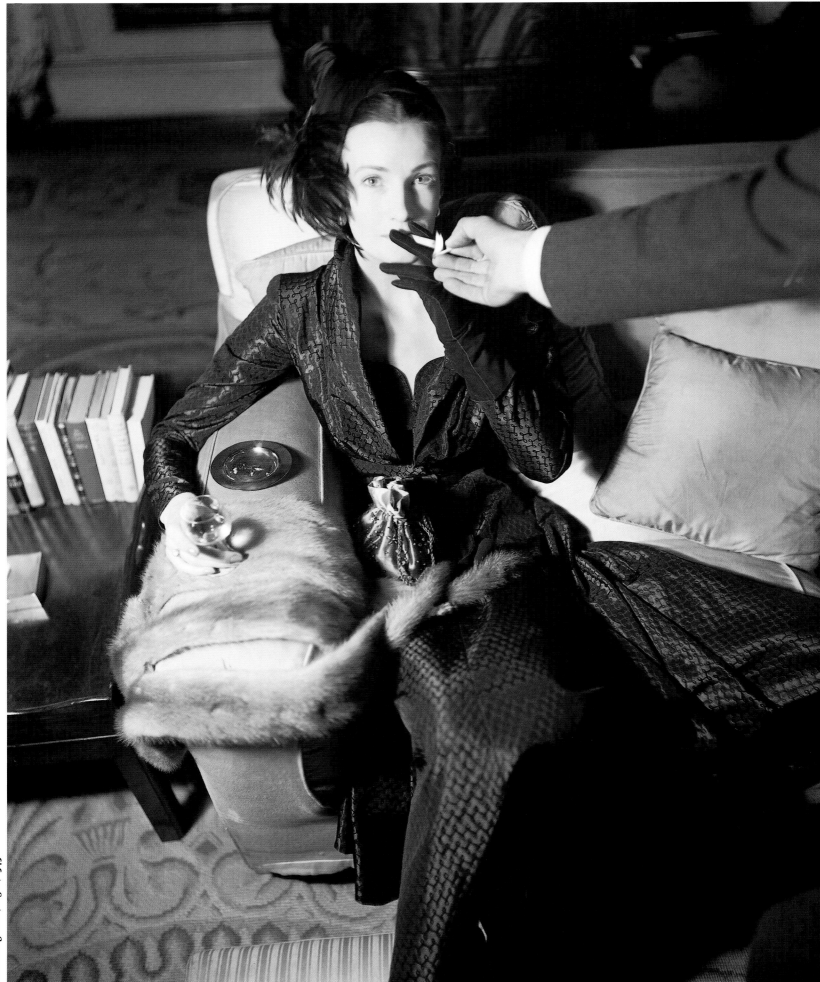

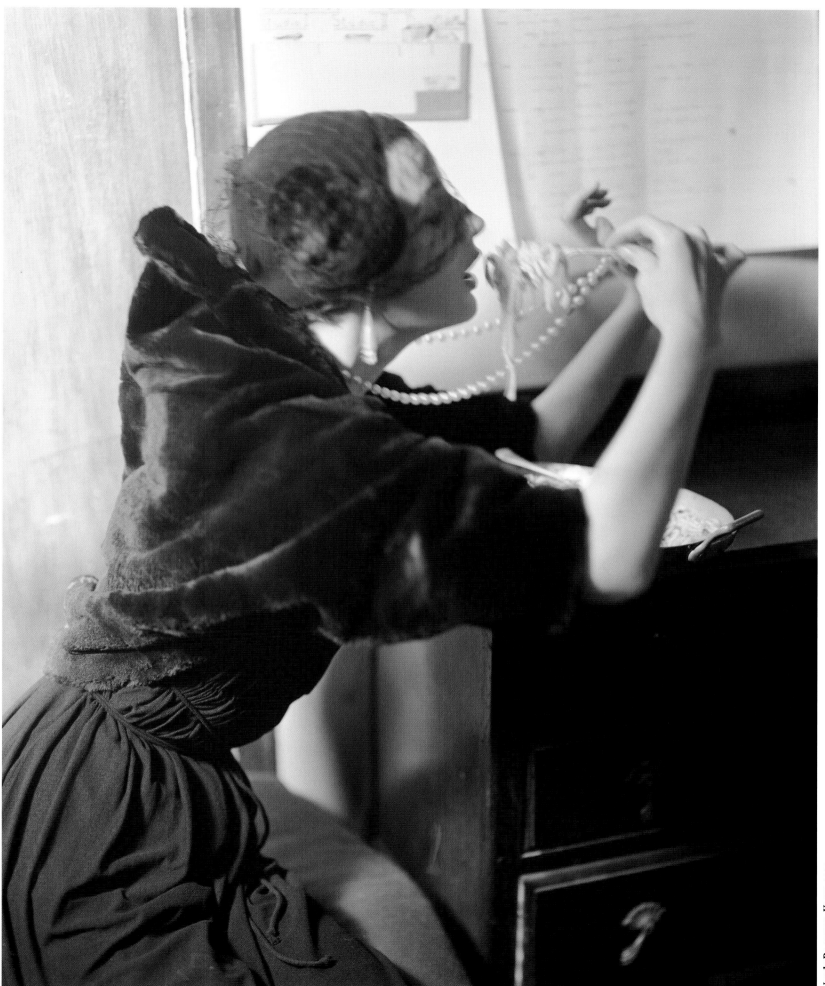

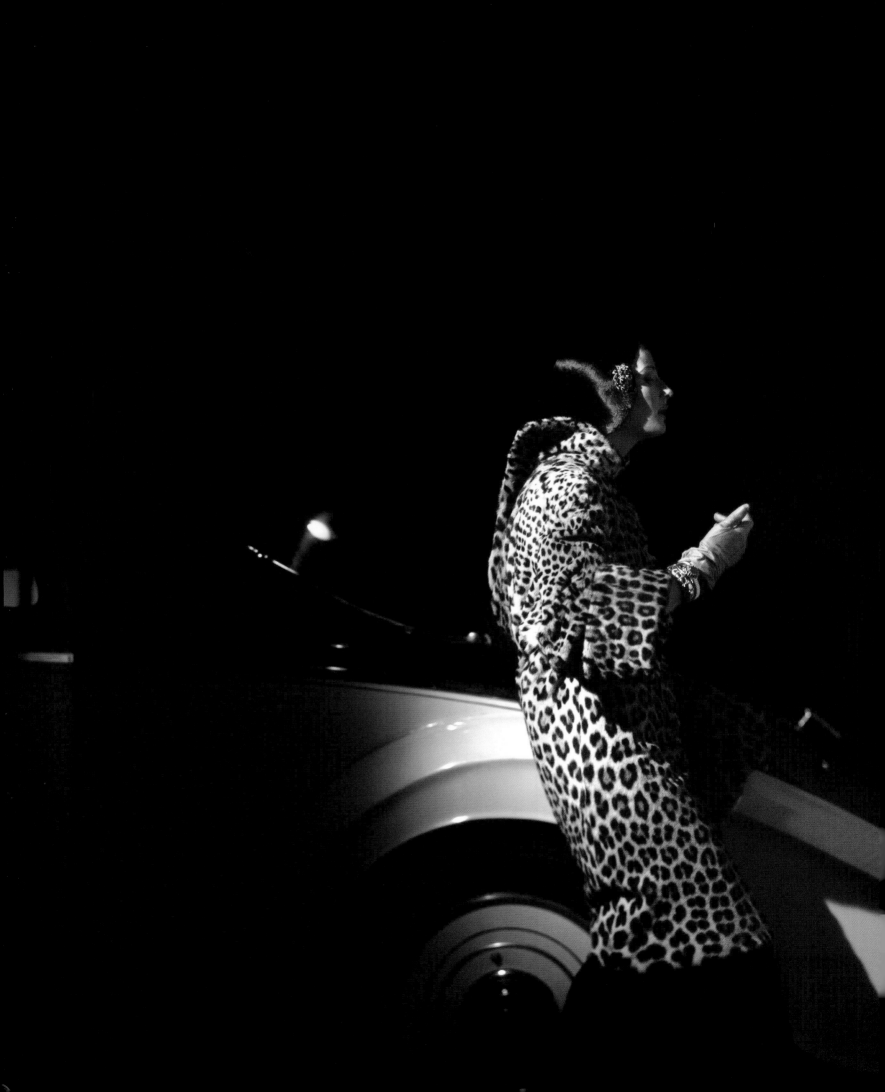

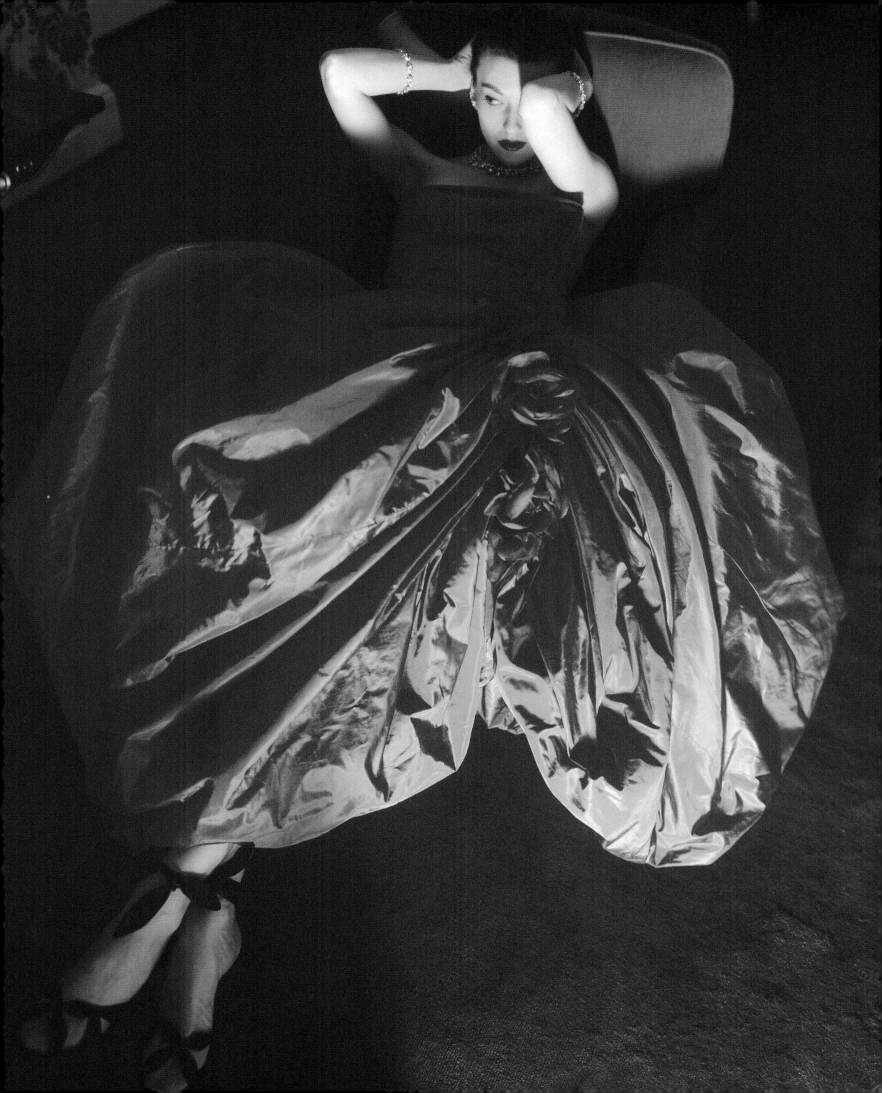

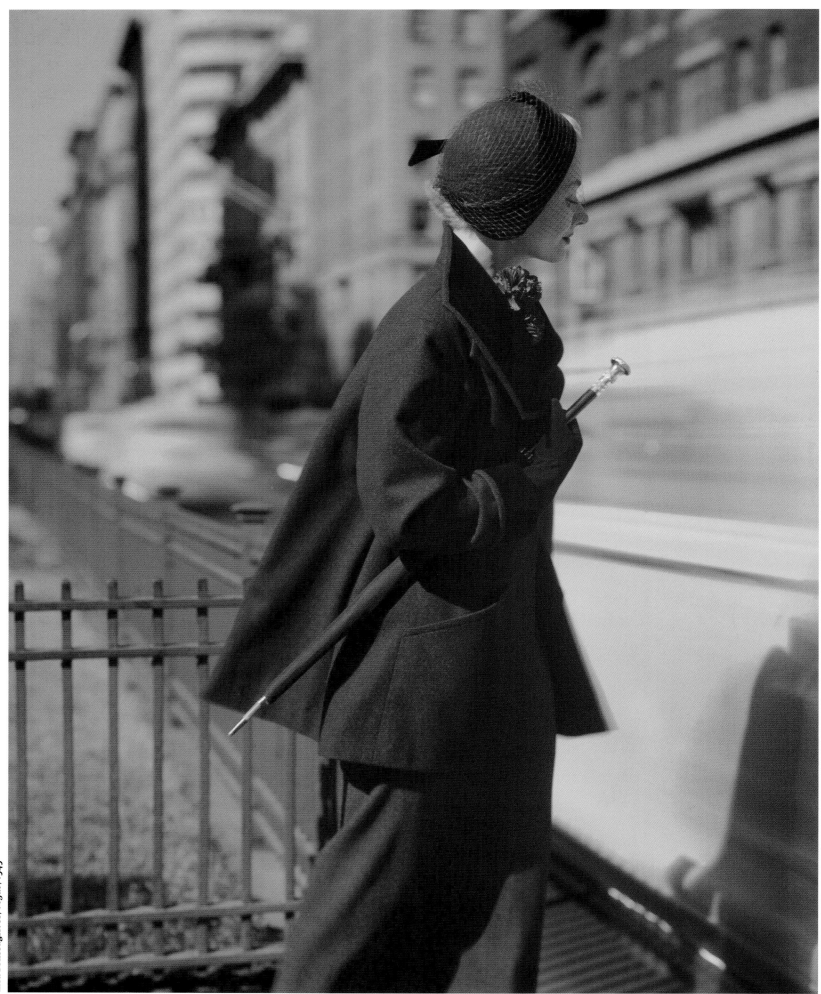

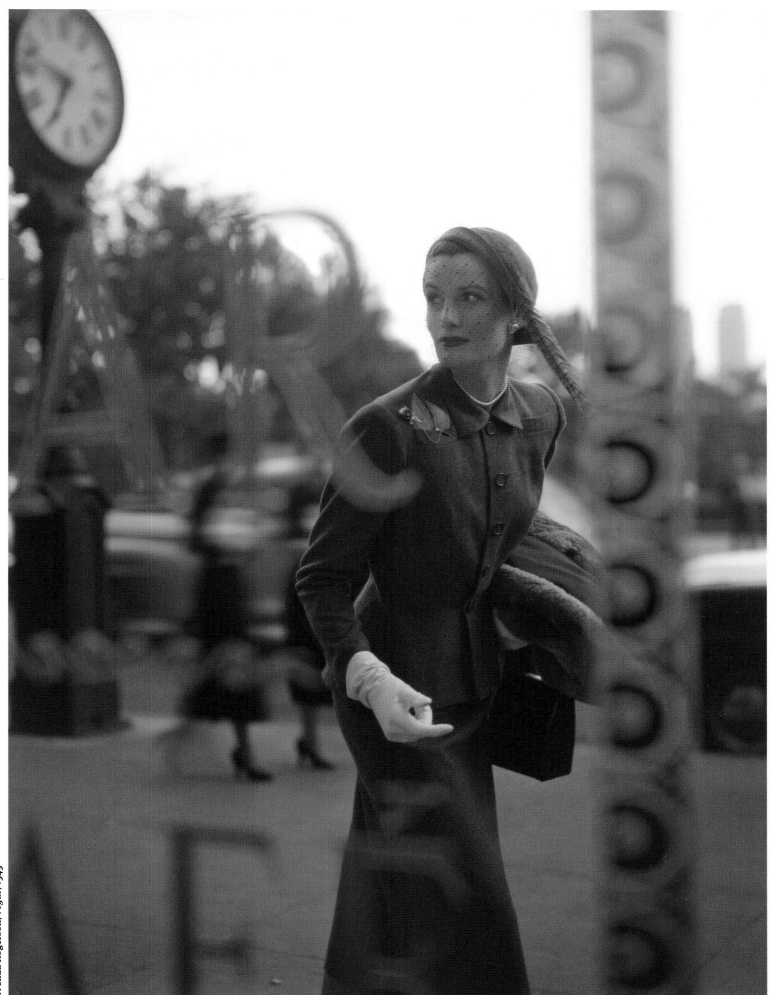

Wenda Rogerson, *Vogue*, 1949

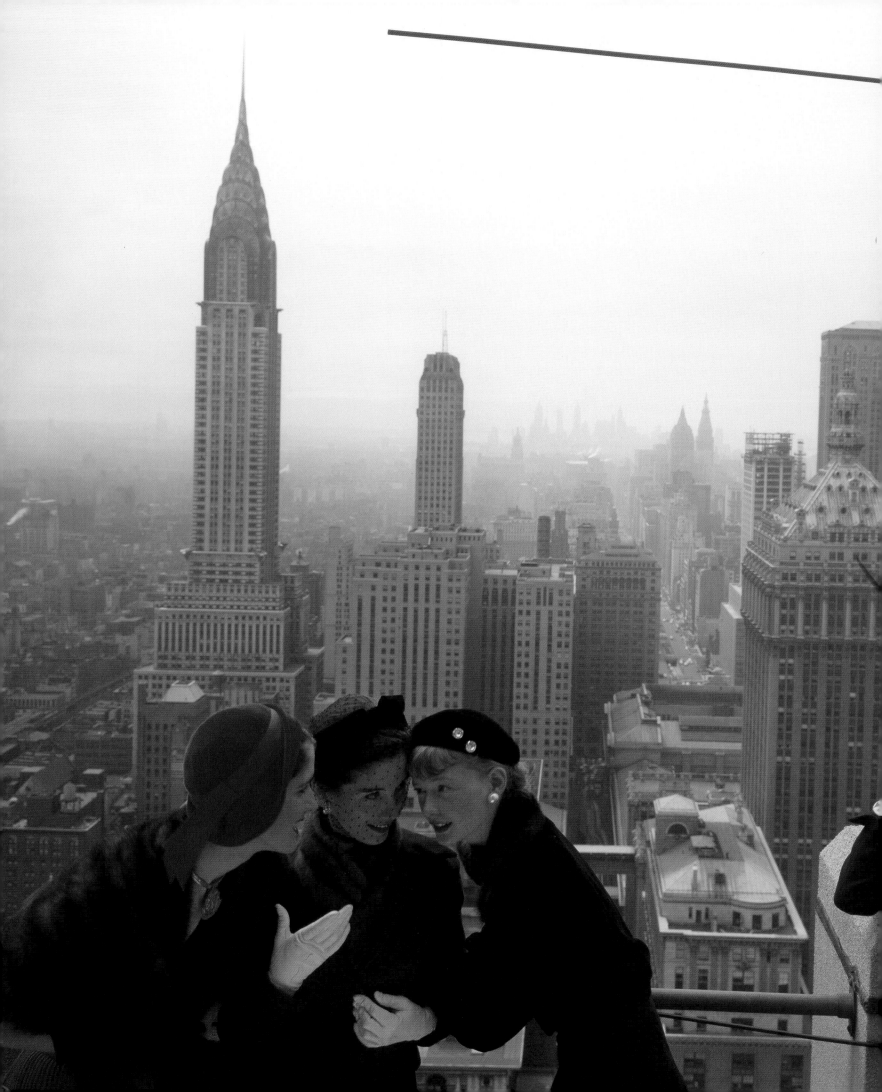

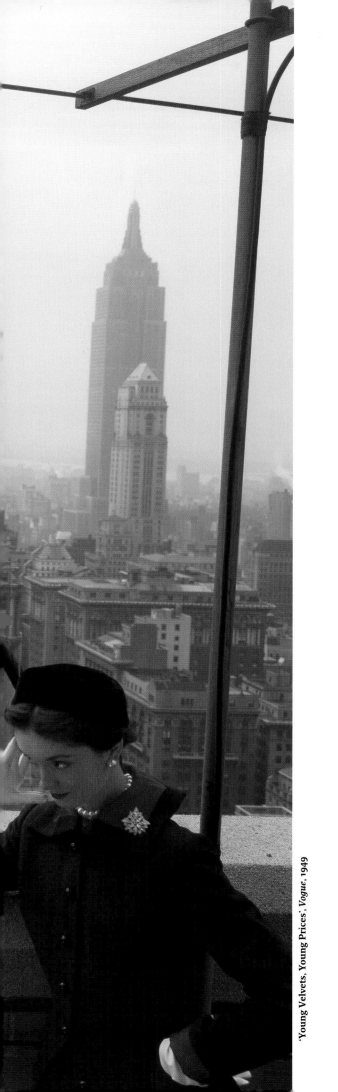

'Young Velvets, Young Prices', *Vogue*, 1949

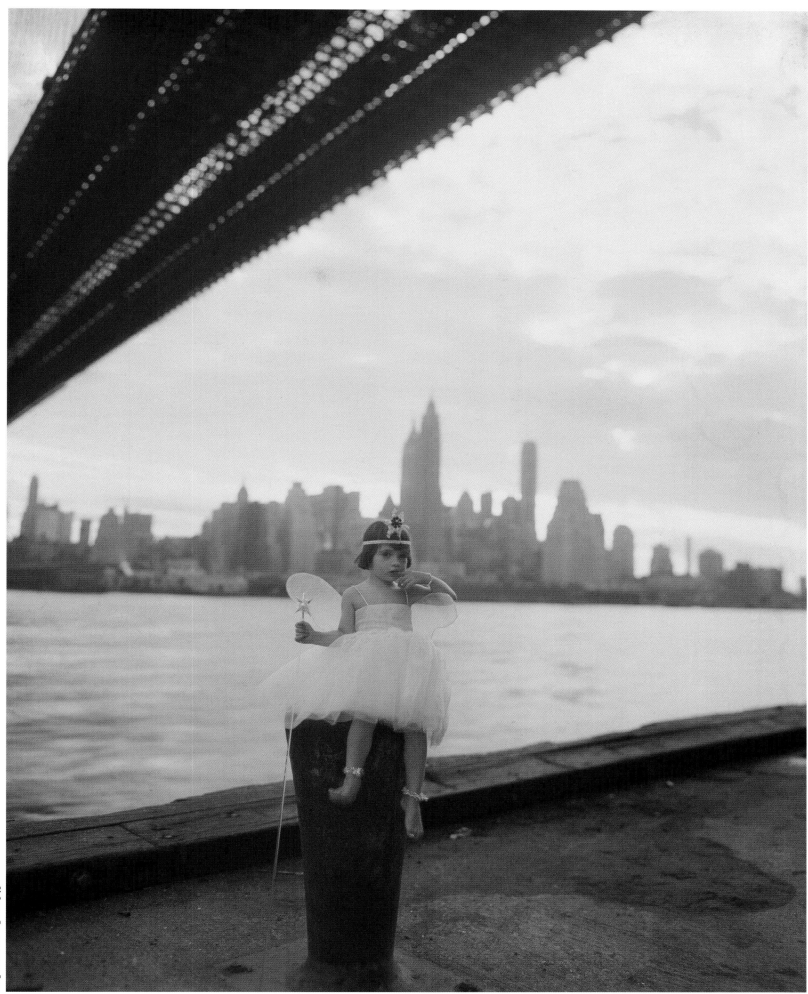

The Fifties

'To photograph something of today in the manner
of yesterday may be diverting, but it isn't likely to
be good fashion photography. To put it all into that
capacious and possibly elastic nutshell, the fashion
photographer photographs with at least half an eye
keyed to the prevailing photographic idiom'

John Parsons, 1955

As a new British decade dawned the outlook was bleak
and, as *Vogue* put it, still 'grey in tone'. Rationing continued,
punitive taxes were introduced and restrictions were still
in force for travel and currency exchange. Out of the gloom
arose the morale boosting cultural and technological trade
fair – the dazzling and radiant Festival of Britain of 1951.
'Suddenly on the South Bank, we discover that, no longer
wealthy, we can be imaginative, ingenious and colourful',
said *Vogue*. It continued, 'if all goes well, what a country
we shall live in, what a Britain we shall have!'. The Dome
of Discovery possessed the largest unsupported roof in the
world, there were pavilions devoted to slices of British life
and festooned with patriotic bunting. The towering Skylon
became the Festival's symbol. Parkinson photographed its
director-general, Oliver Barry for *Vogue* and Edward Bawden
too, in front of his mural of British character and tradition
for the 'Lion and Unicorn' pavilion – a successor, for the
eve of the 'New Elizabethan era', of the Brugière/Parkinson
photomural for the Paris Exposition Universelle of 1937.
The fashion photographs he made for the special 'Britannica'
issue of *Vogue* are among his best-known images of the early
1950s. The festival heralded too a new age of affluence,
cemented by the second Churchill administration of 1952.

Vogue's art director, John Parsons, responded to the
change in the air: 'the lean and hungry beauty, living in
her airless world is giving place to women with warm blood
in their veins and gaiety in their hearts ... a visual evocation
of some of the happier aspects of life as it is lived today'.
Though he might whisper 'Zoffany' and 'Gainsborough'
in Parkinson's ear, Parsons curbed Parkinson's excessive
flights of fancy forestalling too retrospective a neo-romantic
inclination. Parkinson's first major foreign trip for *Vogue* –

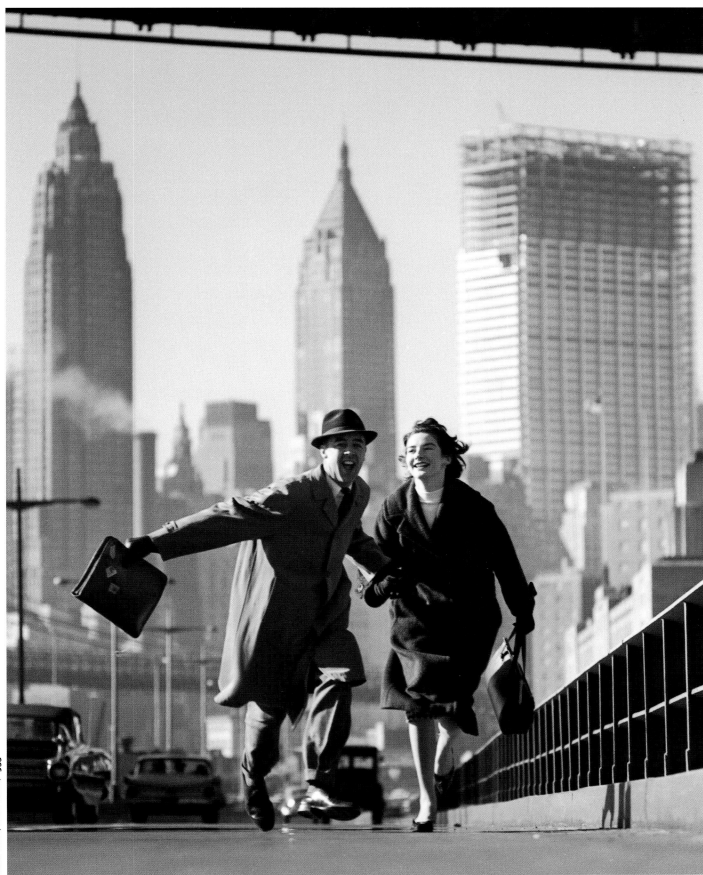

'New York, New York', 1955

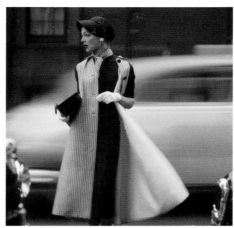

Barbara Mullen, *Vogue*, 1956 'Traffic', *Vogue*, 1957

to South Africa – was made in 1951, and such foreign assignments continued throughout the decade, taking Parkinson, Wenda and a fashion team to Jamaica and India, Australasia and the Bahamas, among other destinations. These stories corresponded to an increase in *Vogue*'s colour page allocation and Parkinson took pains to capture for readers the exoticism of the localities too: 'The world is my studio' he told one interviewer. Parsons and Parkinson did not neglect the idylls that had made Parkinson's wartime reputation. 'The cold and damp of the English winter plus the fleeting furtiveness of the summers produce among other things the greenest lawns, rheumatism, people who look like pit-ponies, the cosiest fireside scenes and beautiful children,' noted the writer Fleur Cowles, in reaction to Parkinson's oeuvre, and photographs of country picnics, of hunt meets and shooting weekends at stately homes were still encouraged. But Parkinson began to bring more of his barely repressible wit into the mise-en-scène, his emphasis, noted Parsons, was on 'charm and elegance' rather than on 'smartness and chic'. His photographs of Barbara Goalen and Anne Gunning, for example, in hats and long gloves, purveyed a look of elitist sophistication that had all but ignored the reality of the times. One fashion shot of the model Enid Boulting smoking a cigarette caused Edna Woolman Chase, the editor-in-chief of American *Vogue*, to admonish him from New York: 'Smoking in *Vogue*. So tough! So unfeminine.' It did not escape the photographer that the designer Helen Geffers had entitled her outfit 'Impertinence'. Terence Pepper has discerned this as evidence of a 'new brutalism in fashion', and with her gamine crop and unwavering gaze, Boulting certainly 'strikes a forthright and liberated pose'. Such confrontational

vignettes from real-life were clearly unexpected, and a quasi-documentary fashion photograph of Barbara Goalen running past a wall covered in graffiti, as if pursued by an assailant did not reach the page in its original form.

A certain detached scrutiny also appeared in Parkinson's portraiture. The heads of Jean Seberg and Montgomery Clift fill the frame, their blemishes and anxieties potentially presented for readers to analyse. In the case of Clift, who appeared to have been caught unawares, Parkinson's intimate approach provoked *Vogue*'s caption writer to emphasize the actor's 'superb ordinariness transfigured by neurosis and soul-searching'.

In *Lifework*, Parkinson refers to *Vogue*'s editor Audrey Withers angling 'more and more photographic opportunities in the direction of a considerably untalented photographer, a confirmed alcoholic ...' . This refers to his *Vogue* contemporary John Deakin, who had made the psychologically penetrating portrait his own there. Not believing in photography as a medium of refinement gave Deakin's portraits an edge, which Parkinson attempted to emulate. But where Deakin's eye is all but pitiless, Parkinson's attempts at grim humour were only partially successful – not least because his innate sense of propriety demanded that a sitting be celebratory. His collaborator Siriol Hugh-Jones, however, wrote of Parkinson's 'catching his sitters at a range of about six inches', one of which, a spatially elongated portrait of Algernon Blackwood 'lives like a tender nightmare with me still'. To the painter John Ward, Parkinson's photographs of painters such as Augustus John, 'always stay in my mind very clearly ...' while in response Parkinson revealed that he considered the approach led to portraits 'almost as death masks'.

It would be misleading to suggest that the dispassionate approach preoccupied Parkinson in these years. Most frequently sitters were invited to arrange themselves in a harmonious domestic interior, mostly, he surmised, because a sitter is more likely to be truly him- or herself in a familiar milieu. Moreover an un-reconnoitred location would always provide stimulus to Parkinson for an unexpected or fresher tactic. The art critic Marina Vaizey has observed that 'Parkinson has memorialised our better selves with an affectionate, clear-eyed wit' and this is, in the 1950s, most manifest in the almost painterly formal portrait of Deborah, Duchess of Devonshire, taken at Chatsworth in 1952. Such colourful portraits appear to have prompted art critic John Russell Taylor to suggest that 'both in colour and in composition Parkinson is the logical successor to Sargent'. Similarly, the 'Mayfair Edwardians', two years previously, with its documentary approach, highlights the anachronistic posturing of a trio of West End boulevardiers. Parkinson was on good terms with at least one of them, Major Peter Coats, but as Martin Harrison has pointed out, it would be invidious, despite his aspirations, to associate them with Parkinson's own lifestyle. But the photographer's lack of intervention and the suggestion that his subjects are unaware of the photographer's presence finds resonance in much of his portraiture from this era. The 'Mayfair Edwardians', The Duchess of Devonshire and 'styled' portraits of film stars, such as Ava Gardner (1953) and Audrey Hepburn (1955) mark the successful elision of the fashion picture and the portrait. For Audrey Withers it marked yet another new era: 'more and more photographers' she wrote, 'have become also "directors" in the theatrical sense and models ... need to have a touch of the actor about them'.

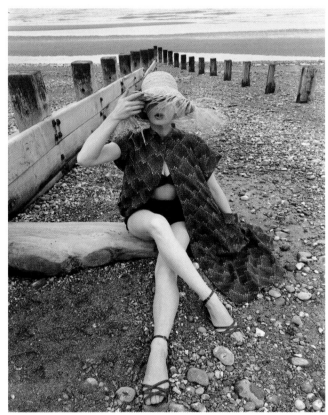

'On the Beach', *Vogue*, 1951

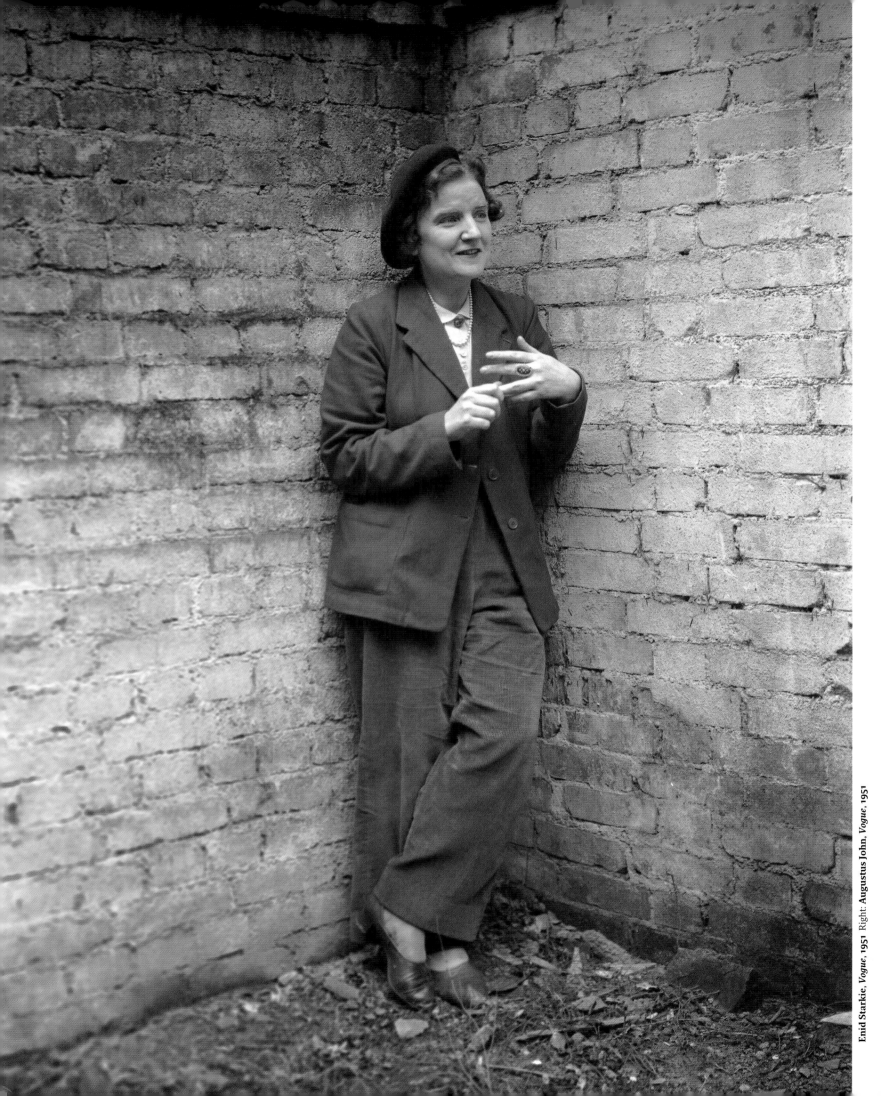

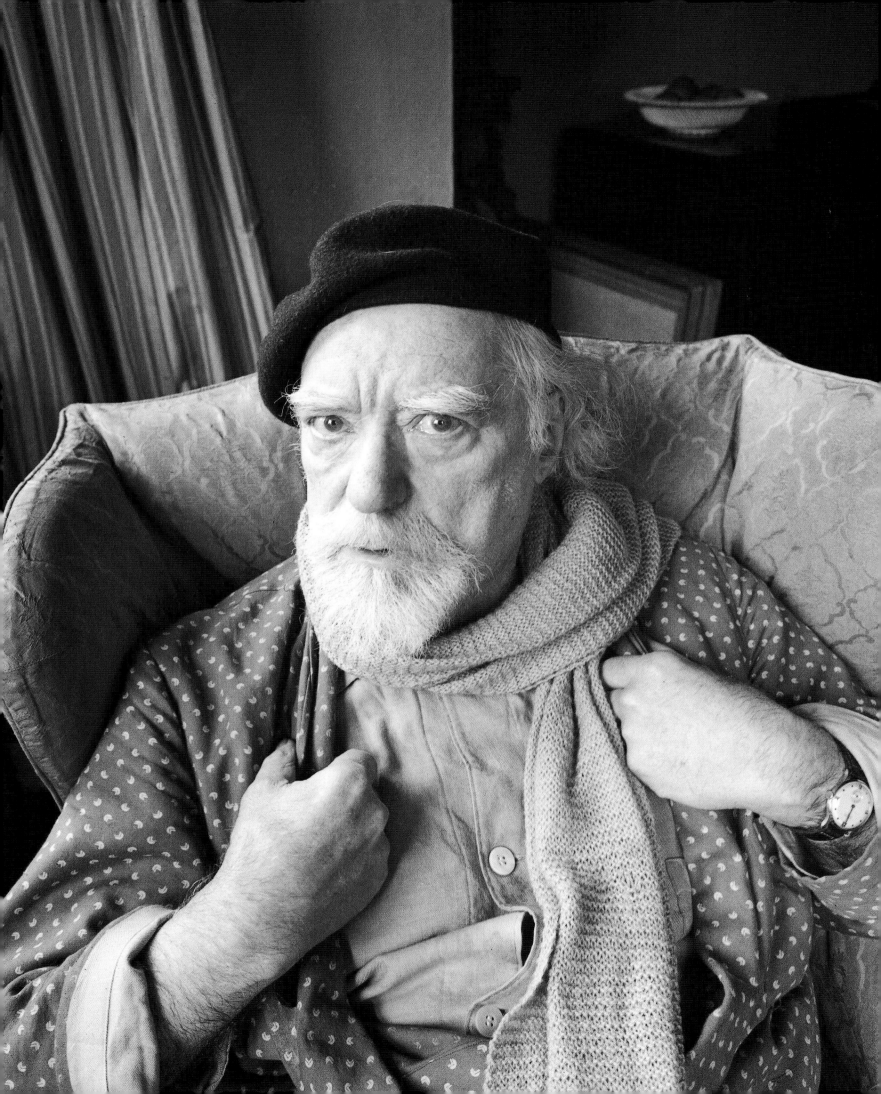

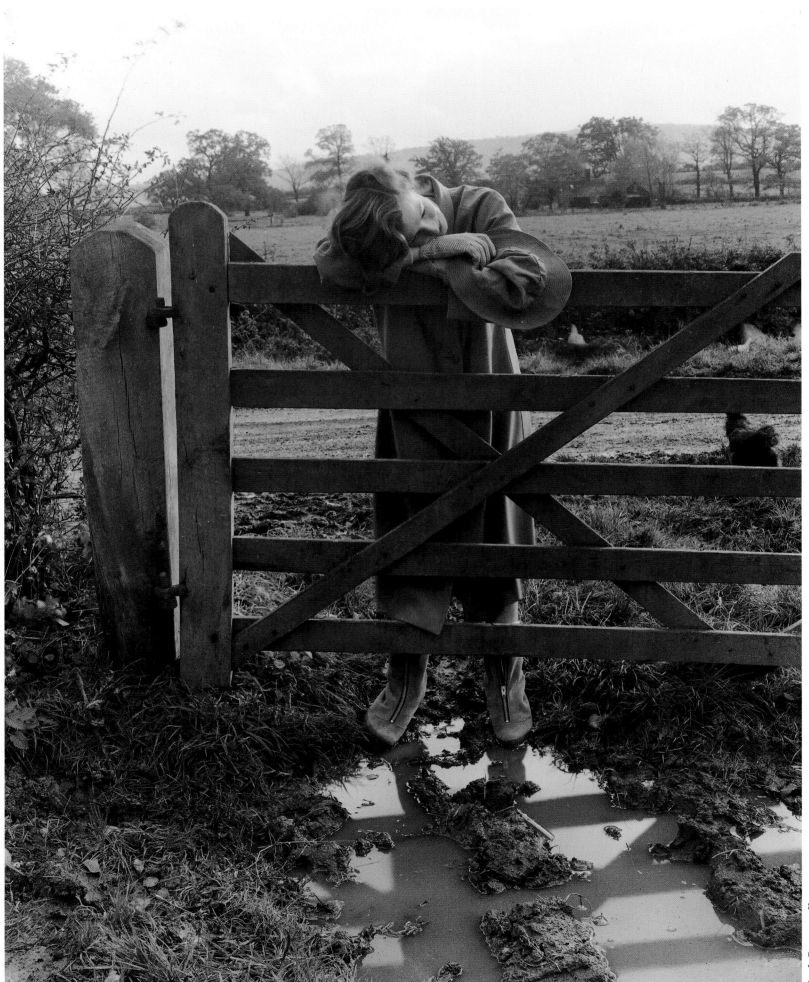

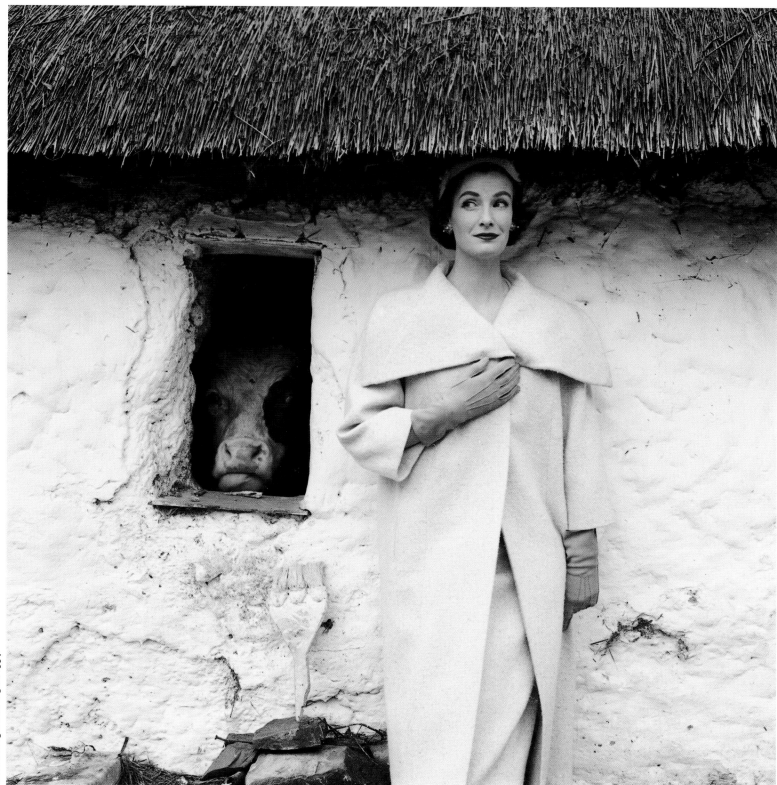

Wenda Rogerson, *Vogue*, 1954

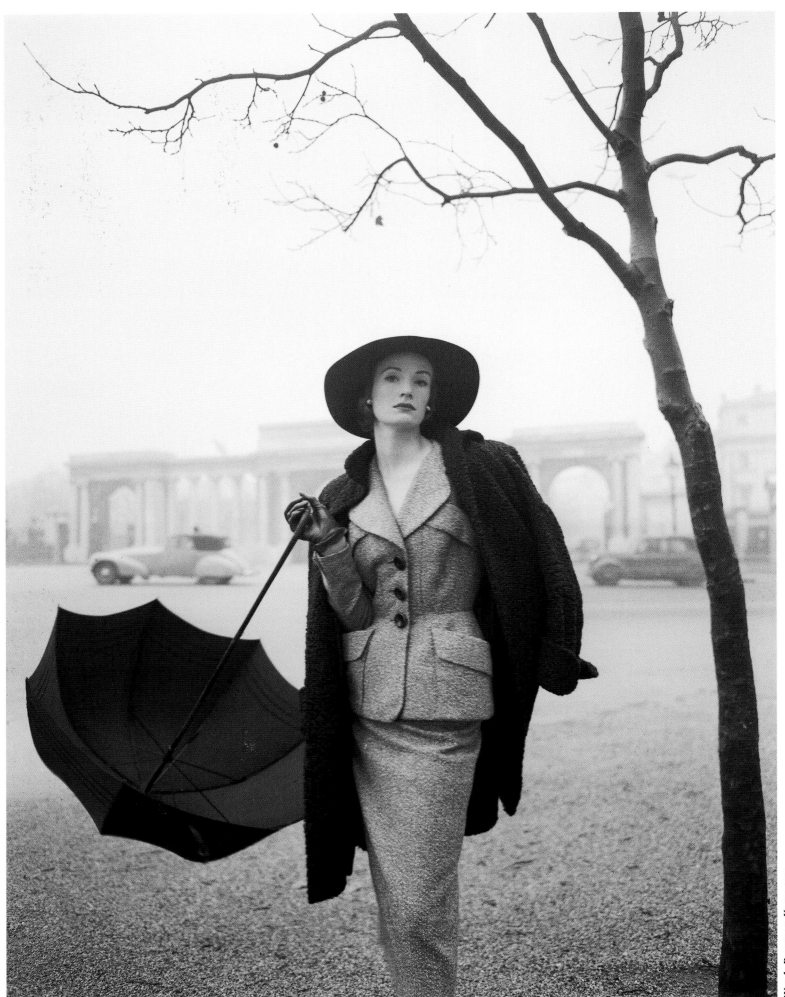

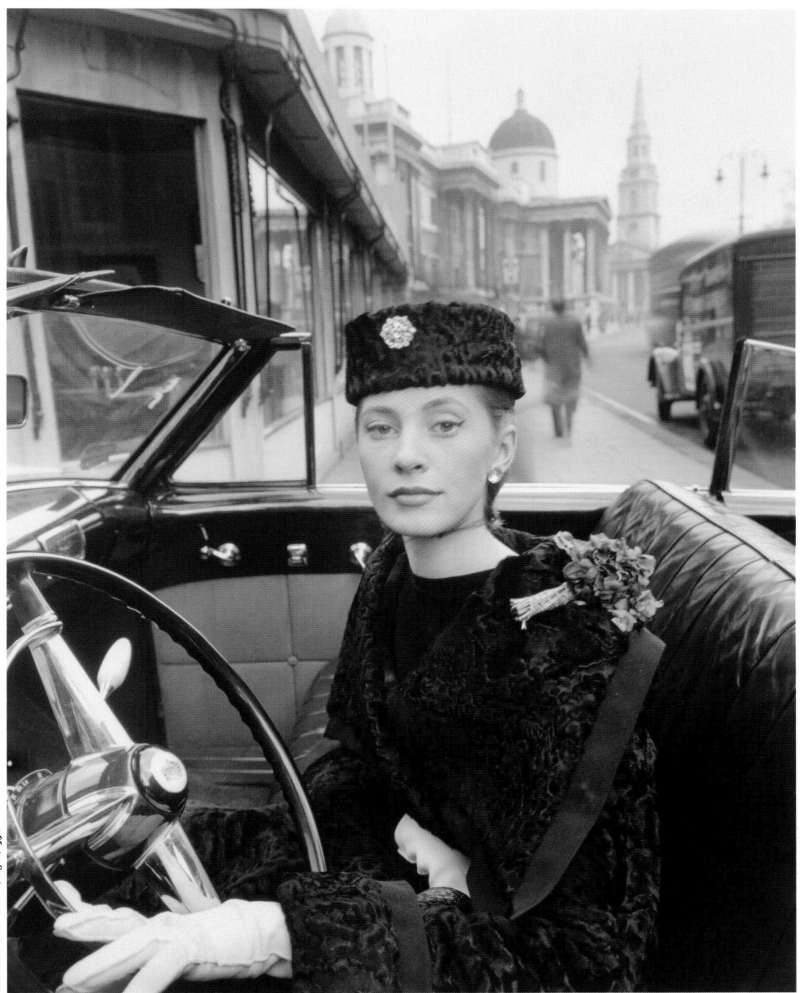

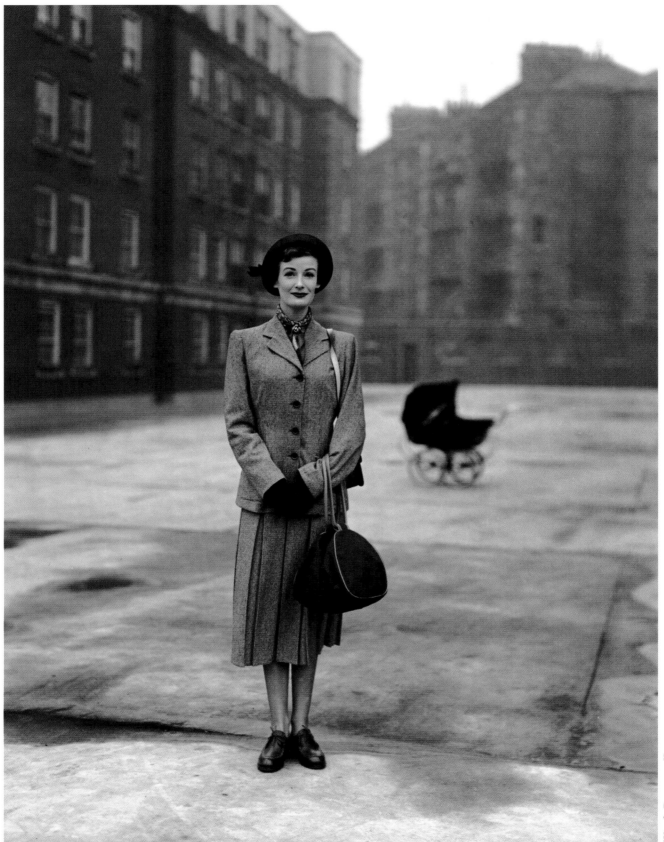

Wenda Rogerson, *Vogue*, 1950

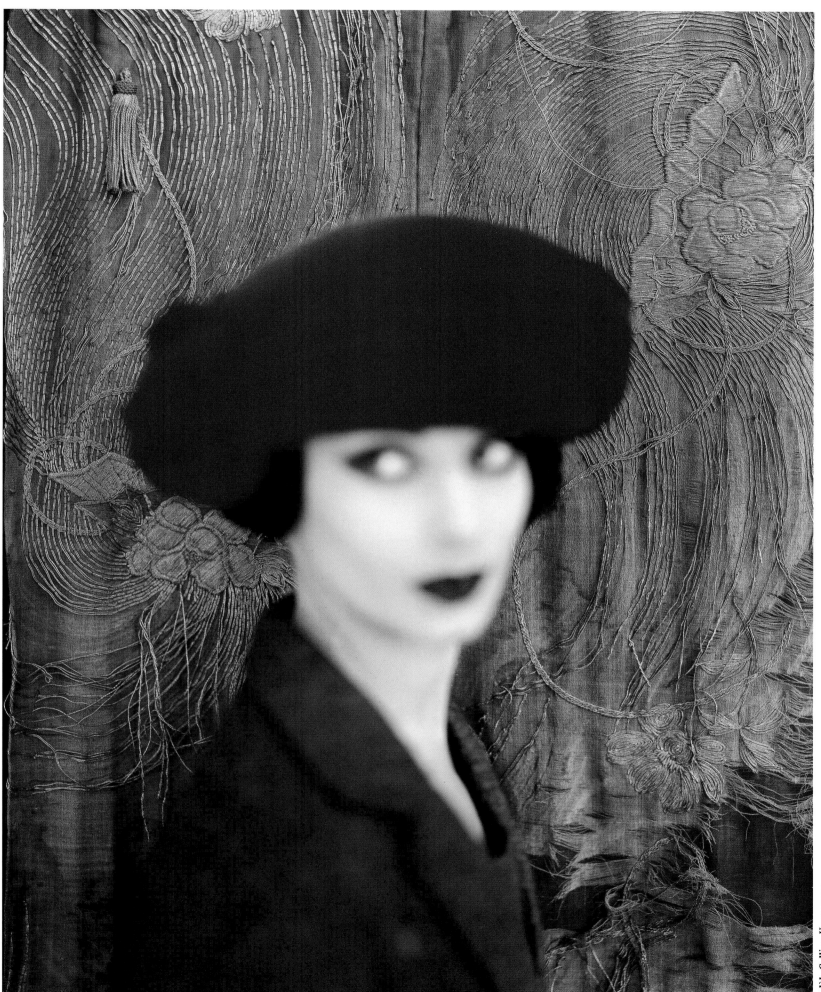

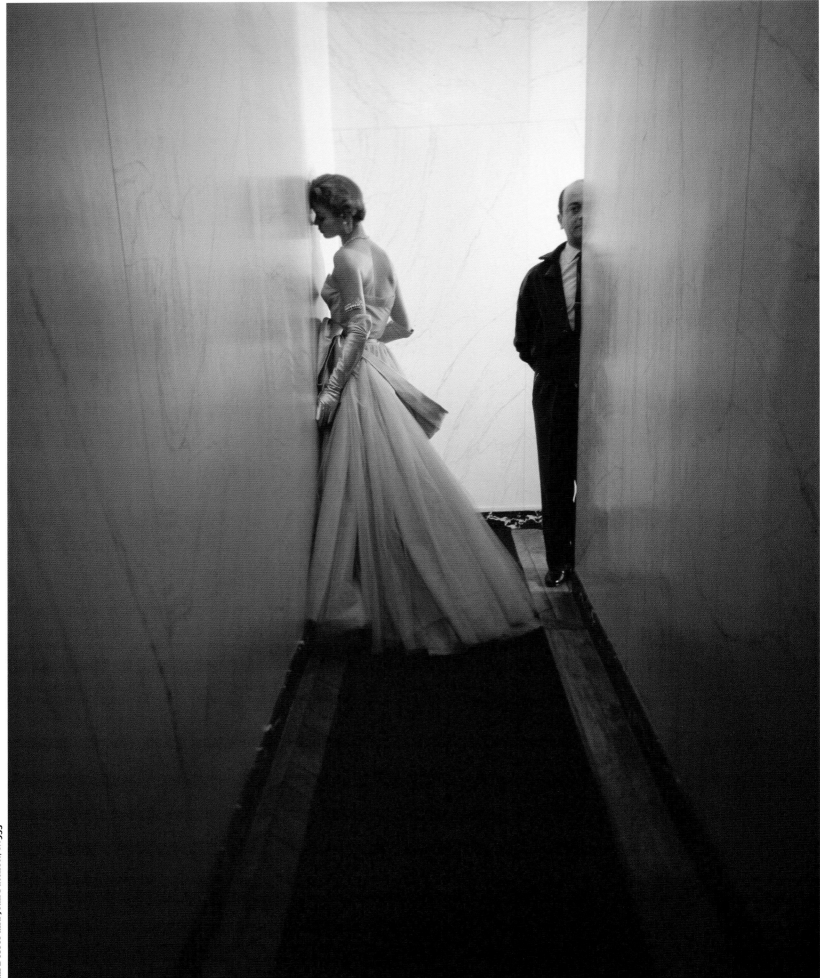

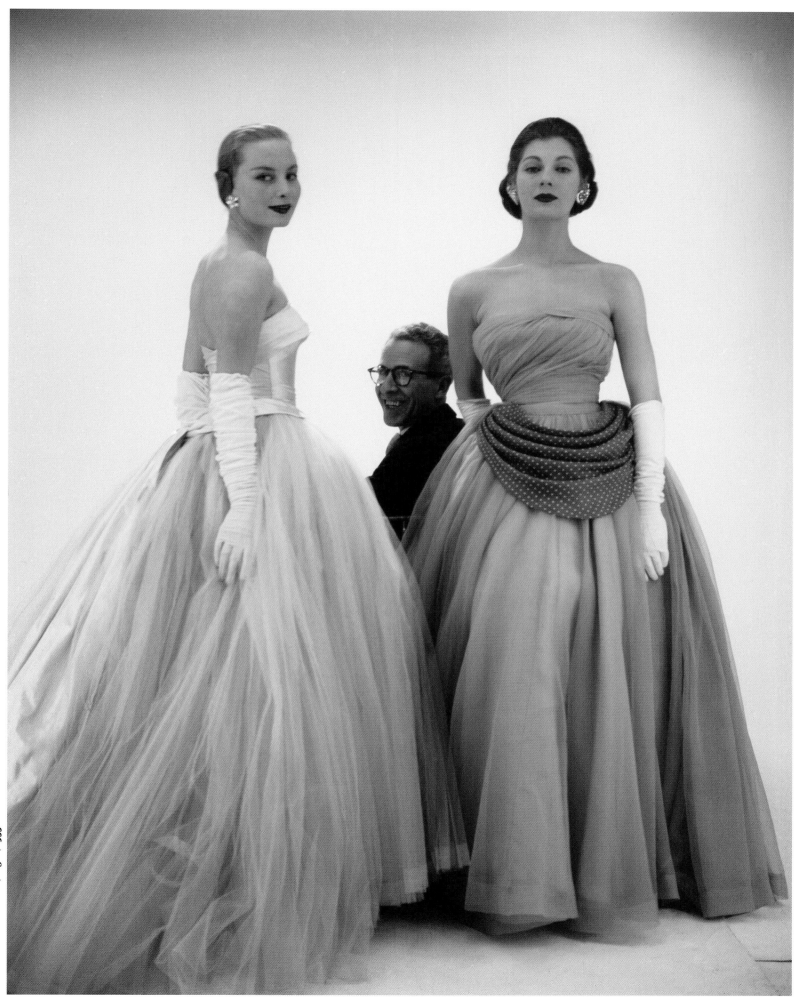

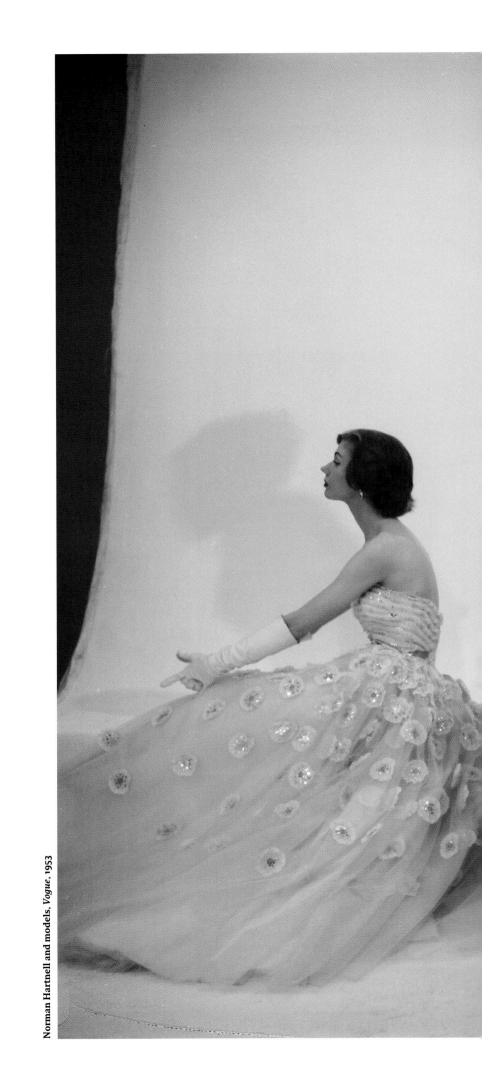

Norman Hartnell and models, *Vogue*, 1953

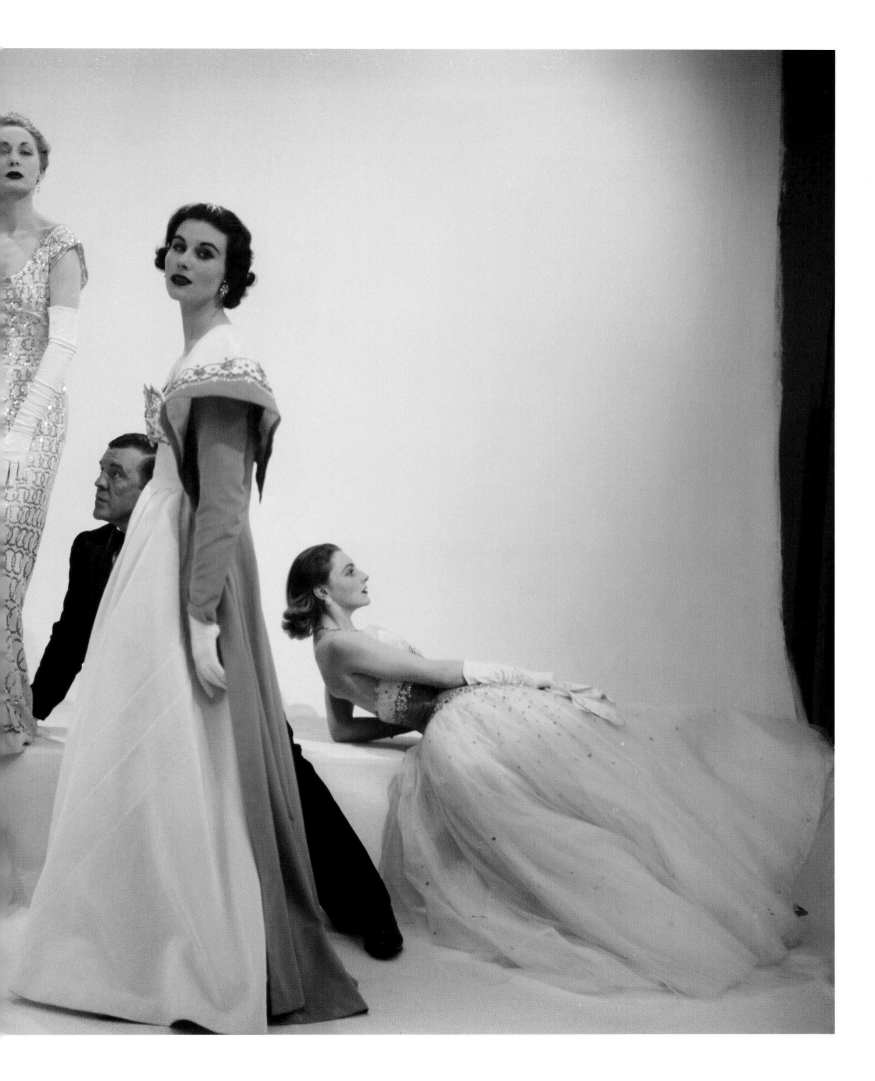

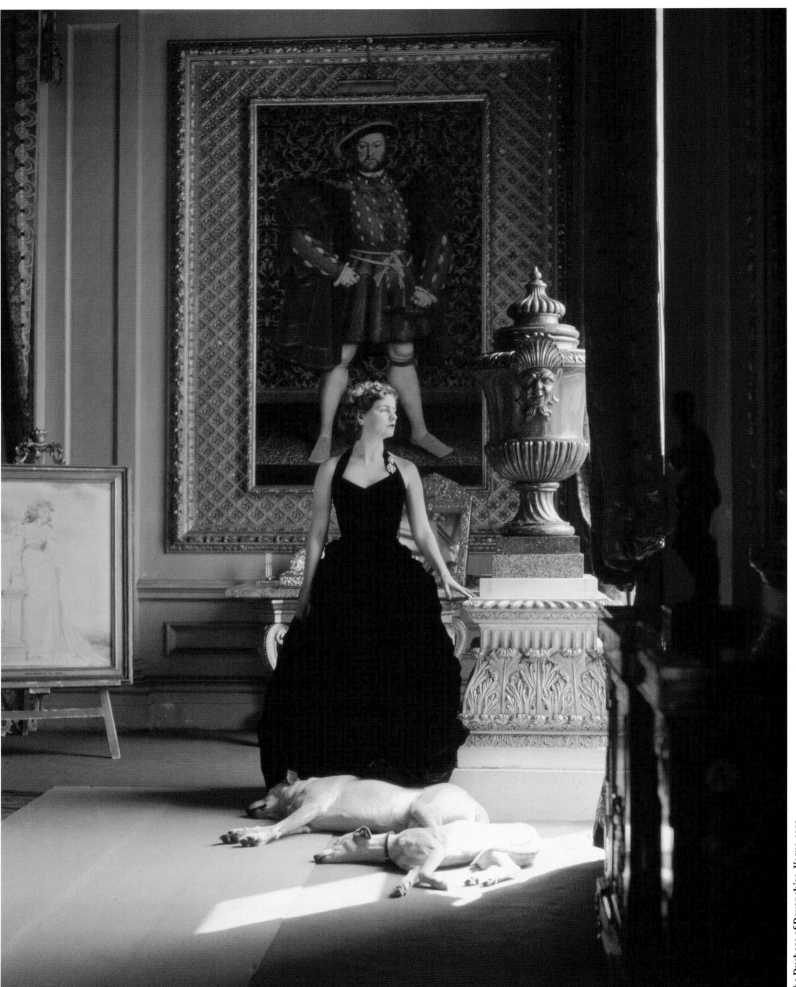

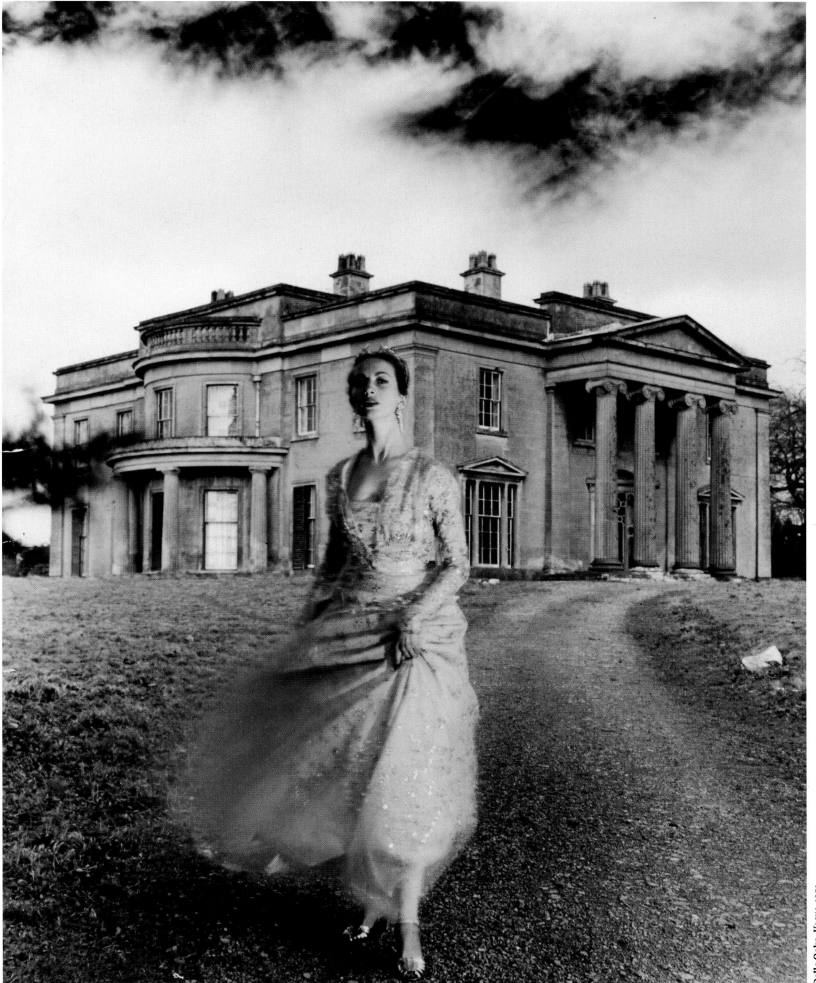

Della Oake, *Vogue*, 1951

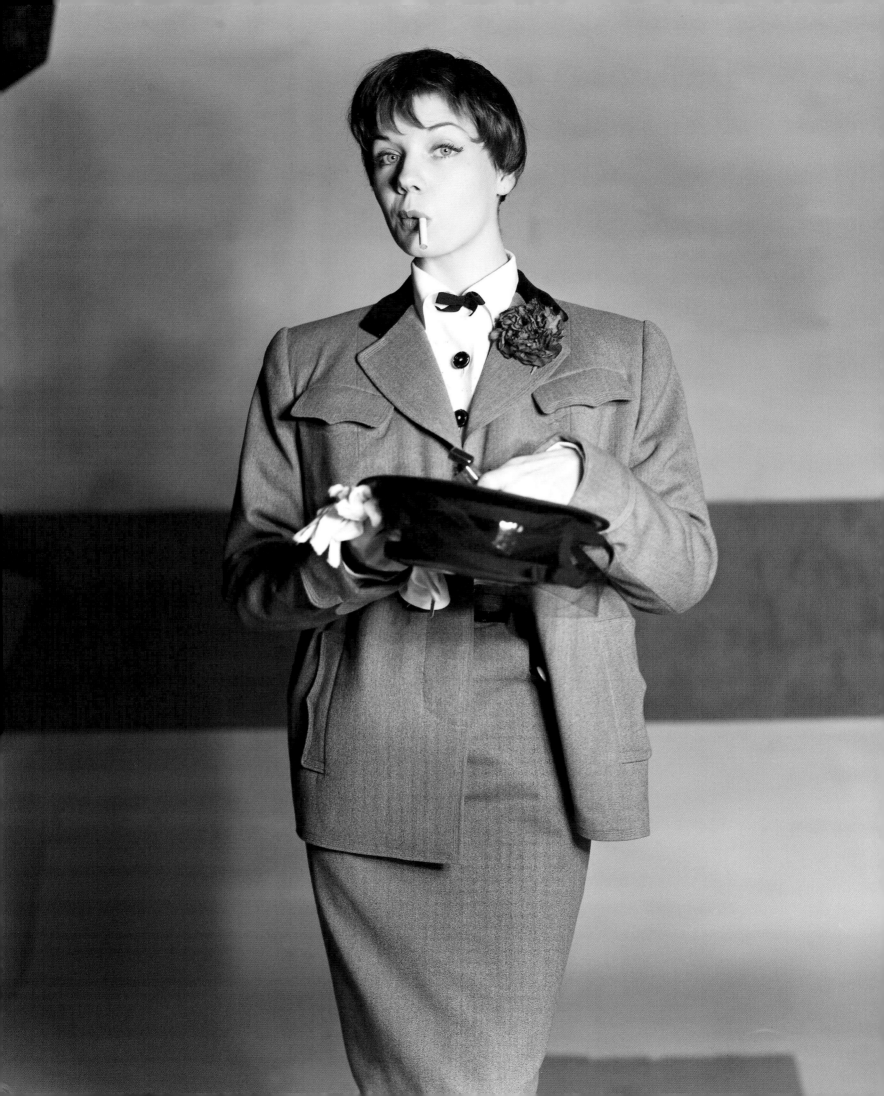

Enid Boulting, *Vogue*, 1950

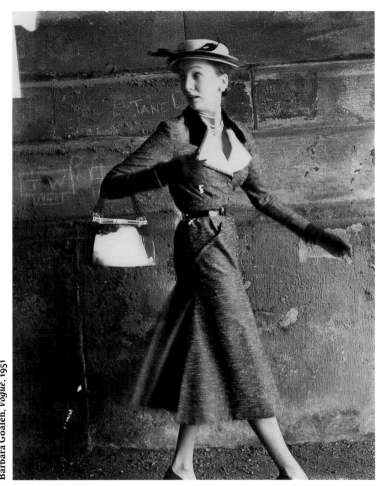

Barbara Goalen, *Vogue*, 1951

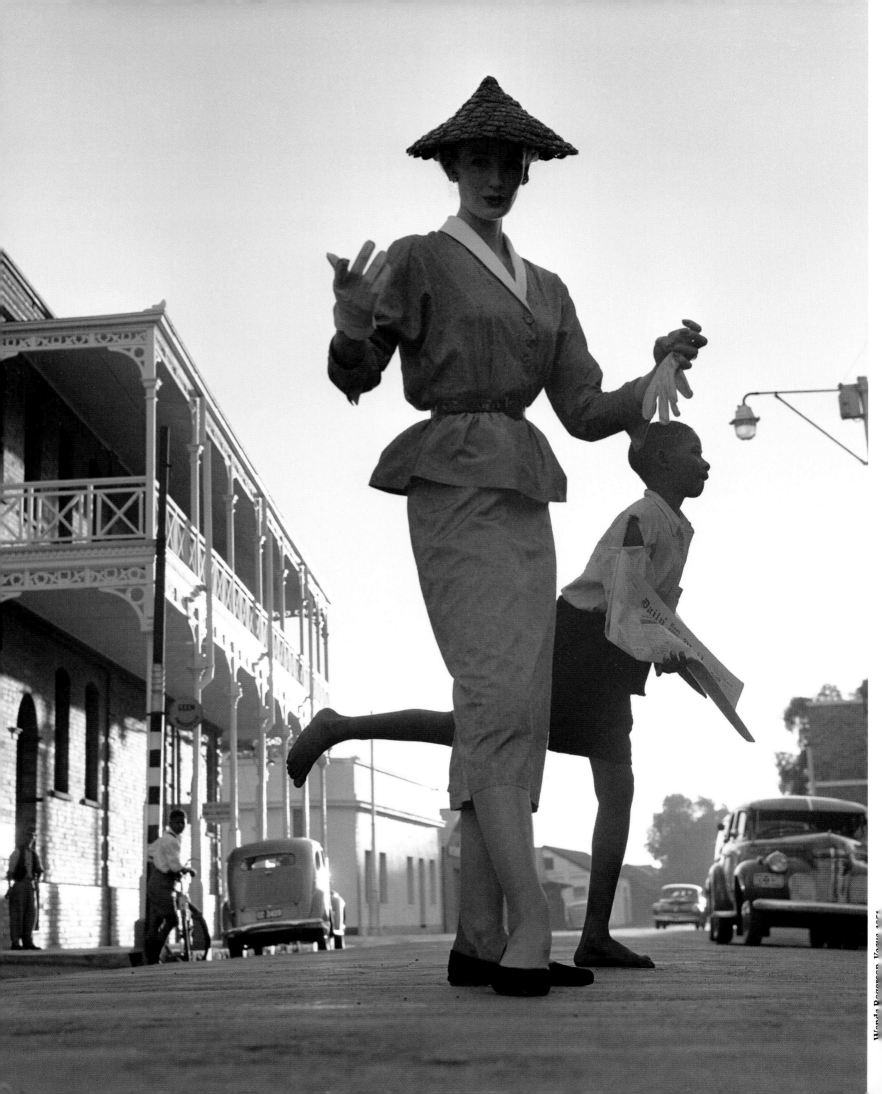

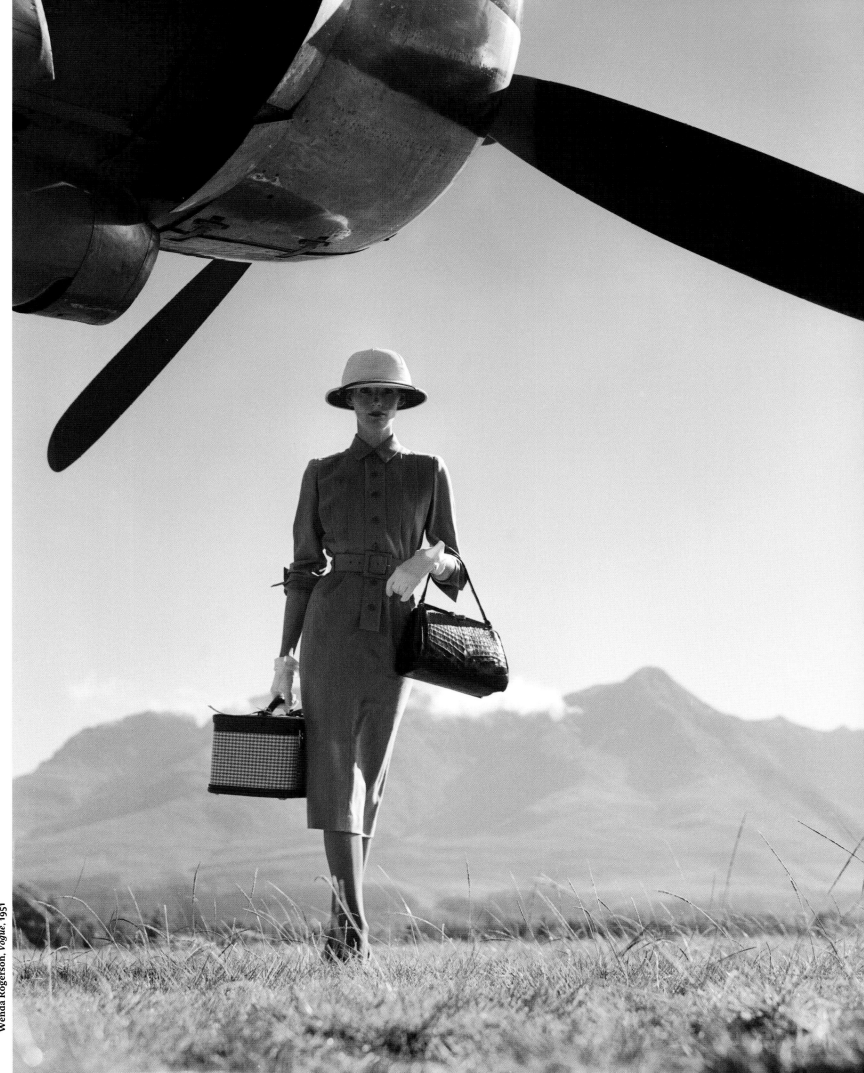

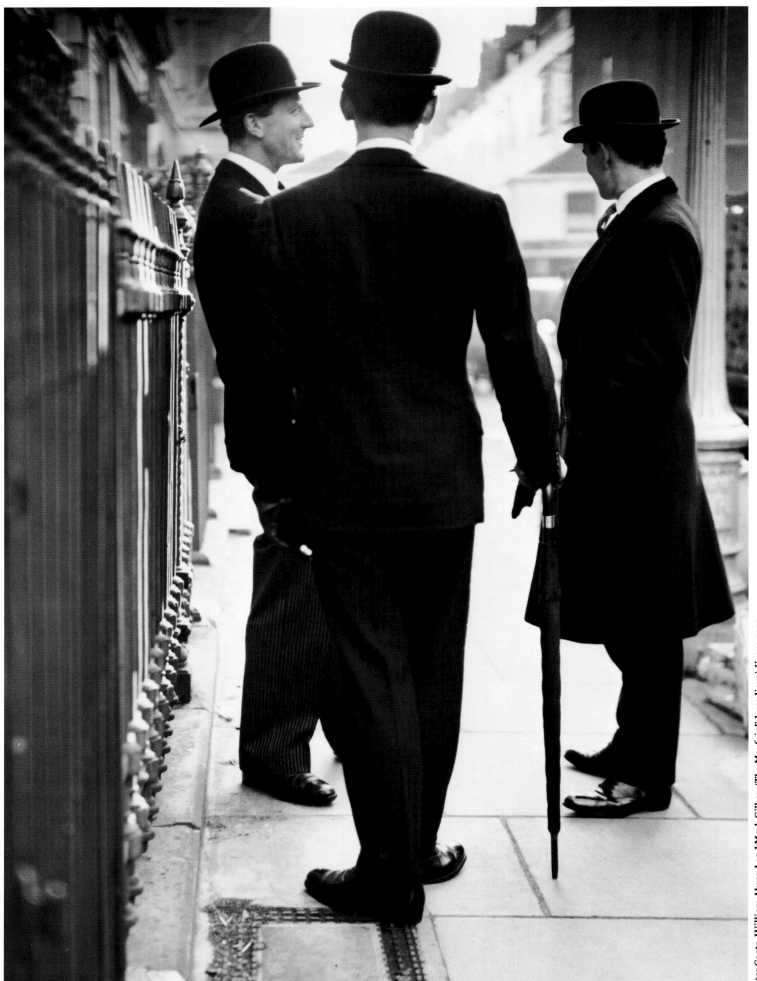

Peter Coats, William Akroyd and Mark Gilbey, 'The Mayfair Edwardians', *Vogue*, 1950

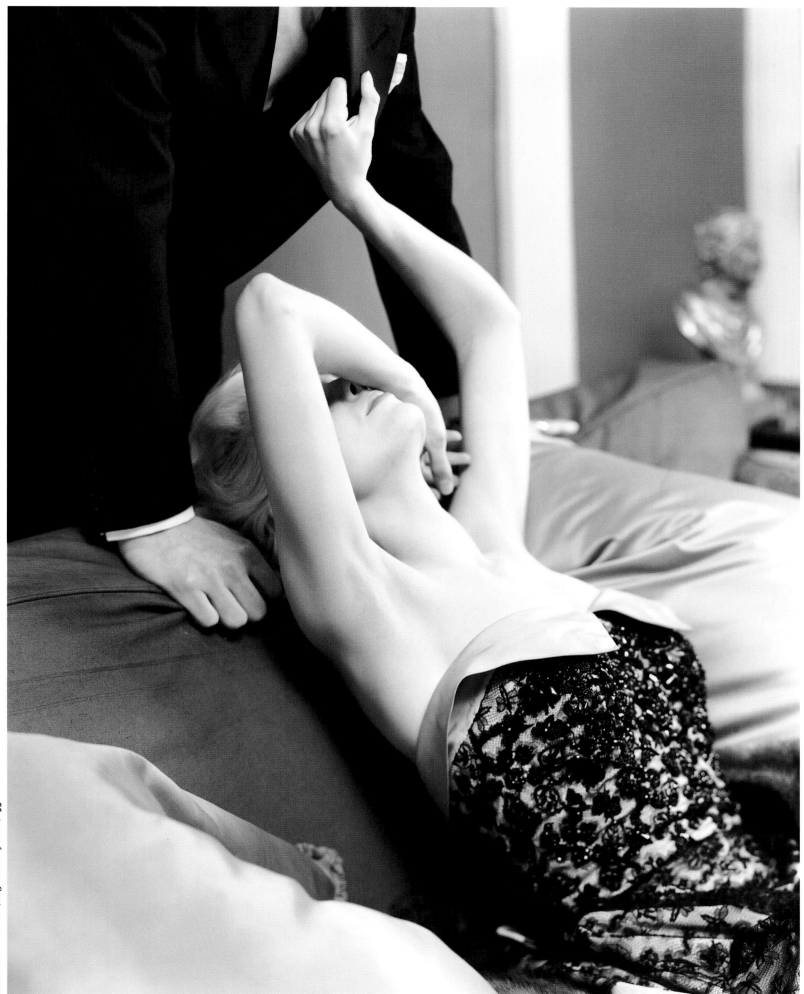

Carmen Dell'Orefice, *Vogue Beauty Book*, 1951

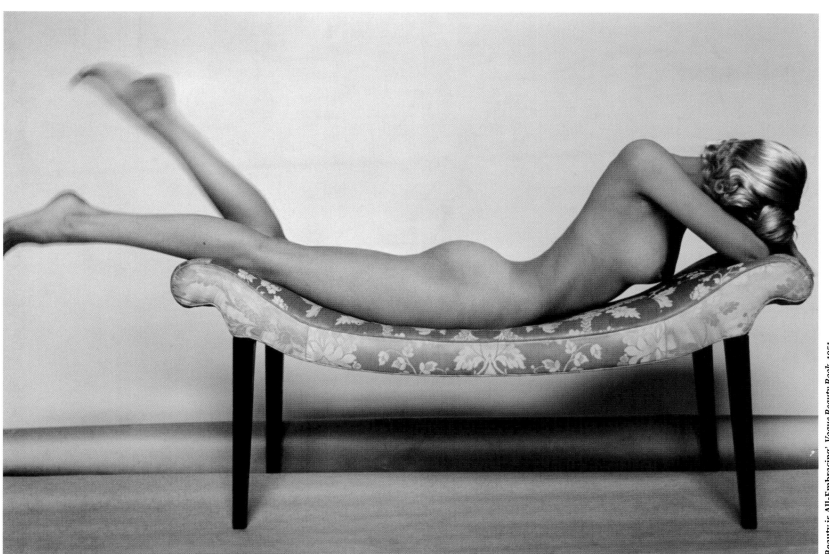

'Beauty is All-Embracing', *Vogue Beauty Book*, 1951

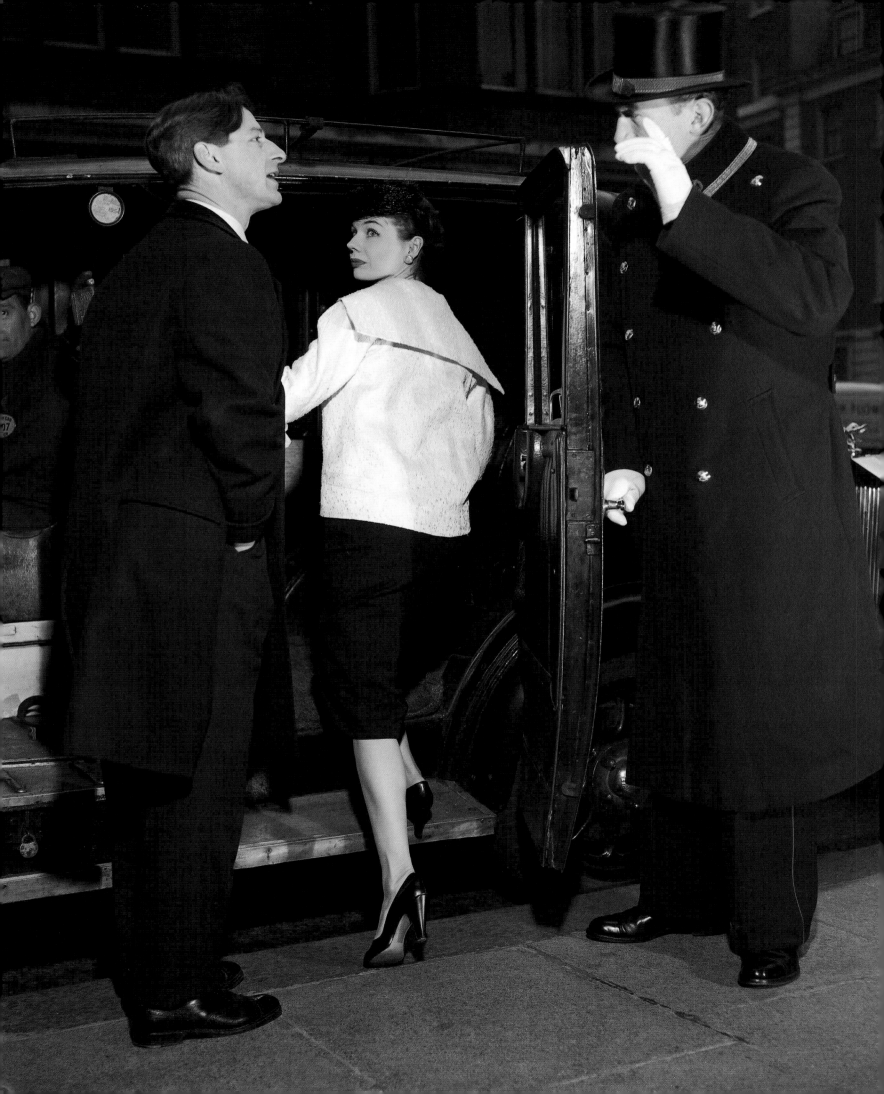

Mr and Mrs Roy Boulting, *Vogue*, 1954

Enid Boulting and children, *Vogue*, 1955

Audrey Hepburn, *Vogue*, 1955

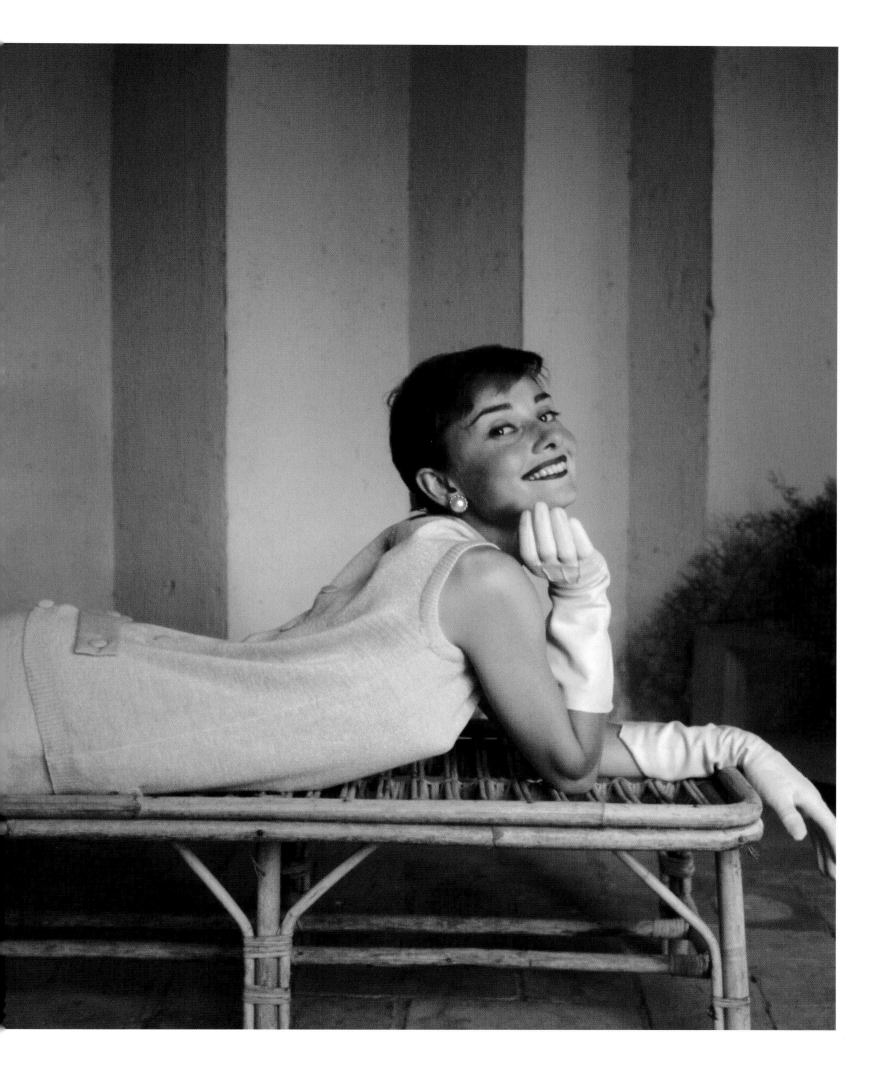

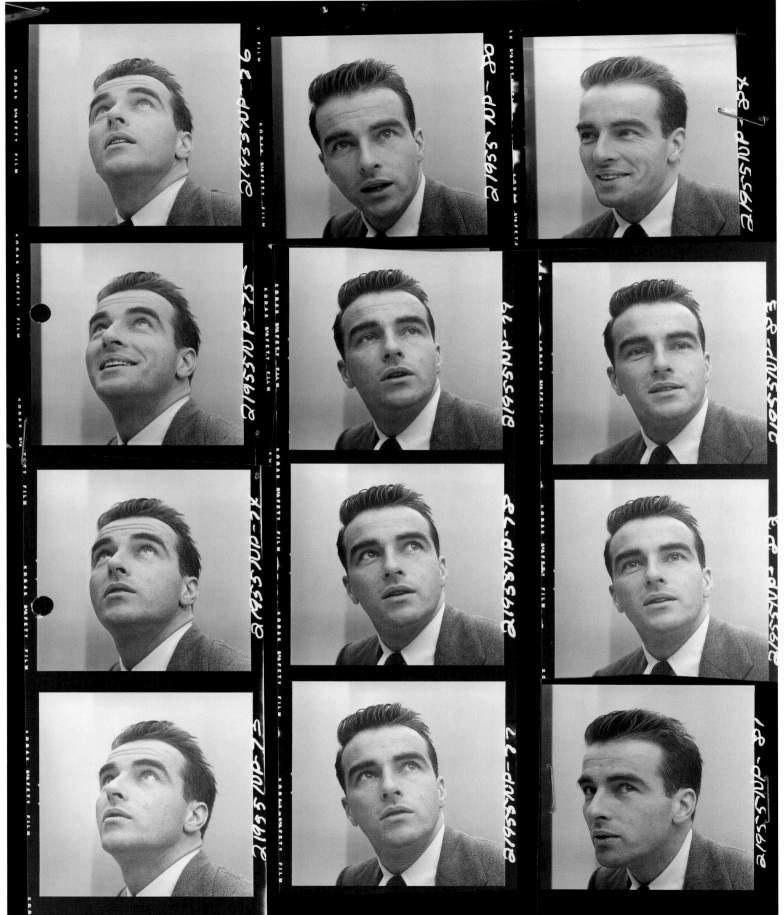

Montgomery Clift, *Vogue*, 1952

Ava Gardner, Vogue, 1953

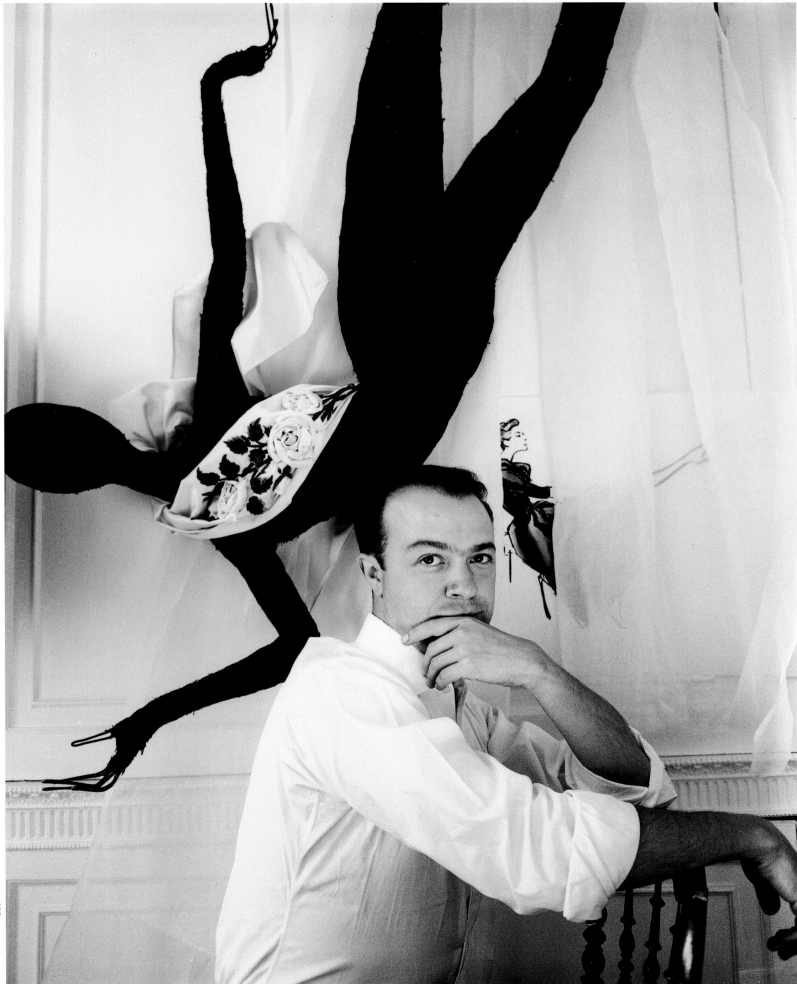

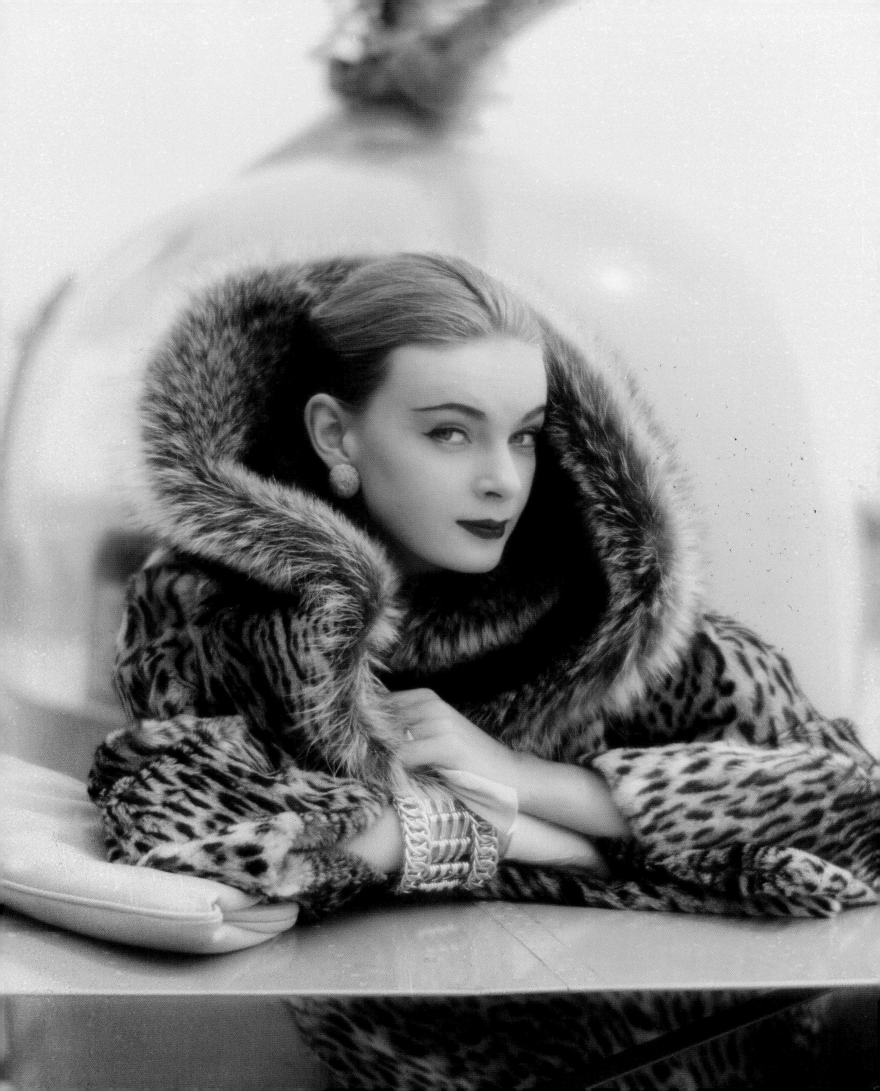

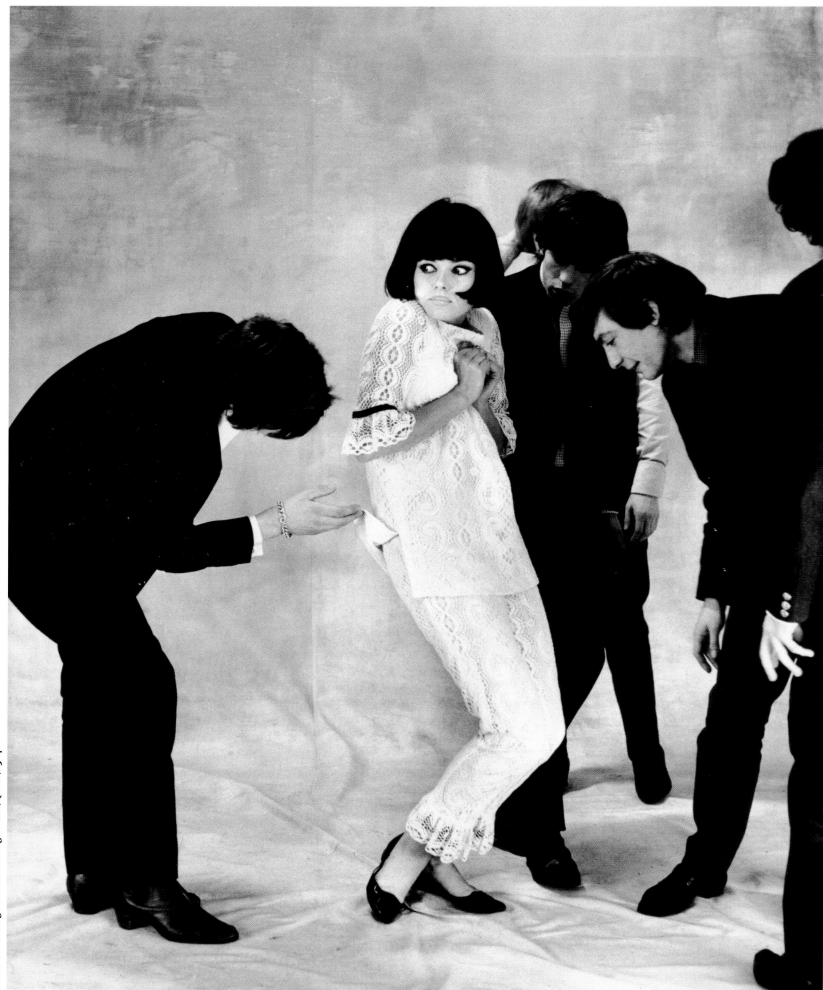

The Sixties

'Suddenly it's 1960. Suddenly it's Norman Parkinson, England's gayest, most impeccably dressed photographer ... What it means is that you will find the fashion world at its freshest, most natural and exciting, photographed by England's undisputed master photographer. You take outrageous risks with the camera – to Parkinson photography communicates magic. What he communicates is the essence of how clothes are: how they move as you walk, turn around, sit down. After all no-one just stands there'

Queen, 1960

Marit Allen, whose prescient and knowing 'Young Idea' features for *Vogue* in the 1960s lent the magazine a credibility it did not necessarily expect (she was formerly with *Queen*) has observed that 'Parks understood completely the dynamics of the sixties'. She added that 'he used his sense of reportage and his sophistication, experience and wit'. He also successfully married, in a fashion photographic context, the traditions of the old order, which as a practitioner by then of thirty years experience he undoubtedly was, with the innovations of the new. A metaphor he used to describe the stylistic dichotomies of his then-favourite model, Nena von Schlebrugge, could equally have applied to the position in which he found himself: 'hovering like some half-filled helium balloon between the two'.

Terence Donovan, who with David Bailey and Brian Duffy comprised the 'Black Trinity' Parkinson strove assiduously to ignore, remarked that for him the 1960s began in 1959, when he opened his studio doors for the first time. Similarly for Parkinson, the new decade began when, in the same year, he decided to leave *Vogue*, the magazine that had fostered his career for nearly twenty years. *Vogue*'s last issue of the 1950s contained a photo-essay by Roger Mayne on the rise of the teenager. That same year he had photographed the dust jacket for Colin MacInnes' prototypical London novel *Absolute Beginners*. Cultural change was so palpable that *Vogue* had no alternative but to put its weight behind it. And so too for Britain's 'leading fashion magazine' the 1960s started fractionally early.

Martin Harrison has rightly perceived that two of Parkinson's last contributions to *Vogue* – a jocular representation of a Mary Quant dress for 'Young Idea' and a portrait of the playwright Shelagh Delaney, a proponent

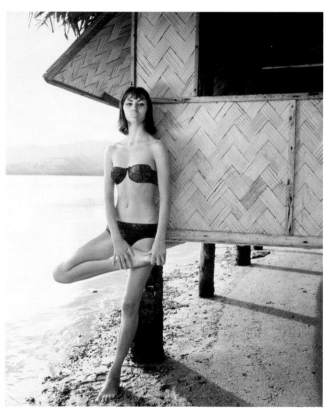

Pastrie, *Queen*, 1960

of the 'kitchen-sink' dramas of British working-class life – 'belong equally in the cultural climate of the new decade'. But photographs, such as a fashion shot of Adèle Collins in a toque by Otto Lucas also taken in 1959, belong firmly – and intentionally – to a previous age, in this case the world of fin-de-siècle symbolism epitomised by Kees Van Dongen, a favourite painter of Parkinson's.

In 1959, Parkinson also discovered one of the models most associated with the coming decade, at the London modelling agency Lucie Clayton. Celia Hammond represented for Parkinson a mid century ideal. He admired her professionalism. She 'was a gorgeous girl, an absolute peach', he recalled in *Lifework*, but added that 'Celia has tremendous imperfections, yet I think these add up to her attraction because other women feel that if they tried really hard they could look as good as she does'. Their first sitting together produced a cover and several inside pages for *Queen*, and the magazine put her under exclusive contract for a year. 'Without Parks', she recalled in a *Vogue* tribute, 'I probably would have had no career in modelling. My looks were very unfashionable at the time. He told me that he liked girls who looked "real". When you developed model girl's habits and mannerisms, he wasn't interested'. Celia Hammond would be linked to the 'Black Trinity's' Terence Donovan, whom Parkinson always singled out for approbation, despite their being 'all very important photographers'. He told *Image* magazine that 'I wouldn't like to say who is the most talented but I fancy it's Donovan. Duffy is unreliable, but a good Duffy is unbeatable. David Bailey is better known as the photographer who put the hypodermic in the photographic scene, but he can take beautiful pictures'.

By 1960 and his associate editorship with *Queen*,

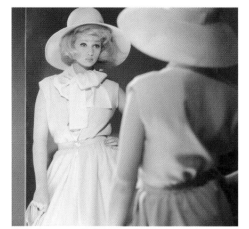

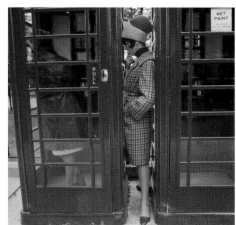

Celia Hammond, *Queen*, 1962

Melanie Hampshire, *Life*, 1963

Parkinson was already a personality, noted for his sartorial excesses as much as his photographic accomplishments. He was certainly enough of a personality to be photographed for its first issue of the decade. Parkinson responded to the new challenge of a younger-orientated magazine by making outlandish requests, especially for helicopters, which Withers had forbade him to hire at *Vogue*. For his intended purpose, 'I pointed out that aside from the cost being astronomical, it was almost certainly illegal'. He was 'easy but difficult', recalled her fashion editor, Sheila Wetton, 'if he wanted a pink elephant he got it'.

Parkinson's arrival at *Queen* coincided with a sense of gradual de-glamorisation in British fashion photography, which Parkinson tried hard to resist, at least at first. But over the course of his four-year tenure with the magazine he produced his wittiest and most inventive fashion photographs. 'My sort of photography is still a charming deceit. People want to believe that the camera cannot lie', he remarked in 1962. Moreover his 'documentary fashion' methodology, which he never quite abandoned, became more pronounced and reached its finest expression in the nostalgic seaside snapshots of a narrative titled by *Queen* as 'The Use of the Cameras in the Theatres is Strictly Forbidden'. He was not working in isolation. Terence Donovan's groundbreaking men's fashion stories for *Man About Town* magazine (later just *Town*) were played out against an urban backdrop of almost unremitting bleakness. With just such a reportorial slant, David Bailey at *Vogue* was successful in modifying the magazine's self-perception into to his own artistic agenda. A parallel example 'Point to Pointers' taken in the same year as Parkinson's seaside vignettes, and just the sort of rural scenario that Parkinson had once made his own, a fashion story with a horse-racing venue as a backdrop, Bailey combined a handheld verité style with a formal documentation of the clothing provided. The results pleased the magazine and the photographer. Whatever the magazines presented as a guideline, the inventive and intuitive photographer of the old school or arriviste would find the means to flout it, subtly or blatantly, allowing British fashion photography to thrive in specifically British milieus. It was noted by one commentator that 'the Black Trinity are still eager to know what he [Parkinson] thinks of their work ...'.

By 1964 and the expiry of his *Queen* contract Parkinson, now fifty, and living in Tobago, betrayed weariness with a world he regarded as progressively more frivolous: 'Fashion photography has reached an impasse. I hate all those girls with a look that if they could have a baby they could eat it. There are so many photographers who are just not interested in women and who treat models as dolls to be dressed up.'

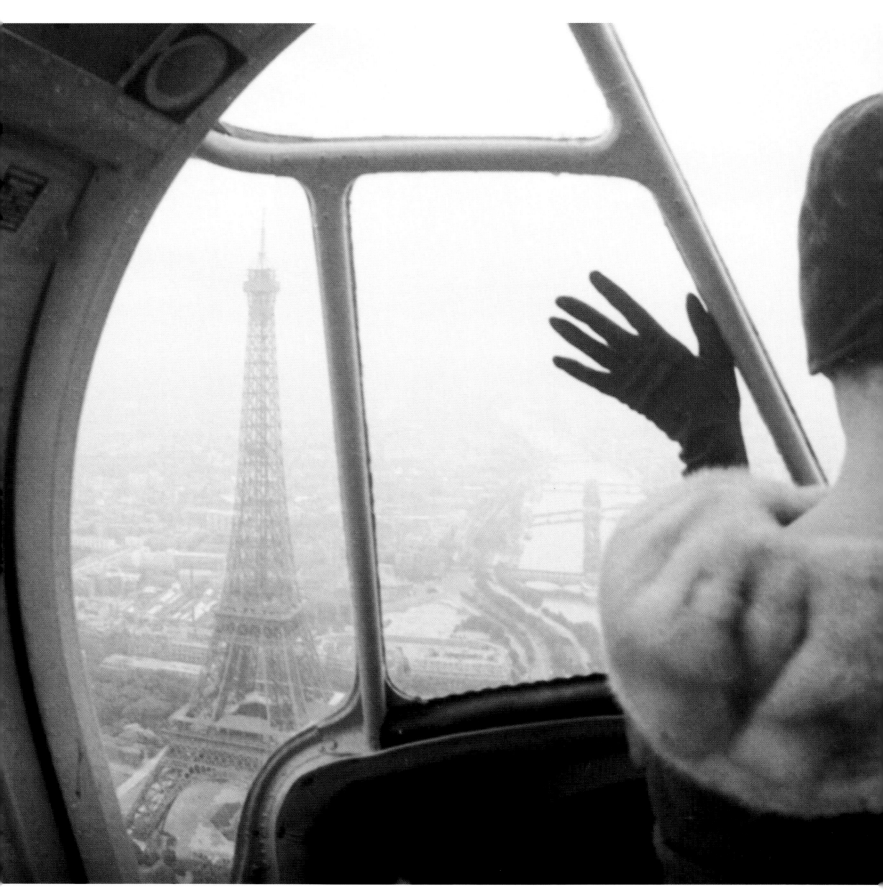

'The Paris Collections', *Queen*, 1960

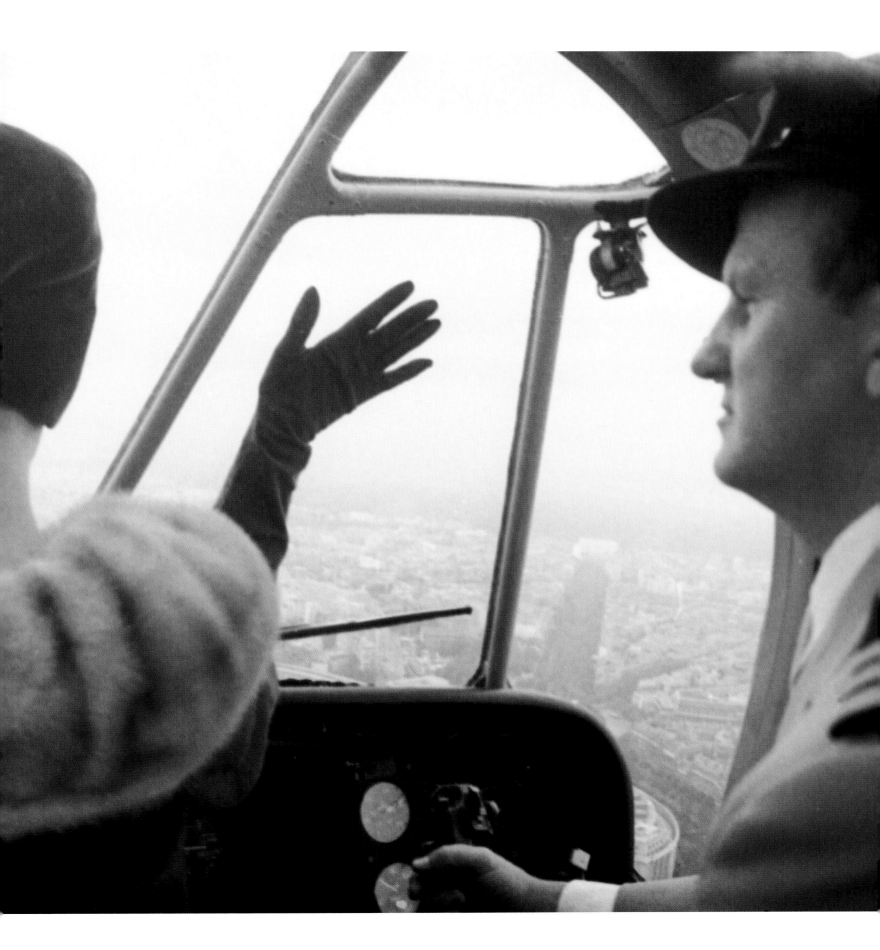

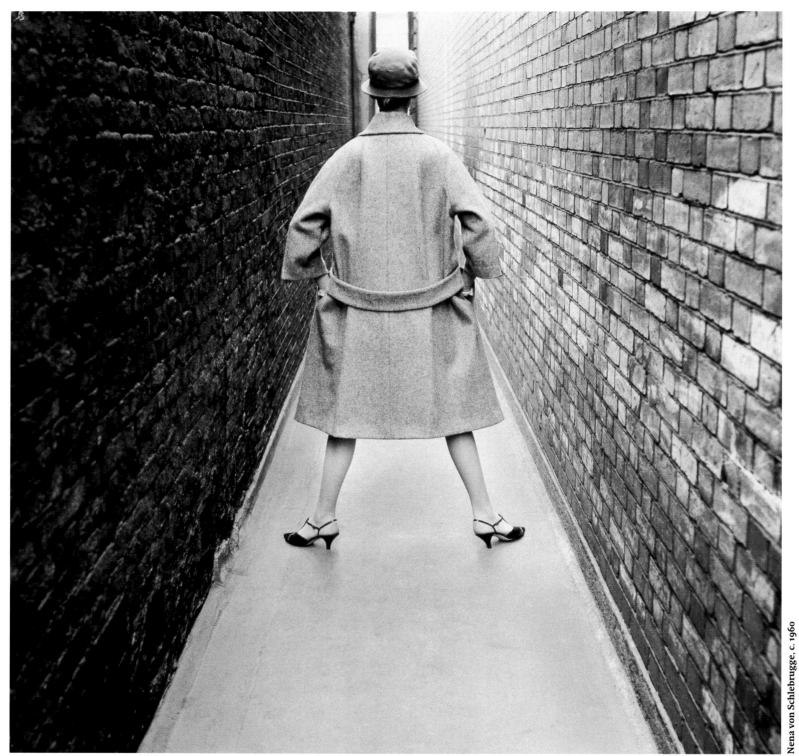

Nena von Schlebrugge, c. 1960

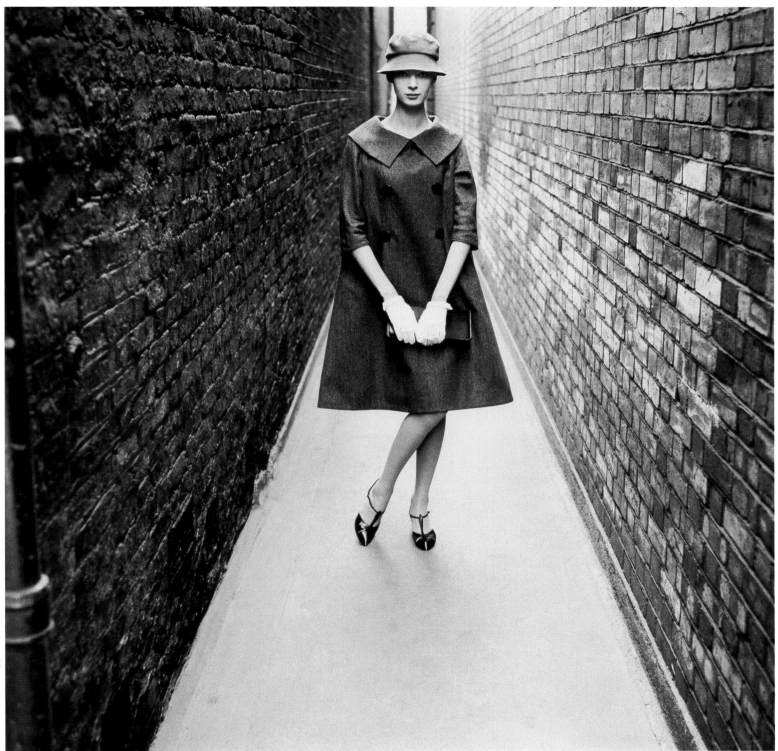

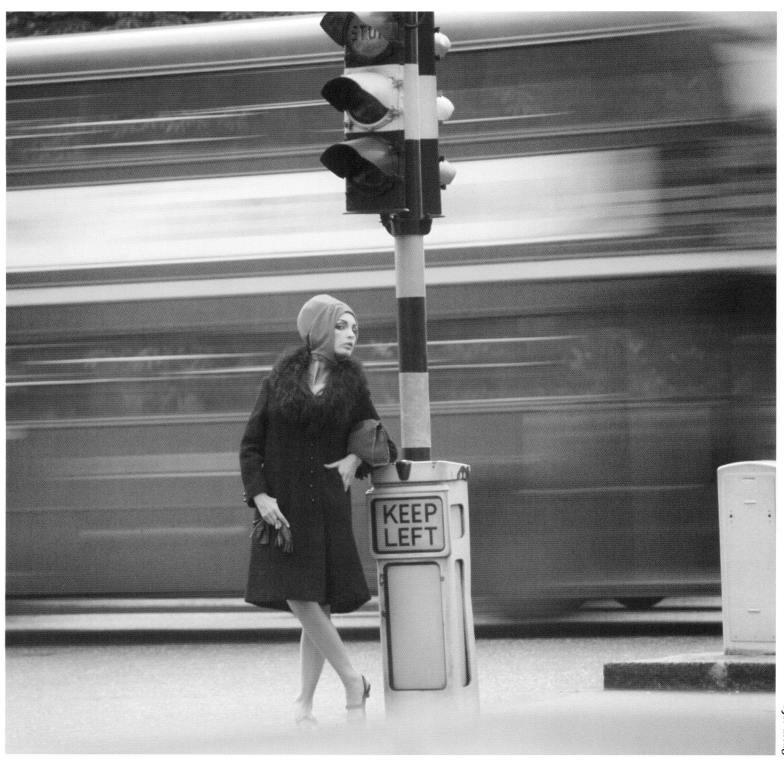

Queen, 1960

Blanche Cardinale, *Queen,* **1964**

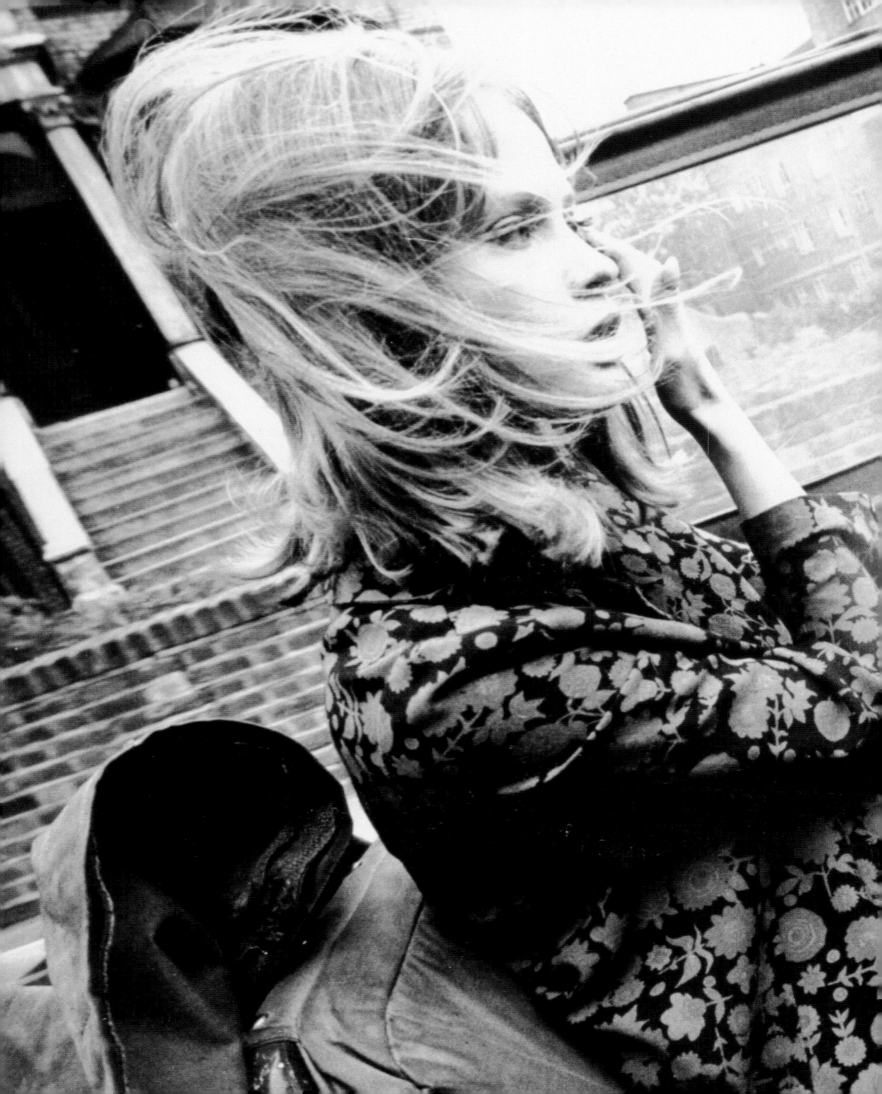

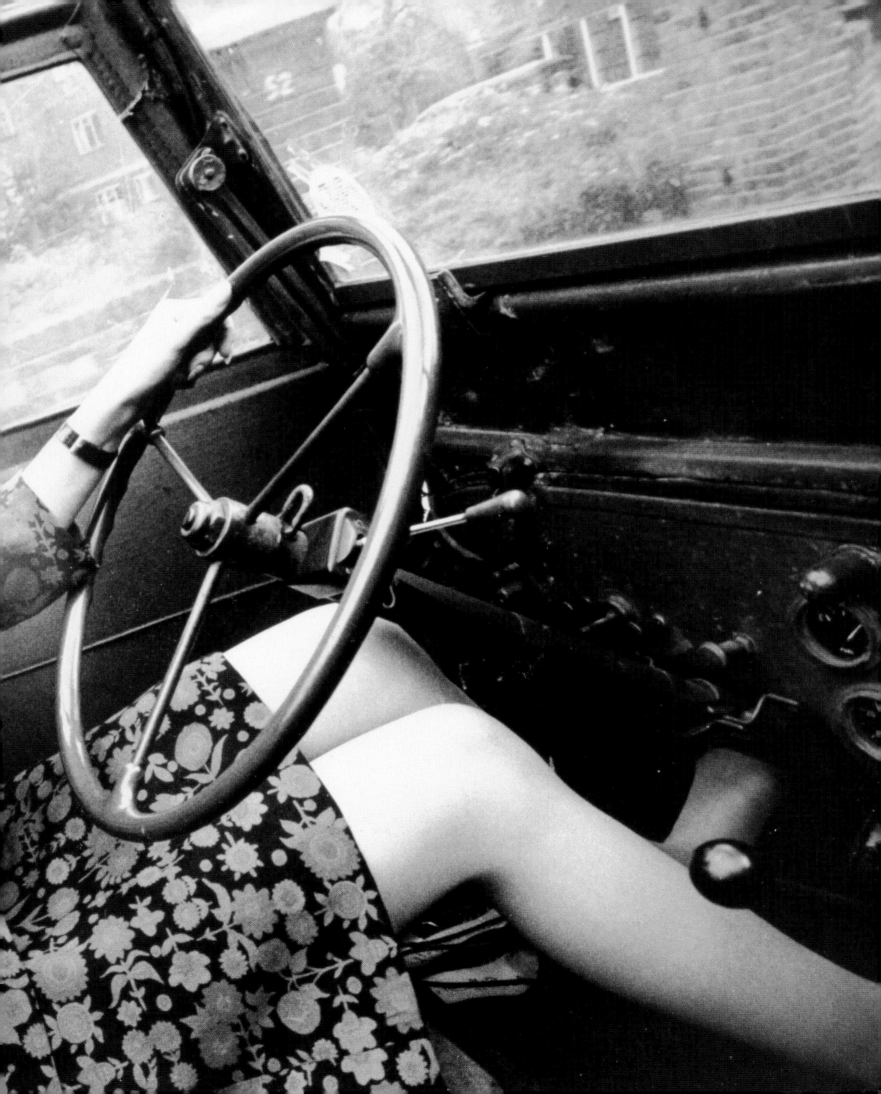

Previous pages: **Celia Hammond**, *Queen*, 1964

'International Fashion', *Life*, 1963

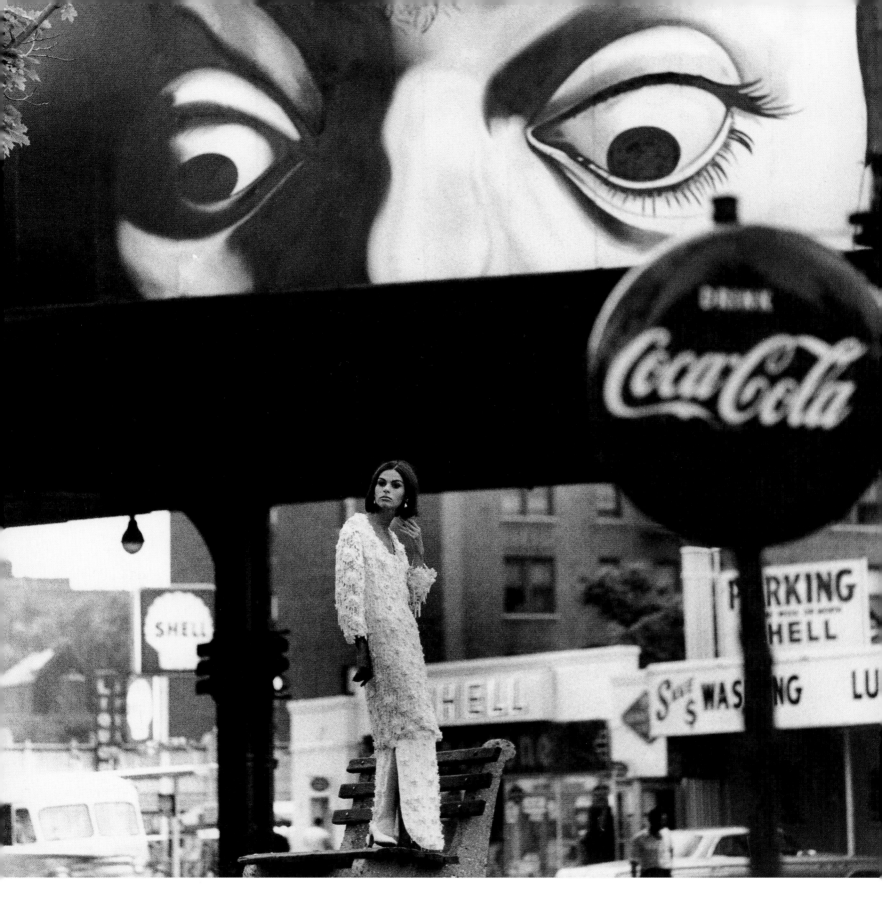

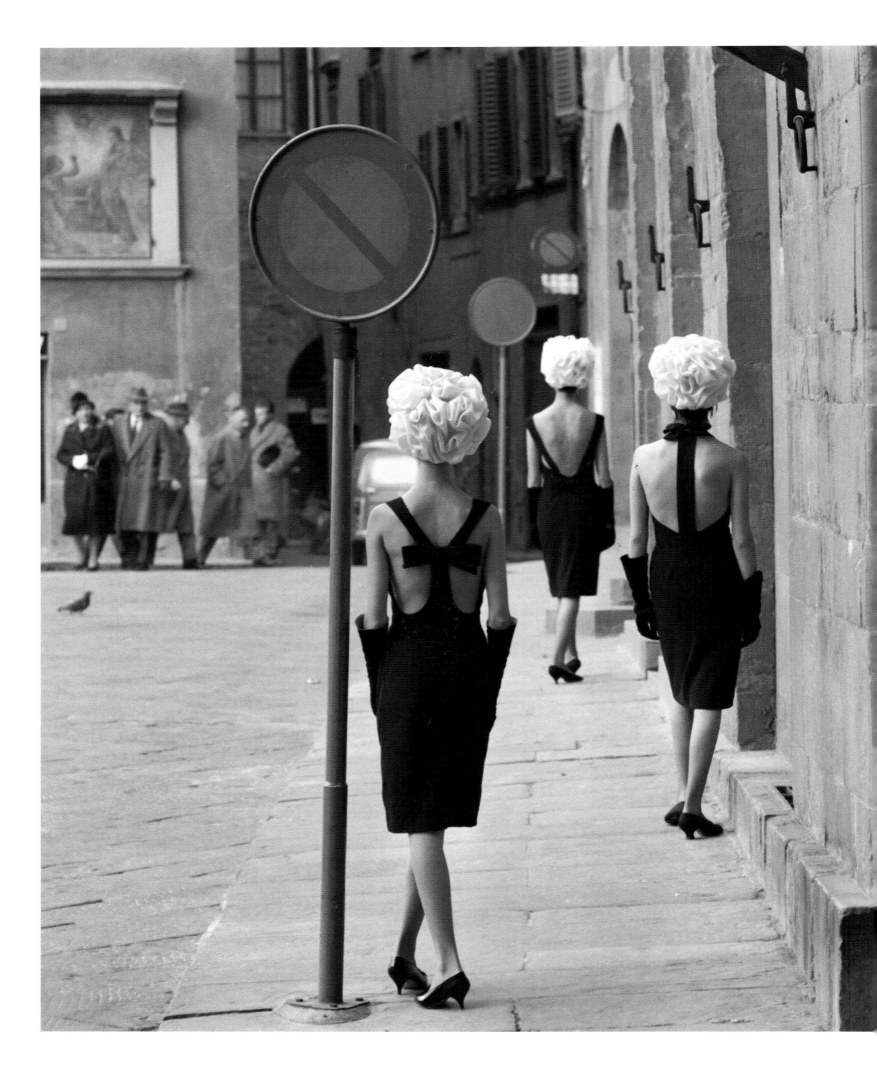

'The Italian Collections', *Queen*, 1961

Following pages: **Celia Hammond,** *Queen*, 1962

Ann Ford, *Queen*, 1962

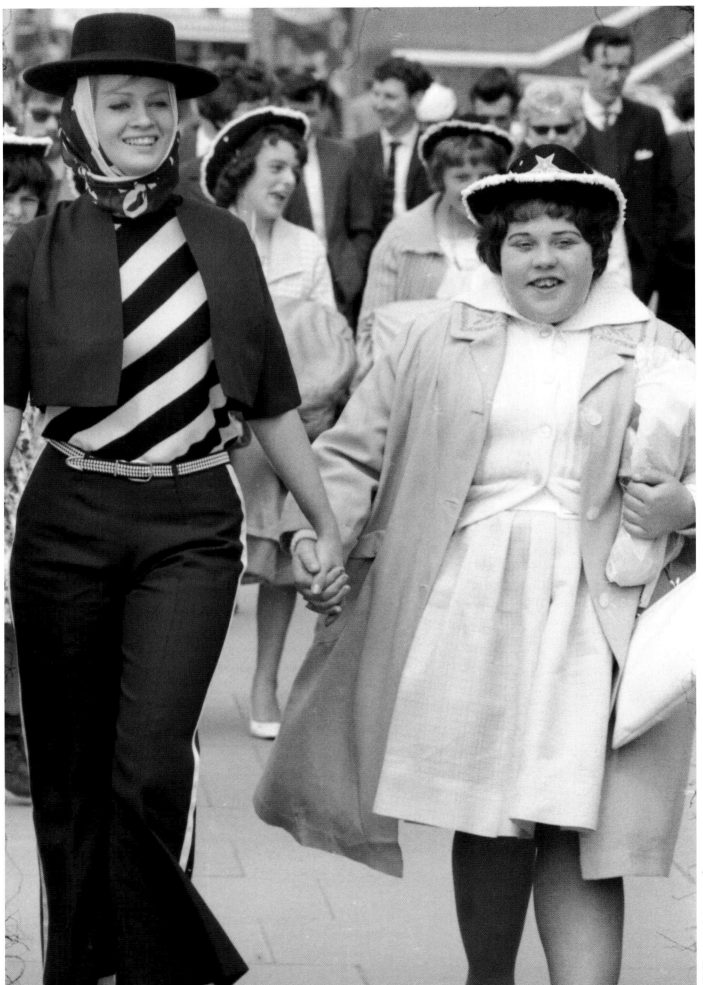

Celia Hammond, *Queen*, 1962

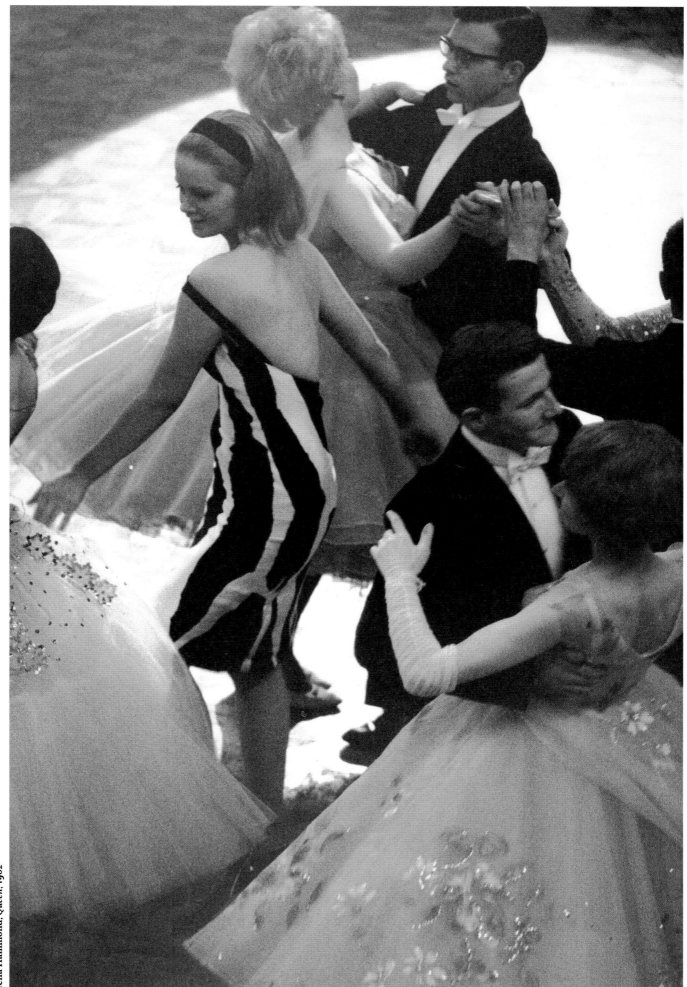

Celia Hammond, *Queen*, 1962

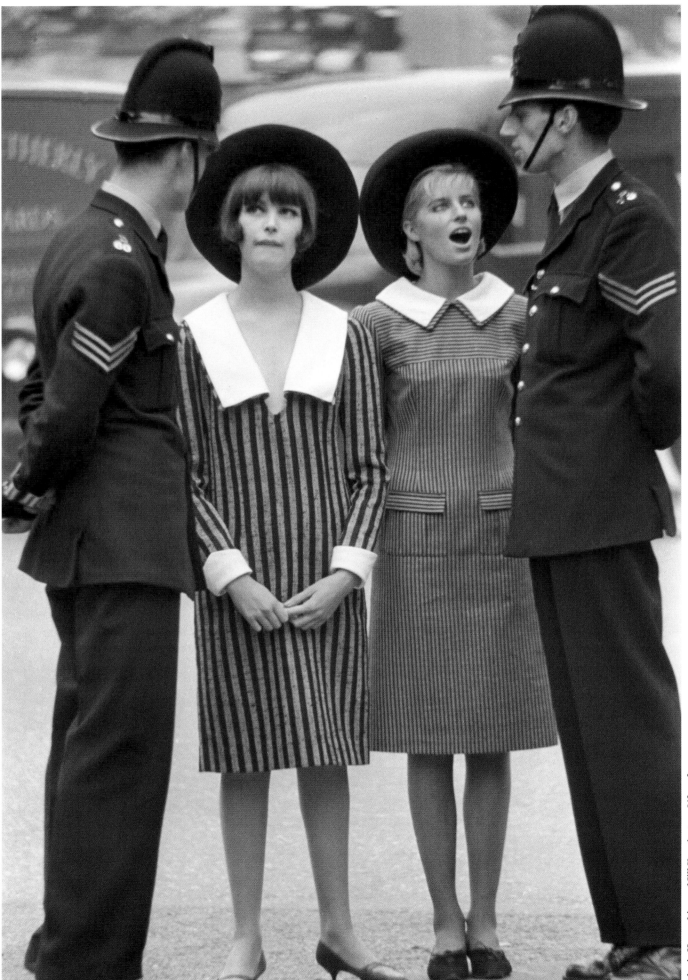

Melanie Hampshire and Jill Kennington, *Life*, 1963

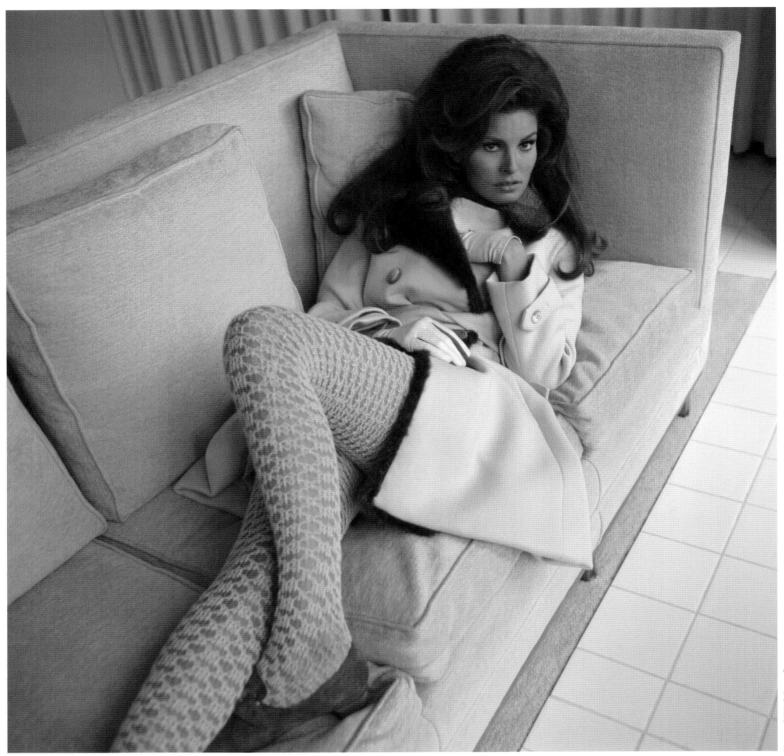

Raquel Welch, 1967

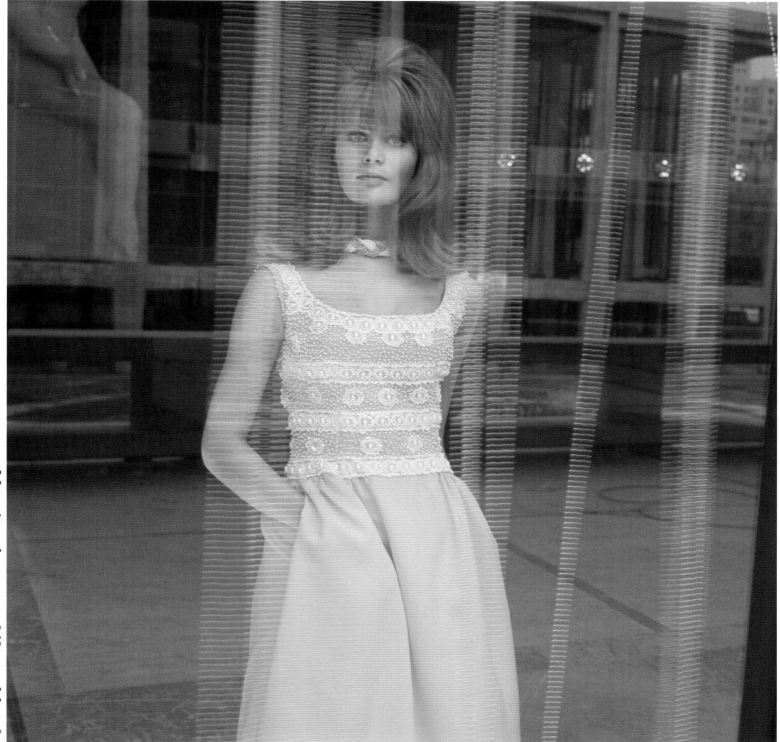

Vogue, c.1965 Following pages: **Melanie Hampshire, *Queen*, 1963**

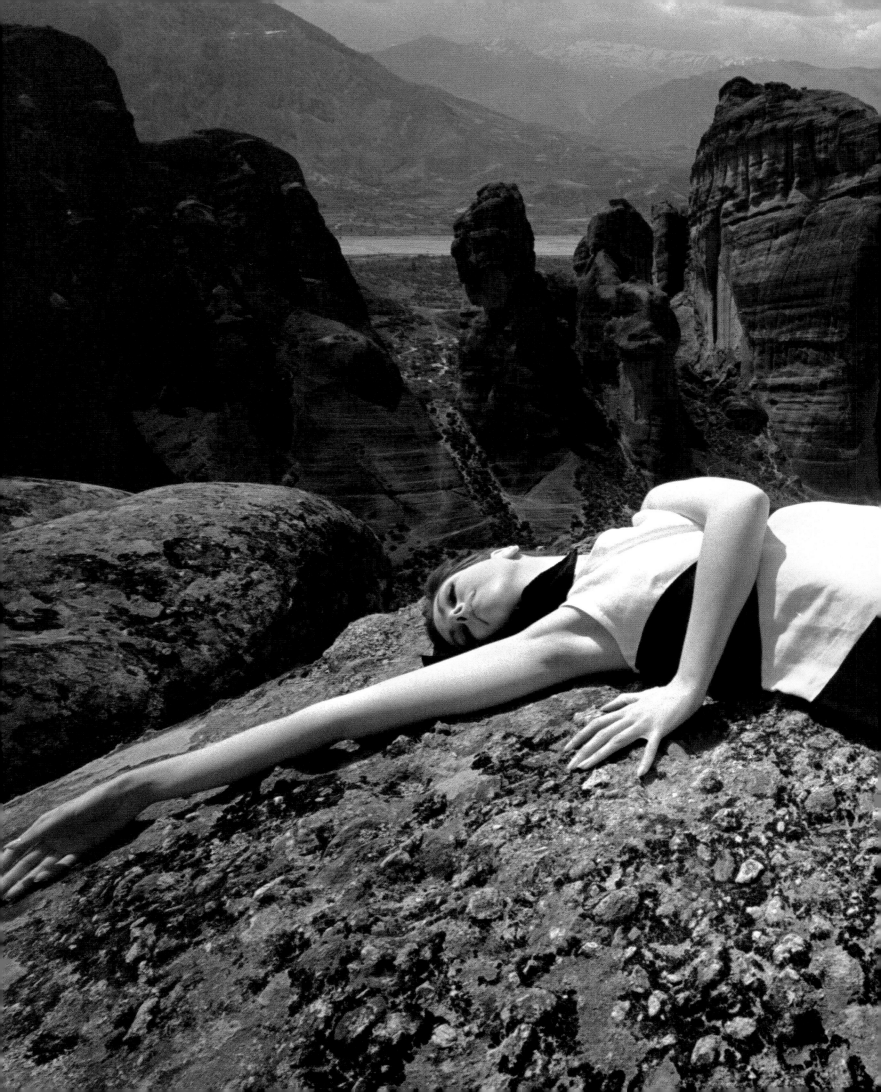

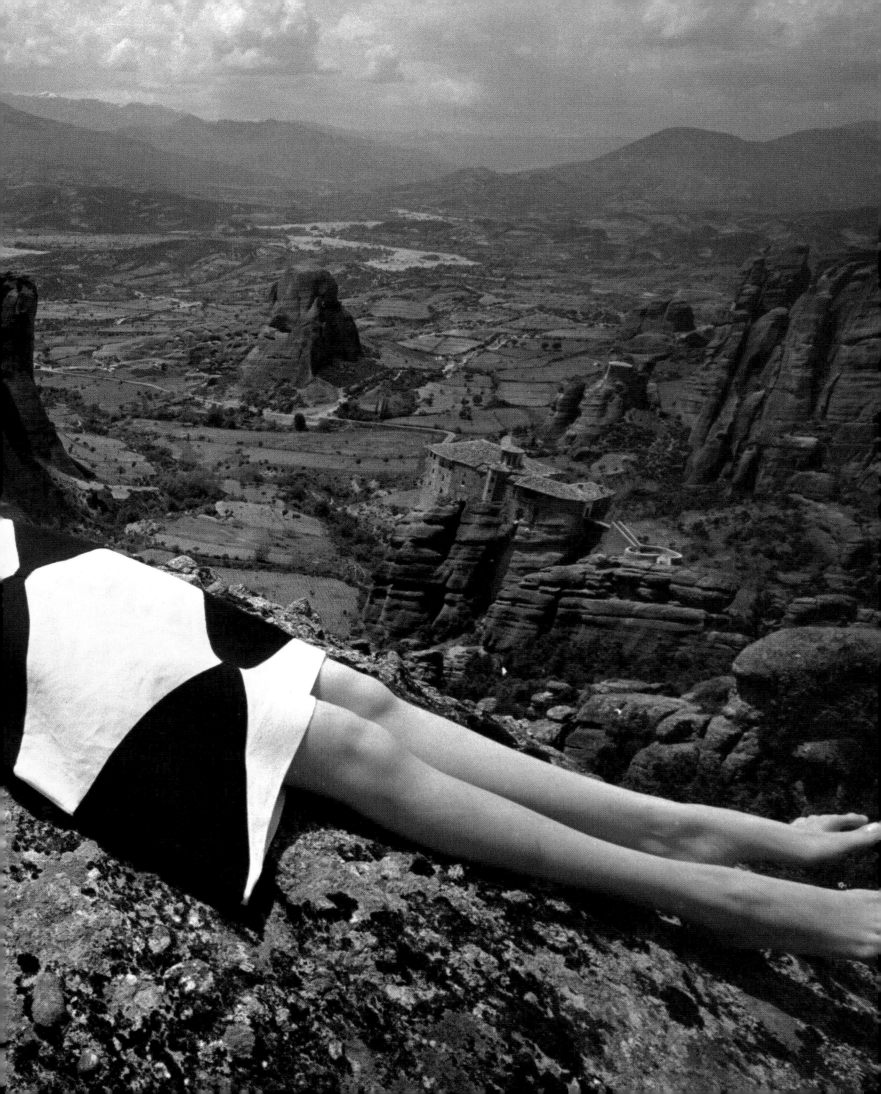

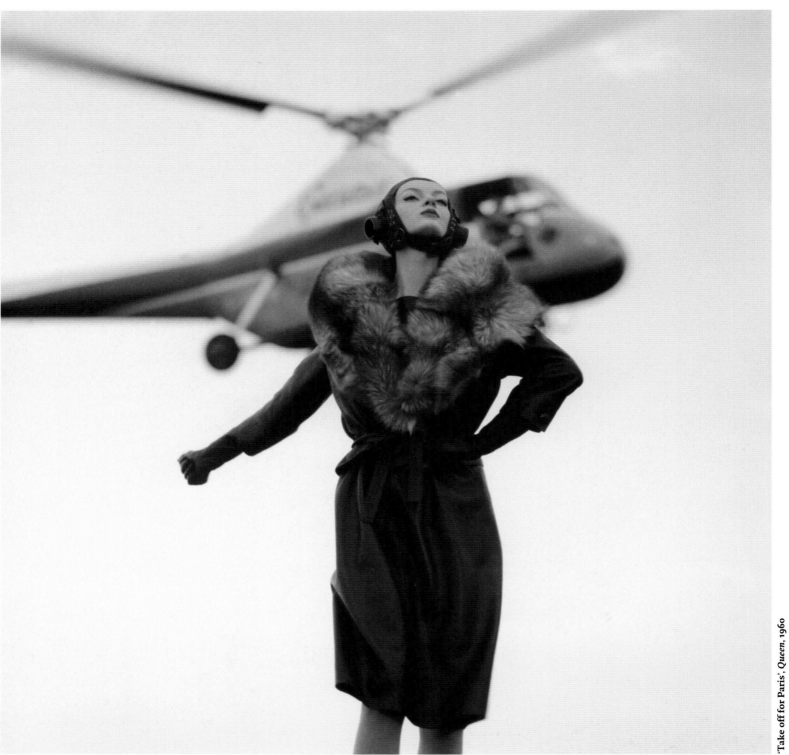

'Take off for Paris', *Queen*, 1960

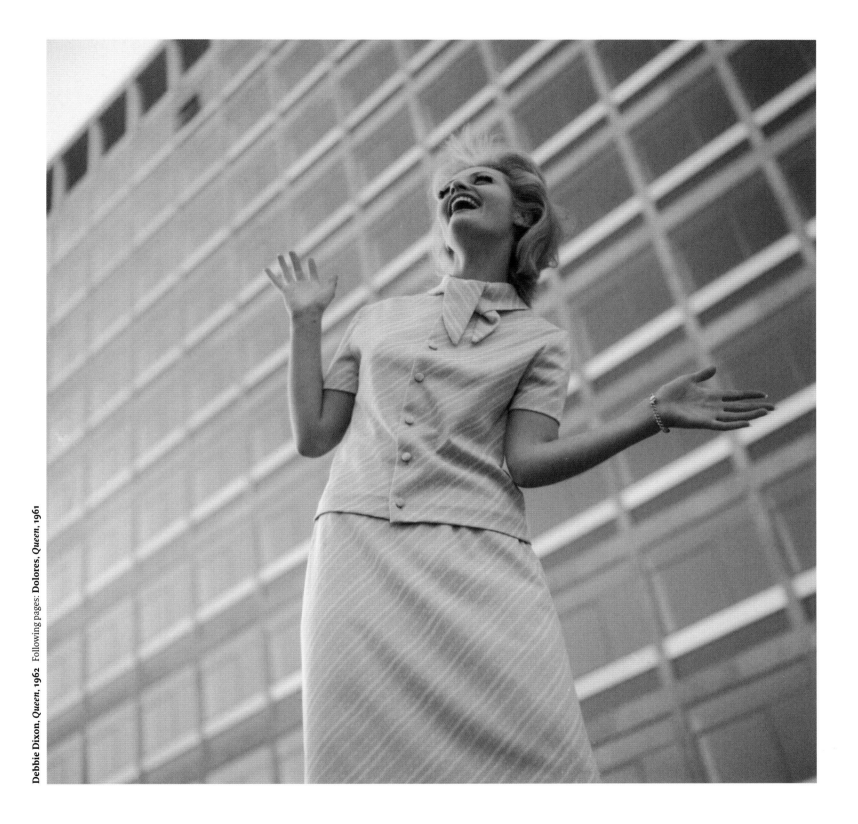

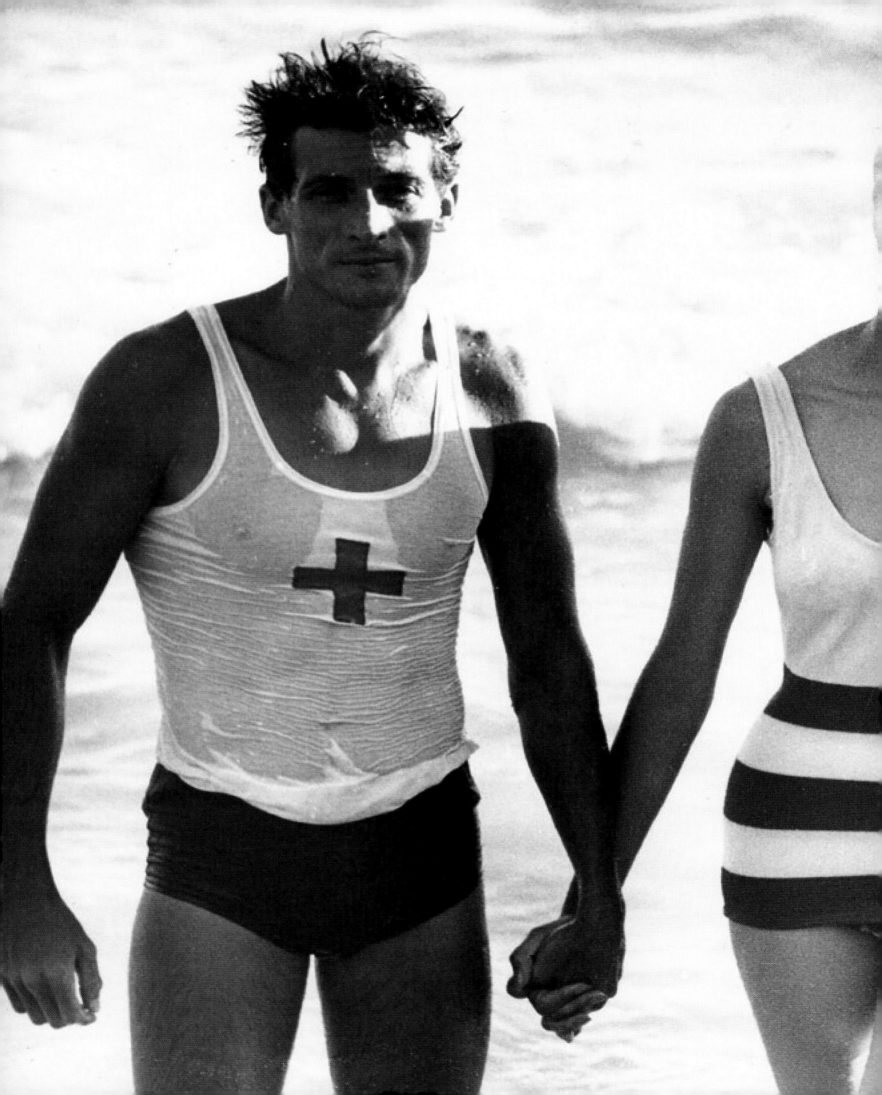

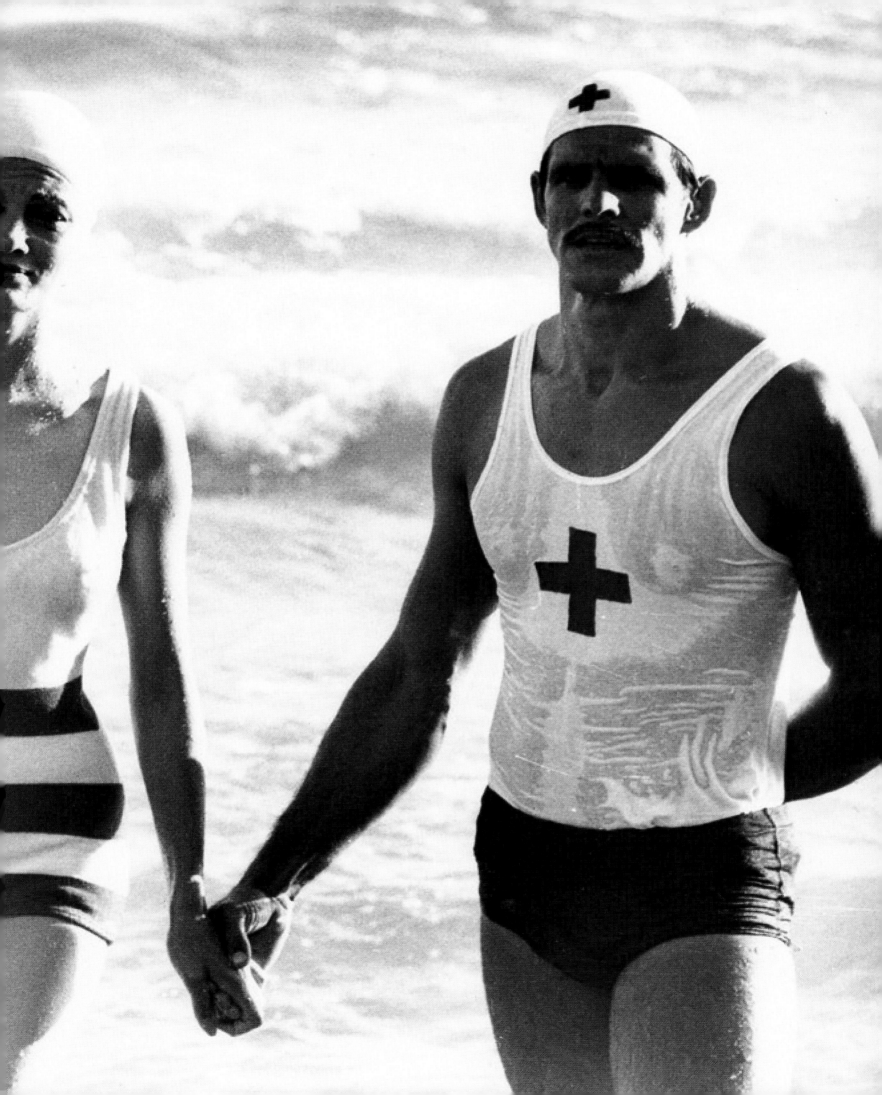

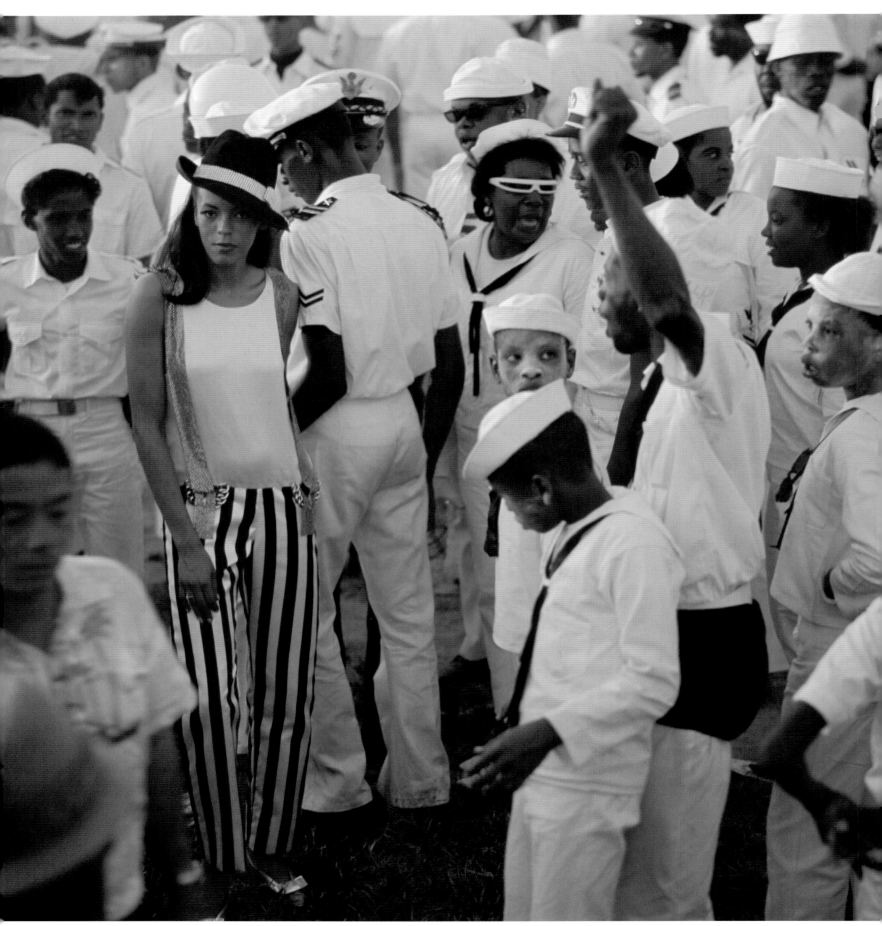

Life, 1966

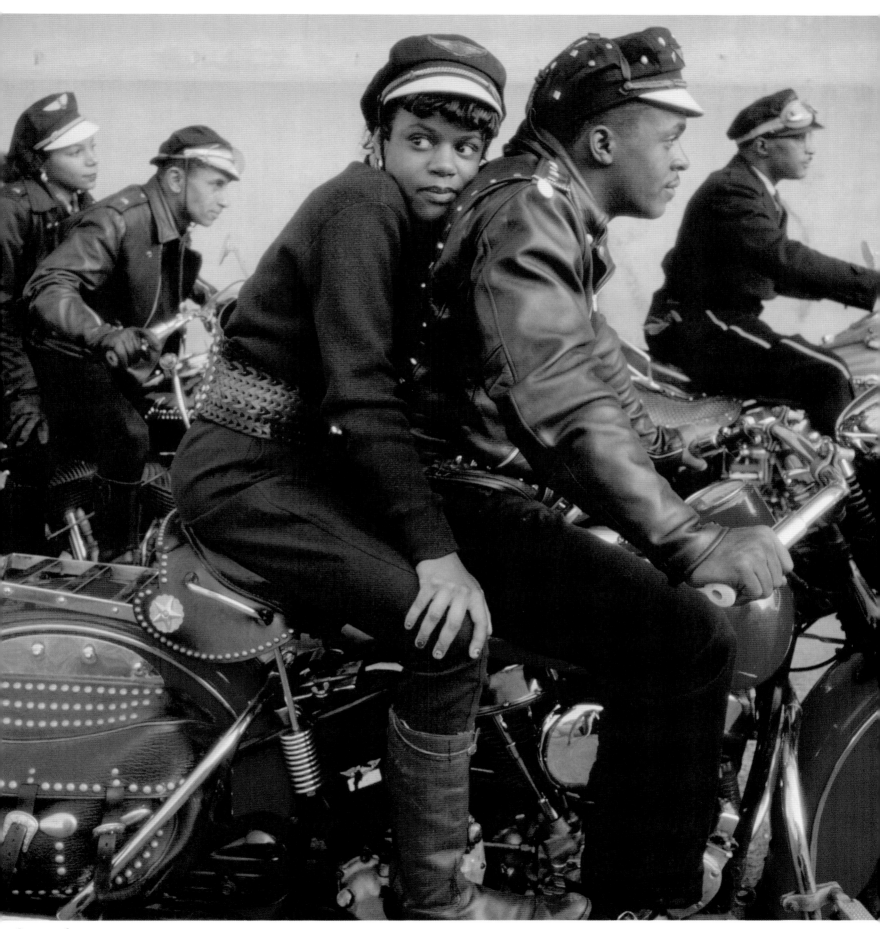

Queen, c.1960

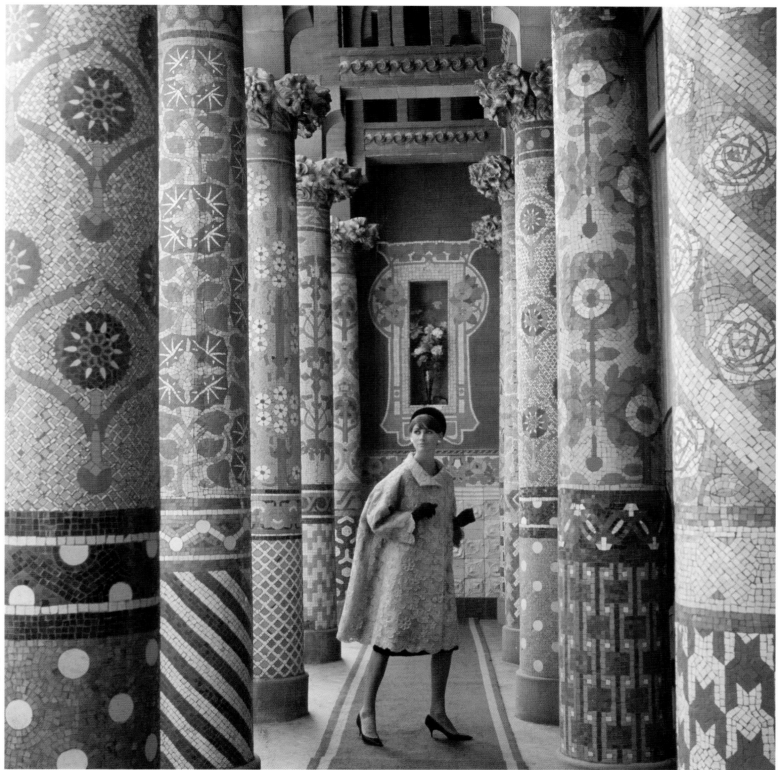

The Seventies

'Remember, Parks, there is nothing more unchic than a palm tree. Don't let me see one in your pictures.'
Diana Vreeland, c.1966

The 1970s found Parkinson working with colour film to a degree that had not seemed quite so apparent before – at least in terms of vibrancy, or, as more than one commentator has put it, 'stridency'. By 1975 and his historic *Vogue* trip to Russia, he was working almost exclusively in saturated colour, at least for fashion work. By contrast, the earlier part of the decade found him working with a markedly more restrained palette. Terence Pepper has observed that he could temper it to a surprising starkness. In relation to his photograph of Appollonia van Ravenstein on a Seychellois beach beckoning to a stray dog, he noted that 'the colours are all the more dramatic for being so few'. Similarly his fashion photographs of Jan Ward taken at Utah's Monument Valley makes restrained use of the dramatic landscape, the orange hues emphasizing the cinnamon of Jean Muir's dress.

Until the late 1970s, the European *Vogues* remained the primary showcase for Parkinson's increasingly spectacular photographs, though he was commissioned on several occasions by *Life* magazine, among others. Scrutiny of *Vogue*'s pages reveals a patent voyeuristic streak to many of the colour fashion pictures of his rivals, most notably of Guy Bourdin, whom he admired. Parkinson did not however employ Bourdin's motifs, which included discarded clothes and disembodied limbs, and the distortion of facial features with mirrors – there was also a degree of sexual sadism. Surprisingly, Cecil Beaton was also an enthusiast: 'his experiments have become more and more wild. Some editors consider his latest work beyond the pale, while others snatch greedily for his discarded ideas'. For all his exhortations to treat women with the reverence due the 'bloom' of their sex, Parkinson admitted, in relation to Bourdin's photographs, 'I long to have that madness but something stops me short'.

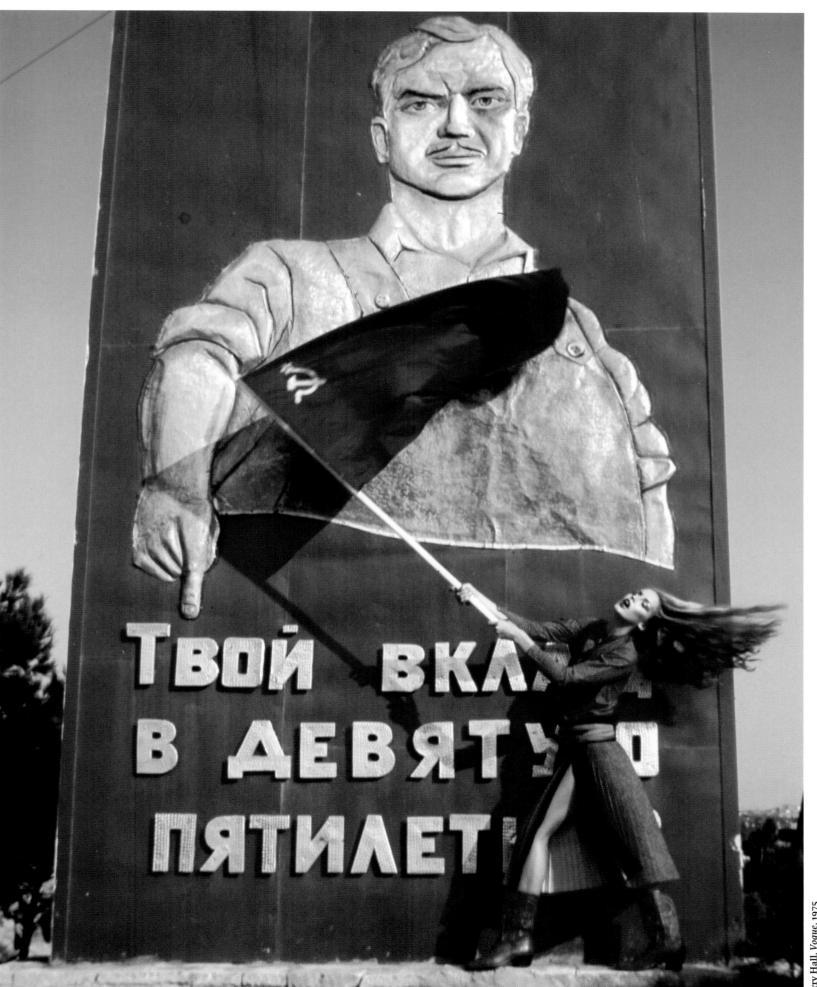

Equally disquieting were the sexually charged narratives of Bob Richardson and the confrontational tableaux of Helmut Newton, the latter he acknowledged in *Lifework* as 'brilliantly portraying some of the world's most beautiful women naked'.

As Parkinson's foreign expeditions became more extravagant, they necessitated much pre-production. As early as 1938 Parkinson was noted for his strong sense of theatre and an ambition, which knew, even then, few limits. Having taken a photograph of two girls on top of a fairground ride in Brighton, the caption writer of *The Bystander* suggested the epithet Norman 'Daredevil' Parkinson. In the 1960s at *Queen* magazine no request seemed too outlandish, no wild notion unachievable and this repeated itself in the decades to follow.

One of the key photographs of Parkinson's later career is the often-reproduced image of Appollonia van Ravenstein standing precariously on top of a column in a swimming pool at Crane Beach in Barbados. Appollonia, Parkinson considered, 'gave me two or three of the best ten photographs I will ever take'. Apart from that one, he also listed, from the same shoot, Appollonia with her head wrapped in a polka-dot headscarf, a wide-brimmed sunhat and a giant pair of sunglasses all but obscuring her face. Another was an earlier fashion shoot on a beach, which, in addition to Appollonia, included a stray dog. He called it 'Dog Friday'. The scenario that unfolded in front of his gaze explains the part played by chance in a classic fashion picture or as Parkinson always claimed it 'the magic of photography'. As the dog appeared as if from nowhere, Parkinson watched the scenario unfold on the ground glass of his camera: 'At the climactic moment, when the composition was impeccable, the divine handler who maintains that overcrowded kennel in the sky decided

that a flea, dormant till this second, should awaken and bite the animal under the tail ... the dog turned to remove the nuisance. Click. "Hold it". Click "Hold it". Click. There was time for only three exposures before he turned and disappeared. I do not exaggerate when I say those three clicks sent electric shocks up my arm. All of us recognised that by some mysterious intervention we had taken a picture that could never be taken again.'

Appollonia recalled their sittings together for a *Vogue* tribute to Parkinson in 1990, 'Parks always liked me to do very dangerous things. He had me on rafts, climbing rocks, riding giant sea-turtles, driving bulls in a bullock-cart, and water-skiing, when I didn't know how'.

But dominating Parkinson's photography in the 1970s and guaranteeing him newspaper coverage with every sitting organised was his royal portraiture. He had photographed the Duke of Edinburgh in Tobago in 1966, an informal sitting that was filmed by the Queen. Two years later he was asked to take the official photographs of Prince Charles to mark his investiture as the Prince of Wales. With a degree of modesty, Parkinson surmised that he was asked simply because the Earl of Snowdon, his perennial rival at *Vogue*, was too actively involved in the staging of the day. The results were considered a great success and in the same year he took the official photographs for the nineteenth birthday of Charles's sister Princess Anne. With this set, which included the Princess riding 'High Jinks', *Vogue* noted that she 'has a flippancy and an elastic expression that makes her the most animated of the family group'. Parkinson's session and subsequent ones (he took the official photographs for her twenty-first birthday two years later) were striking for the degree of informality Parkinson brought – and was allowed

to bring – to the sittings. By the time he was appointed the official photographer to Princess Anne's wedding to Captain Mark Phillips in 1973, he had supplanted Cecil Beaton as their photographer of choice. Beaton's stroke the following year undoubtedly cemented Parkinson's status. He took the seventy-fifth and eightieth birthday portraits of the Queen Mother (Beaton had lobbied for the latter, but died before he received any response). Parkinson, ever sensitive to the nuances of social change as much as shifts in fashion, realised that with Beaton's demise a new age of informality was sought for a new democratic era.

These successes notwithstanding – and they brought Parkinson firmly into the public consciousness – he maintained a degree of weariness with the world he had now been a vital part of for forty years. 'Photography today is not all that exciting', he told one interviewer, 'fashion has dragged it back to where it was in my early days. Photography has become very mannered, you know, a brick wall and shadows playing across it; the whole thing set in a certain light.'

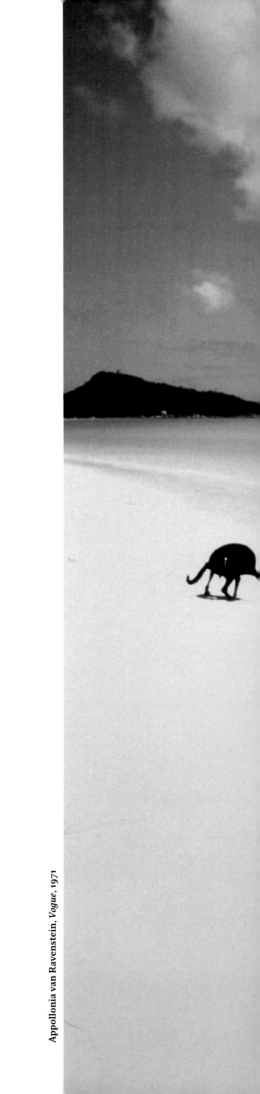

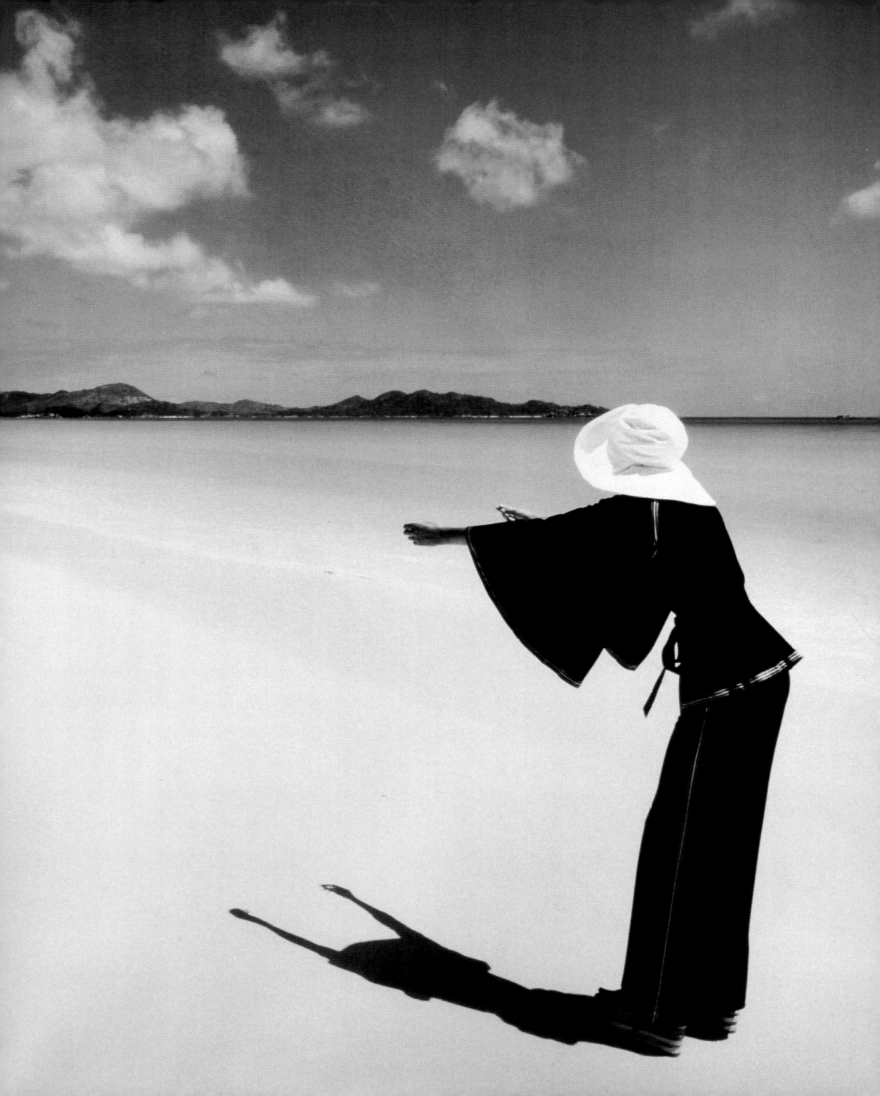

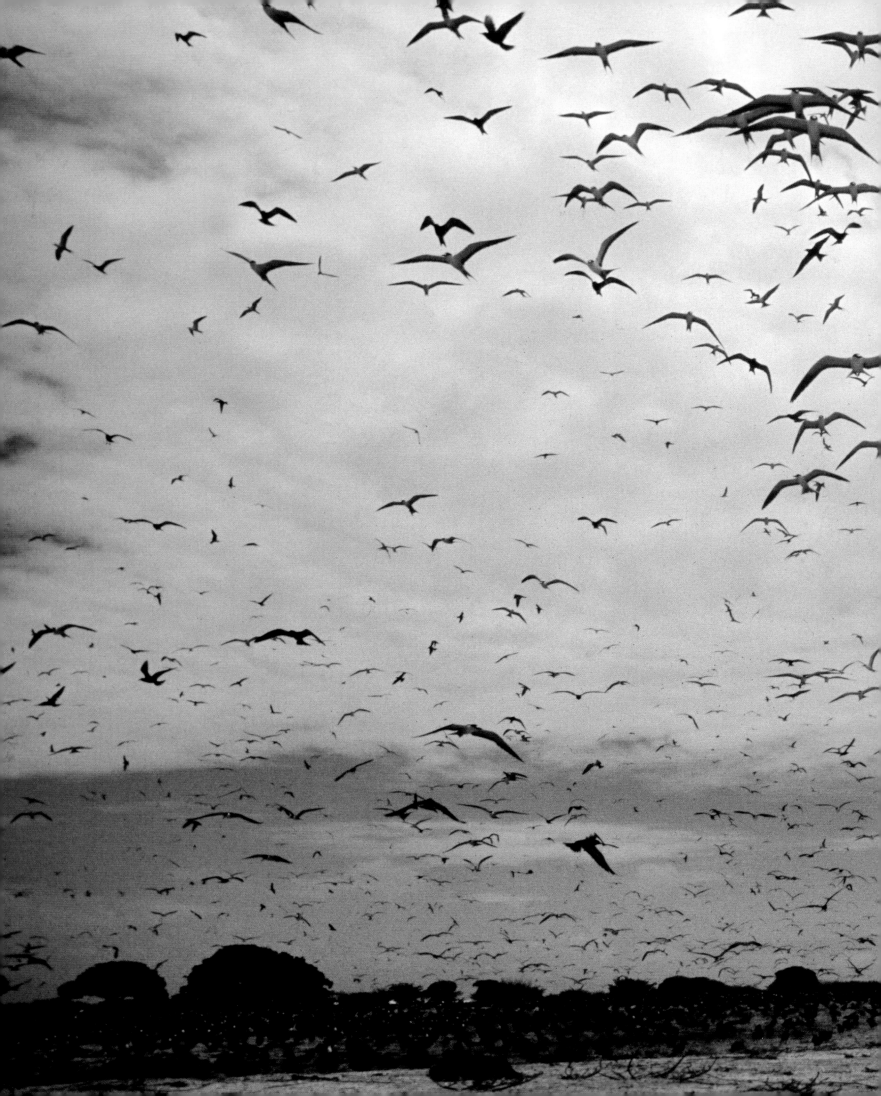

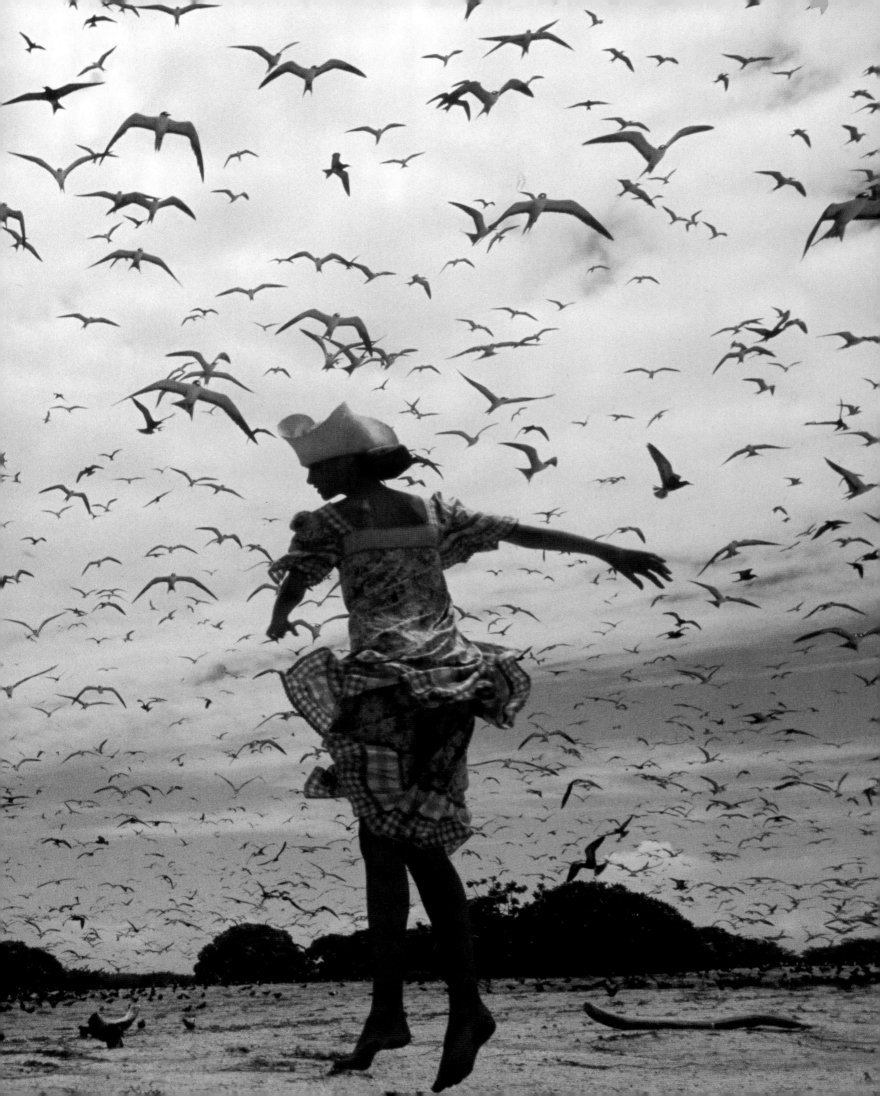

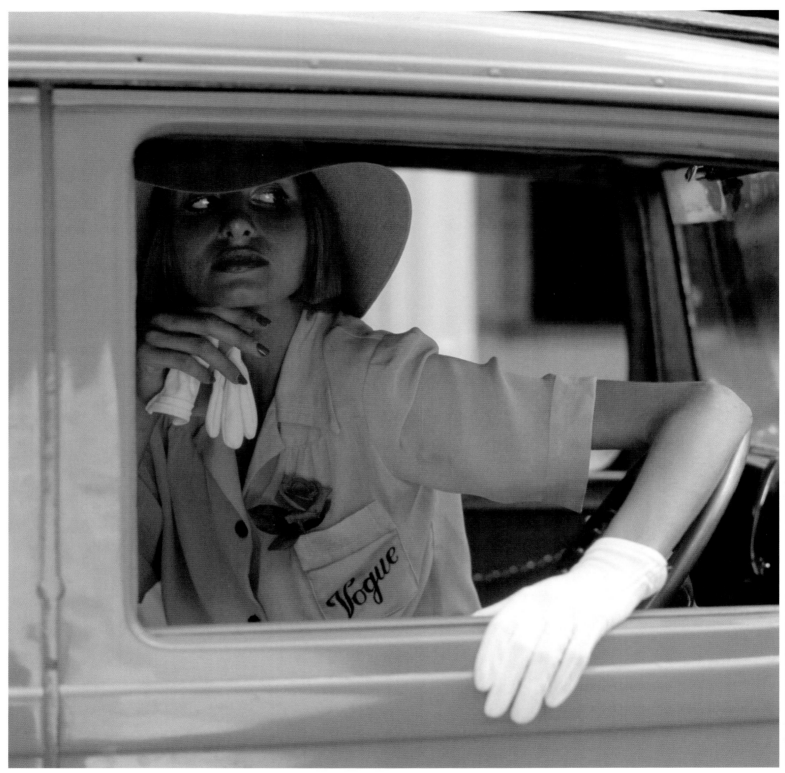

Appollonia van Ravenstein, *Vogue,* **1974** Previous pages: **Appollonia van Ravenstein,** *Vogue,* **1971**

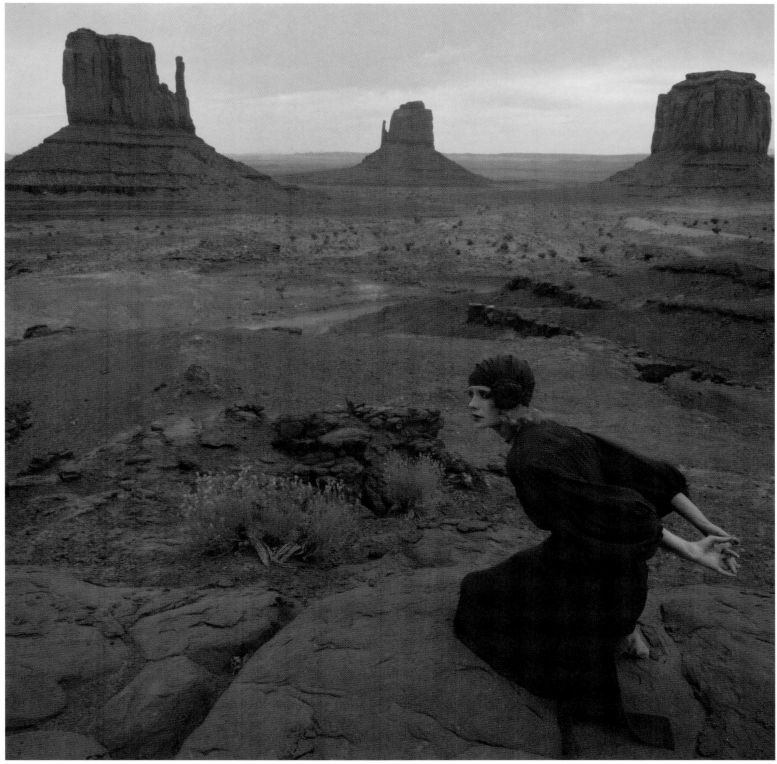

Jan Ward, *Vogue,* 1970

Appollonia van Ravenstein, *Vogue*, 1973

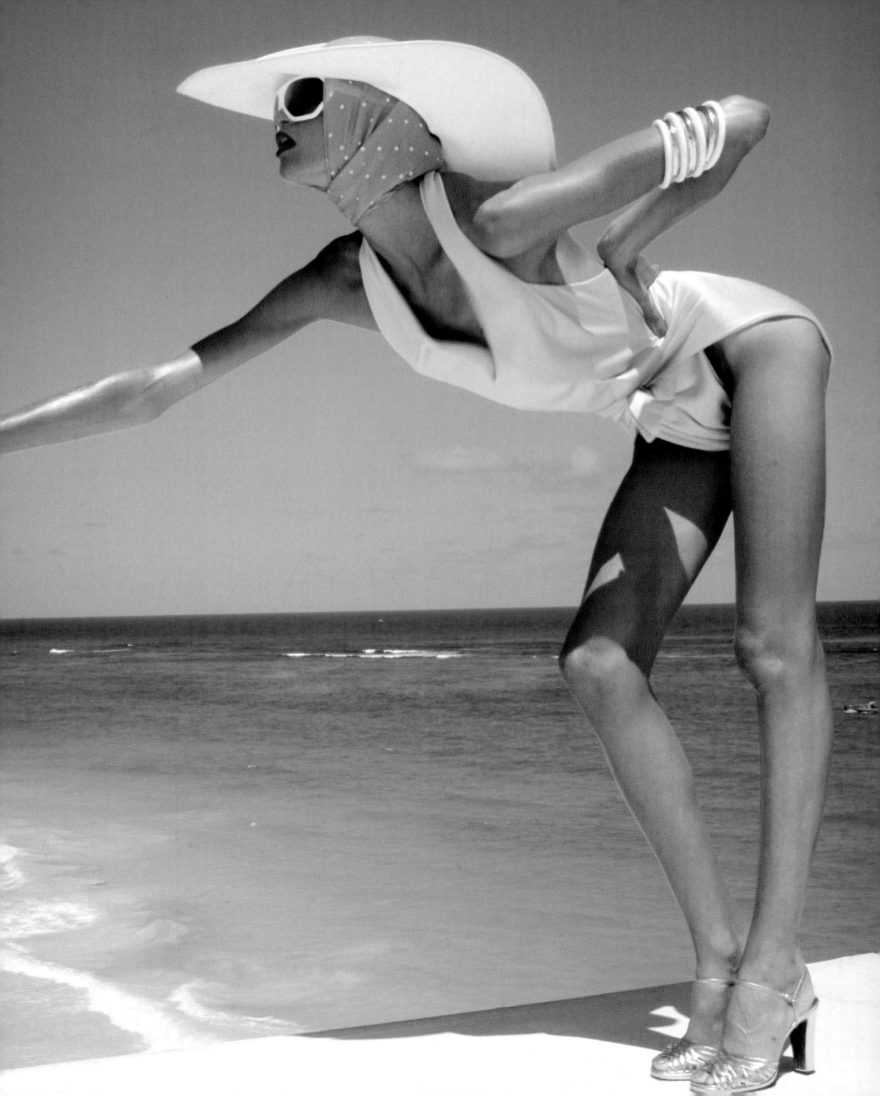

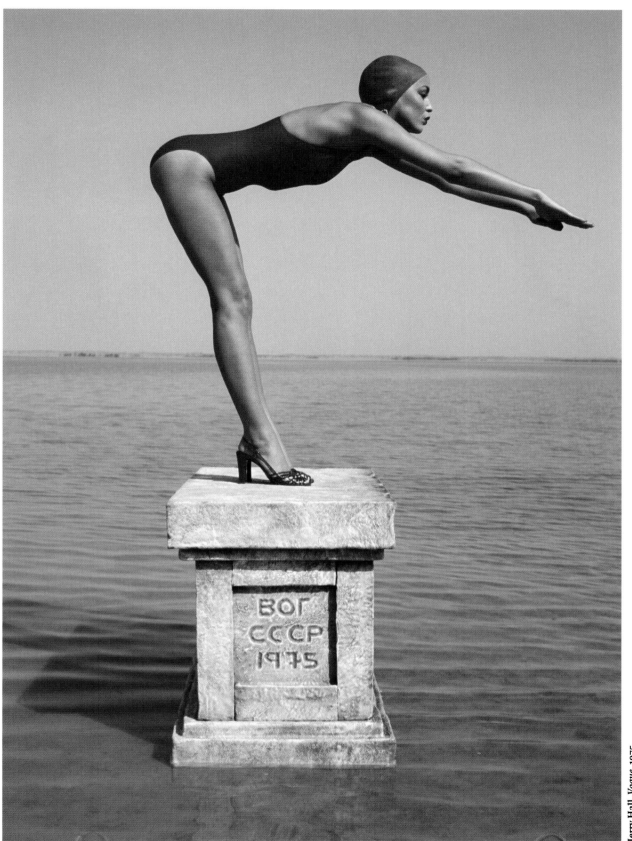

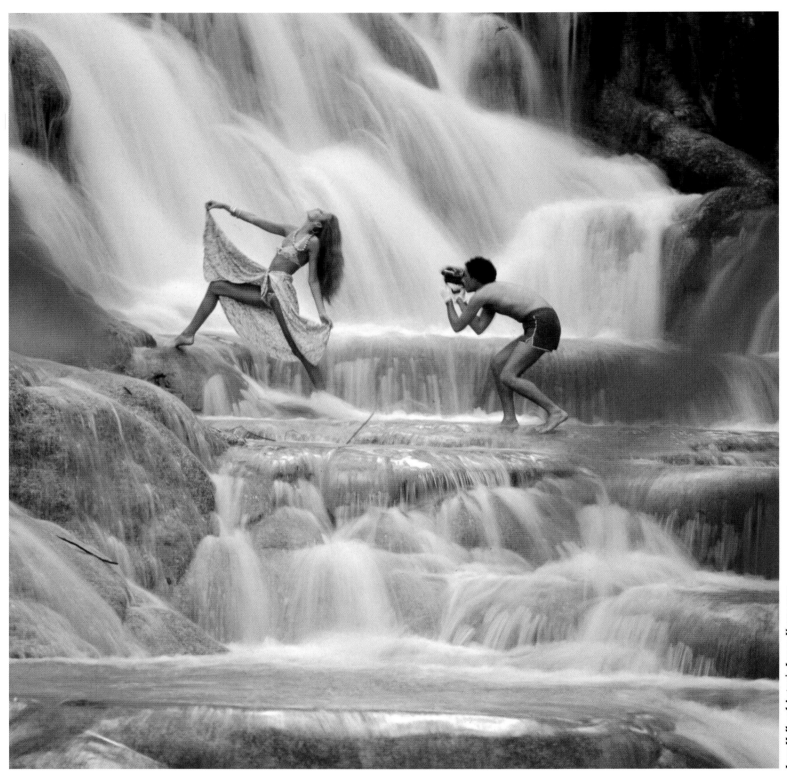

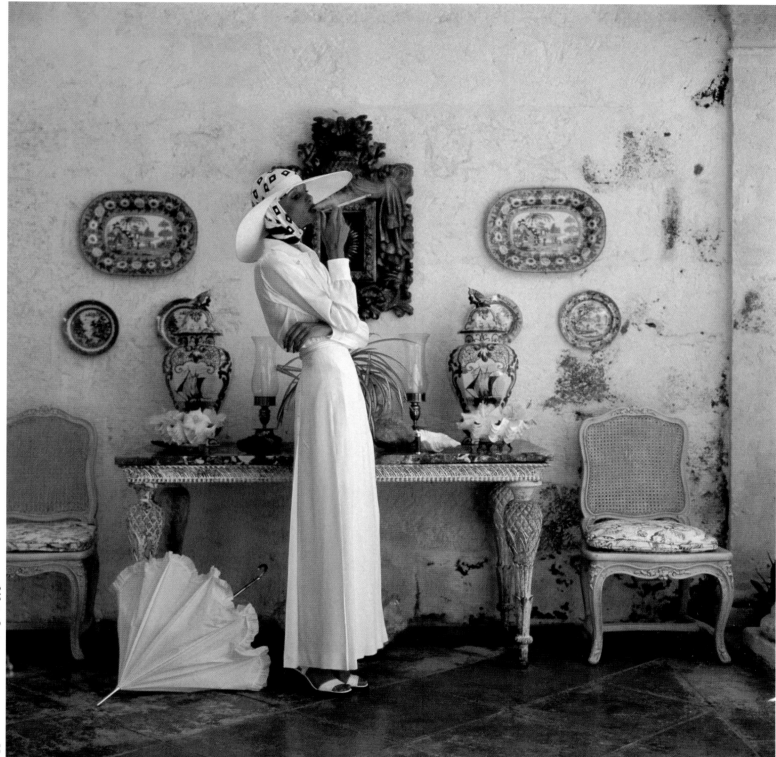

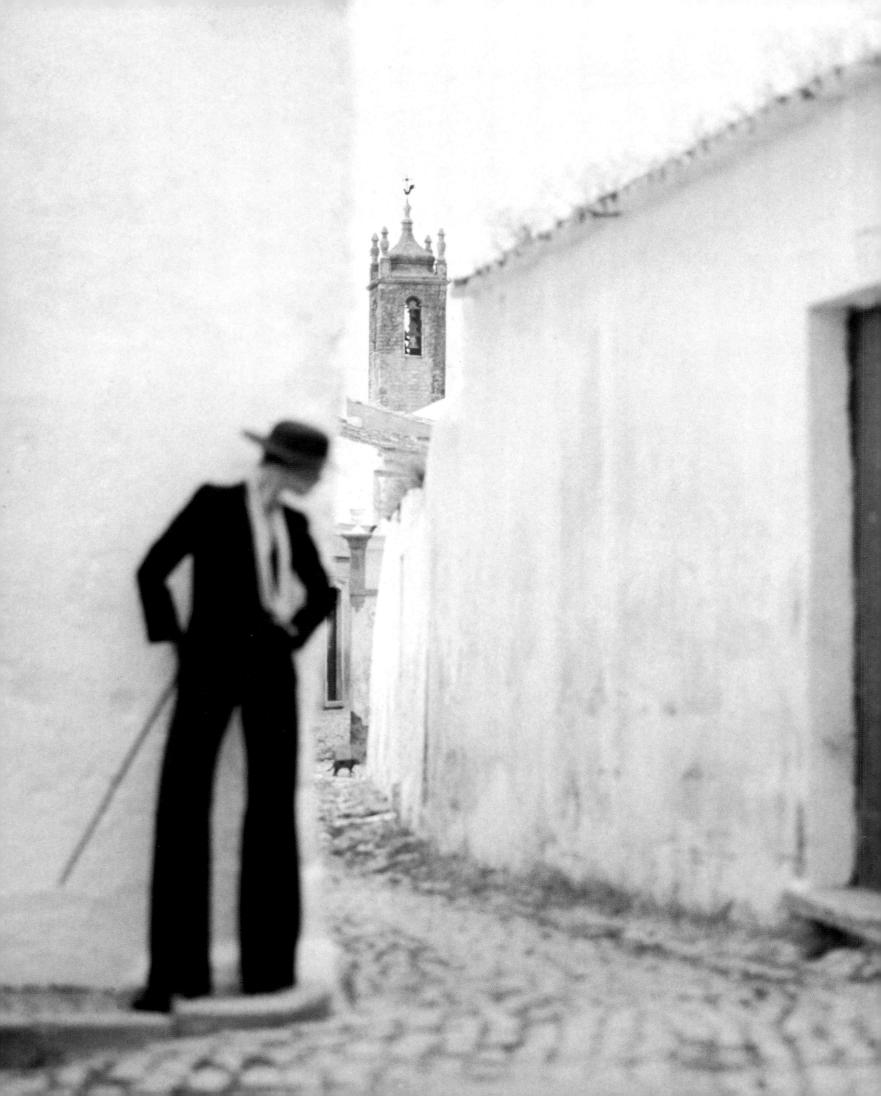

Mouche, *Vogue,* **1973** Following pages: **'Paris in London',** *Vogue,* **1974**

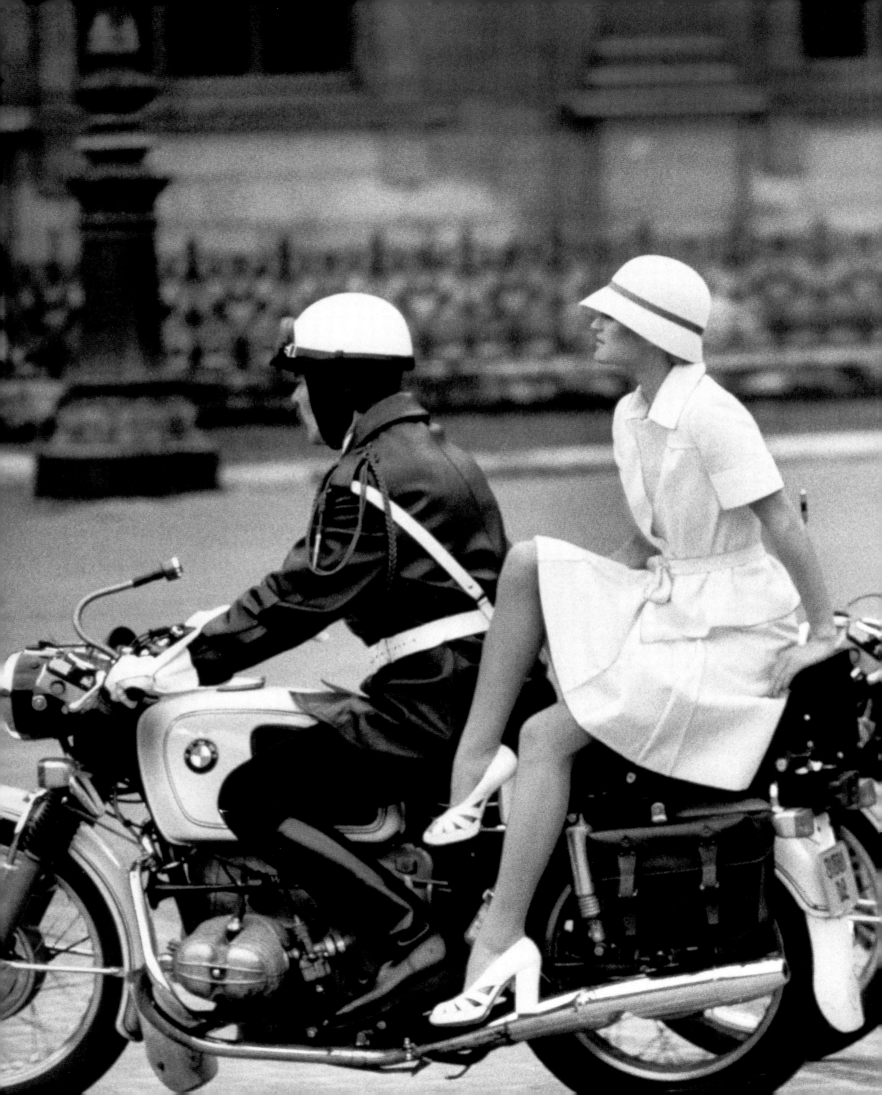

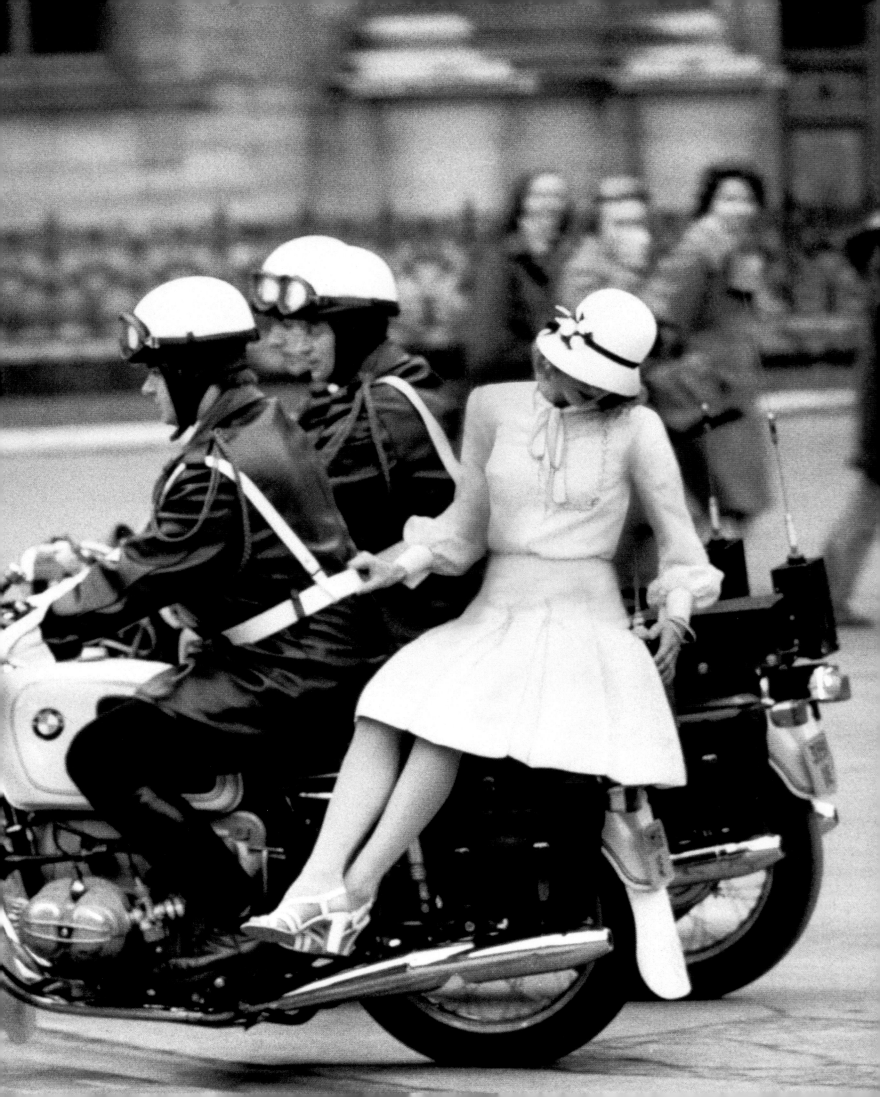

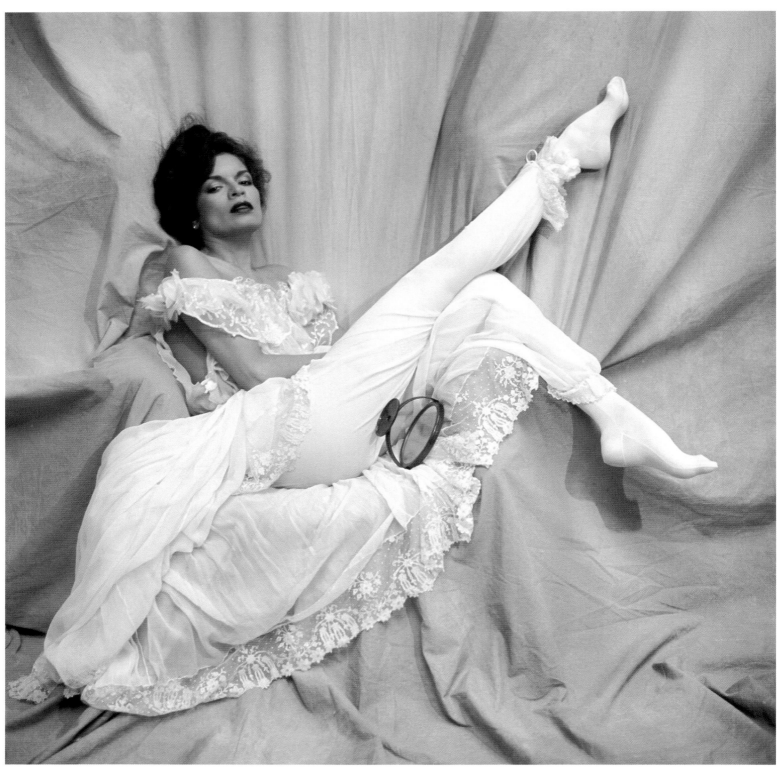

Bianca Jagger, 1976

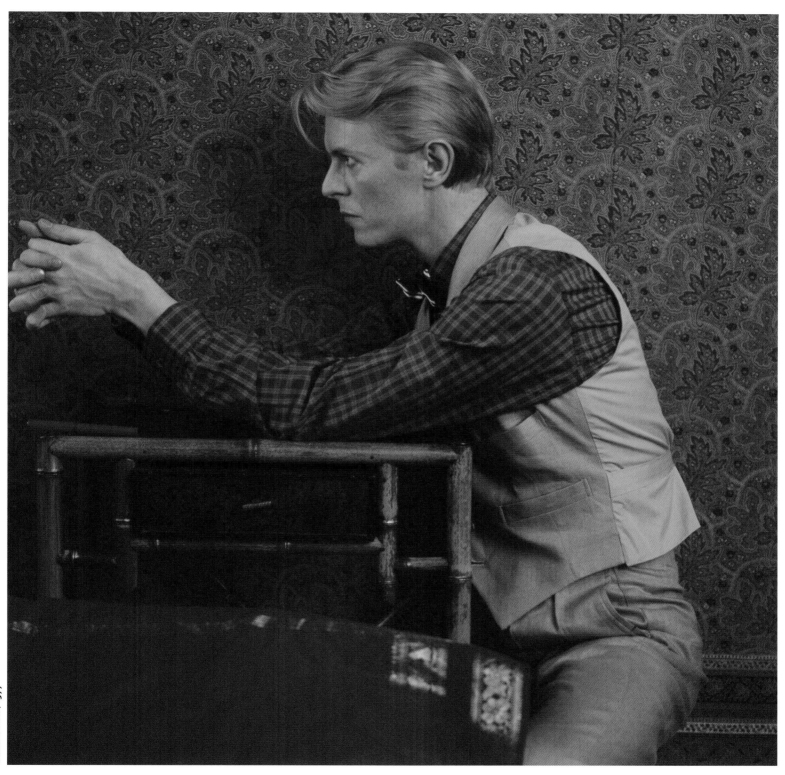

David Bowie, 1977

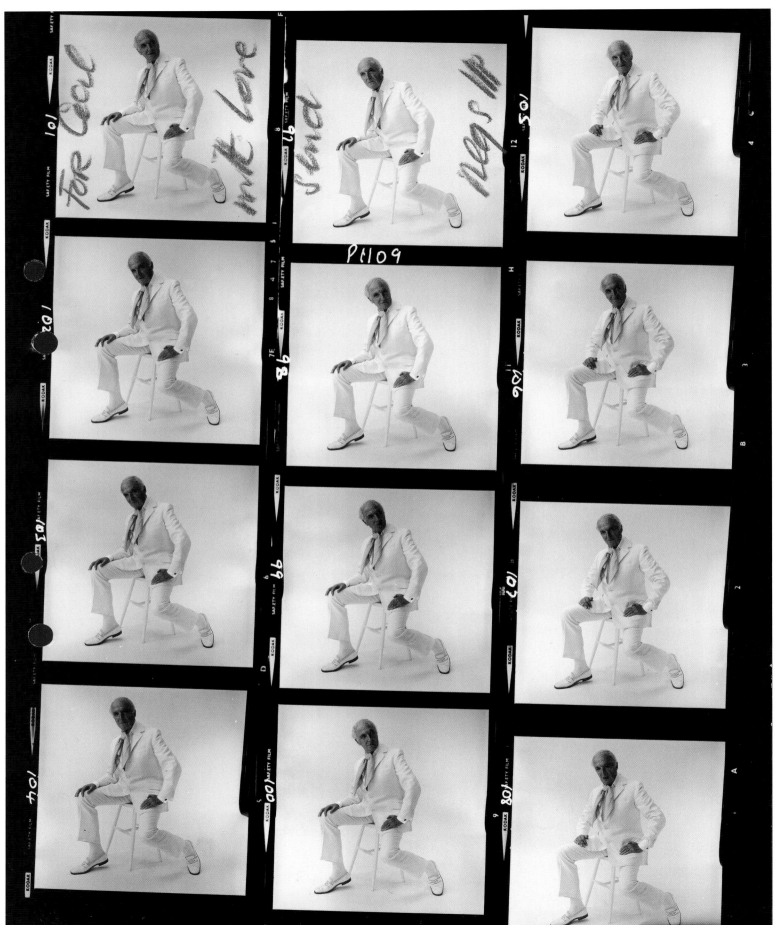

Cecil Beaton, 1972

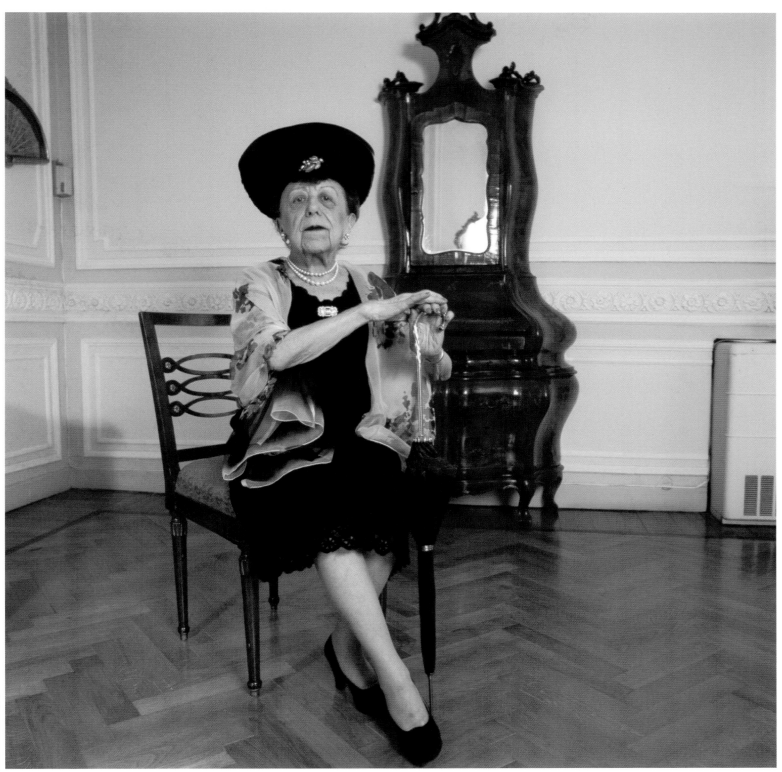

Mrs Boehm, 1979

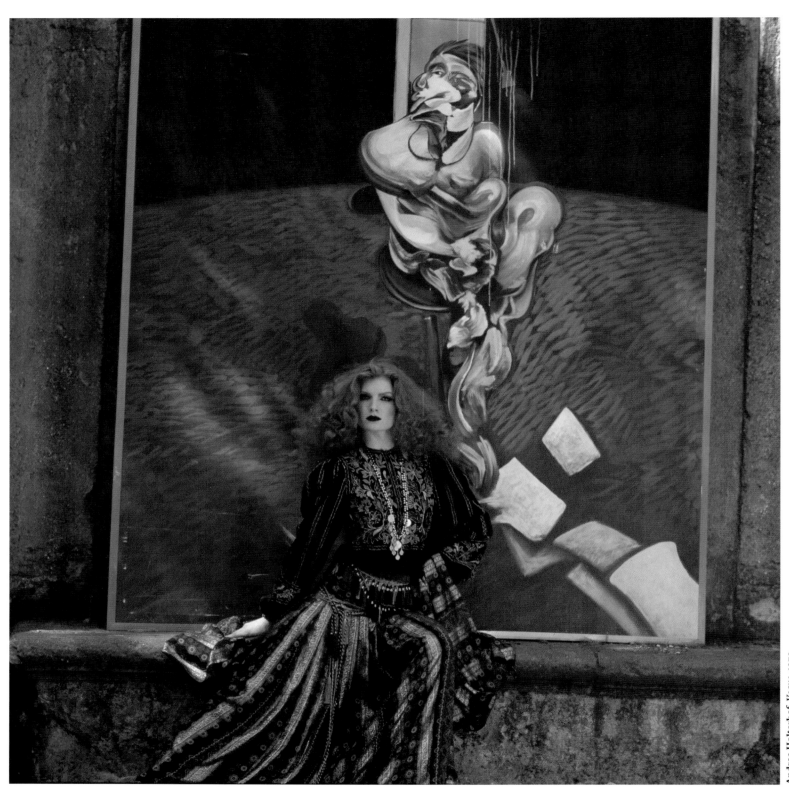

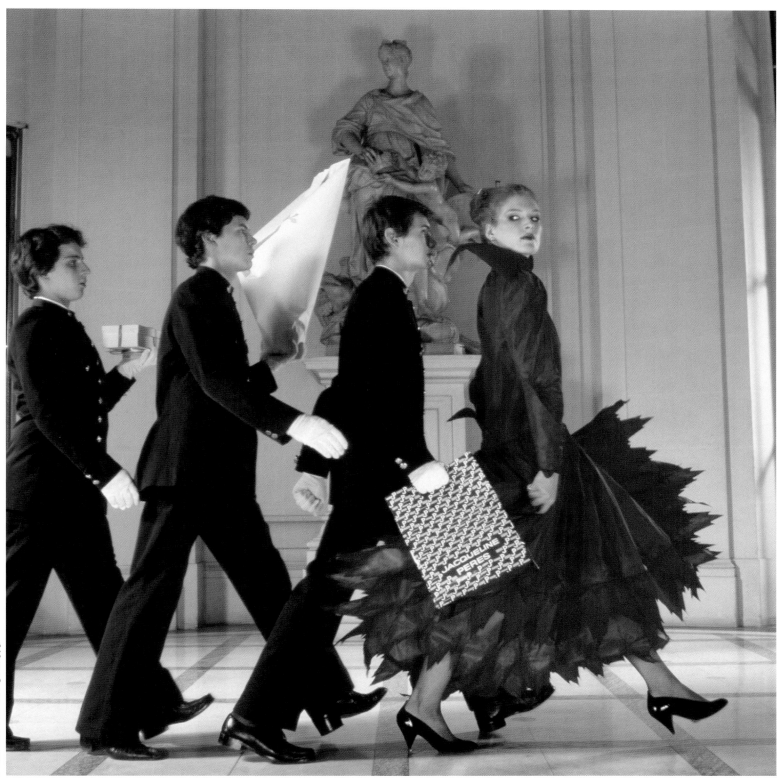

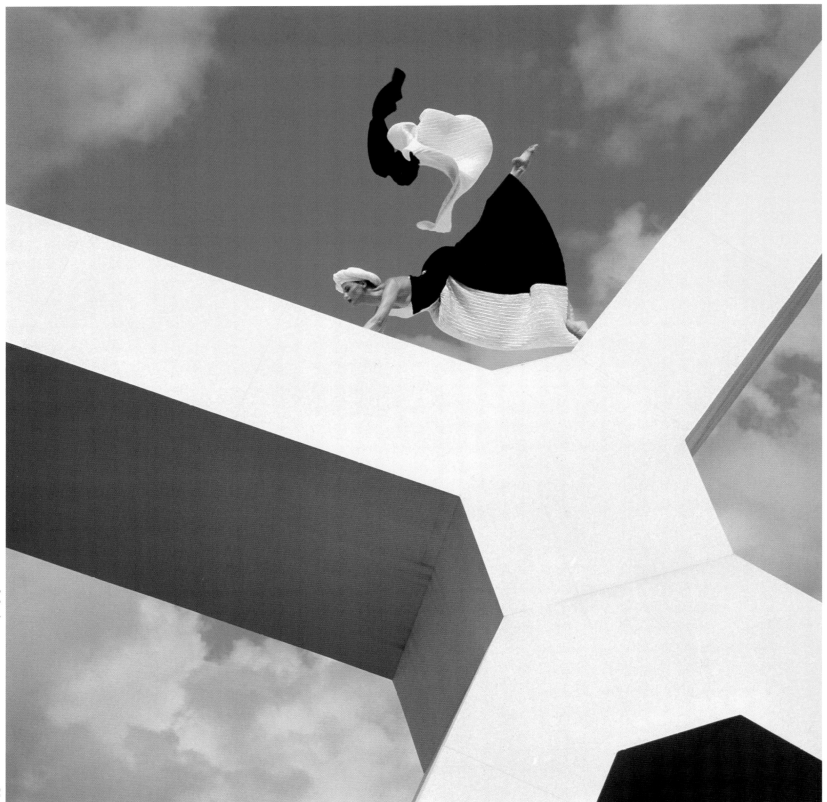

The Eighties

'I love to travel.
I love beautiful women.
I love sunshine – sunshine is my new religion.'
Norman Parkinson, 1982

'If you are going to be an artist
– even a photographer –
I think you have to major in fantasy.'
Norman Parkinson, 1989

In 1978, after his legal wrangling with *Vogue* led to the termination of his contract, Parkinson was a free agent. The furore had cast a pall over the final years of the decade and there was regret on both sides. As *Vogue*'s then managing director, Bernard Leser, wrote to Parkinson: 'The years of working together stretch over too long a period and the relationship and friendship built up over this time are too meaningful to us all to cast aside so lightly, or, for that matter, at all.' Parkinson himself found the 'severing blow heavy'. During 1981 the situation resolved itself in Parkinson's favour. He won back the copyright to his *Vogue* photographs, a victory prompted by Tina Brown, the new editor of the recently re-launched Condé Nast magazine *Vanity Fair*, who saw Parkinson's exuberant and theatrical photographs as an apposite reflection of the new decade and sought to hire him for her magazine. His price was the return of his thirty-five years worth of prints, transparencies and negatives. This allowed the creation of the Norman Parkinson Archive, which continues to disseminate his images today. But Parkinson produced little work for *Vanity Fair*. Though he continued to work sporadically during 1978 for the Italian and French editions of *Vogue*, his years with the Condé Nast publications were at an end.

During the 1980s, Parkinson was fêted in America as an intriguing exotic, a fixture of diary pages and society columns: he was *Town & Country*'s 'Man with the Elegant Eye' and 'A World Celebrity'; the *Chicago Tribune*'s 'Celebrity of the Day' with a 'Snappy Smile'; for *People* magazine 'the Royal Shutterbug'. In 1983 *Interview* magazine reported the transcript of a meeting between the celebrated portrait photographer and the magazine's proprietor Andy Warhol. Parkinson floundered in a conversation that turned out to

be highly insubstantial, as accurate a reflection as any of a certain period in popular cultural history:

Andy Warhol: 'Norman, you a have a great shirt ...'

Parkinson: 'I got this in Teheran about a year ago in the market'

Warhol: 'You were in Iran?'

Parkinson: 'Yes'

Warhol: 'We almost went there too ...'

More significant was a substantial profile the following year in the *New Yorker* by Kennedy Fraser. She recounted in vivid terms the world in which Parkinson now found himself in the mid 1980s – celebrity-fuelled Manhattan – as fashionable a figure as those he now almost solely photographed. 'Parkinson's seventieth birthday came round', she wrote, 'in the fashionable hired rooms, photograph people bowed, squeaked, kissed the air at other photograph people or sometimes cut them dead ...'. Though Parkinson referred directly to the house fire that destroyed his home, not for nothing did he sound bewildered when he said, 'I feel my identity has blown away in smoke'.

Many of the bystanders, who crowd in the pages of the *New Yorker* profile – Bianca Jagger, Calvin Klein, Ann Getty, Mrs Leona Helmsley, Nancy Reagan – had been photographed by Parkinson for *Town & Country*. He had first forged an association with the magazine in 1978 (though approaches had been made to him as early as 1976). Frank Zachary, its editor-in-chief, was warmly appreciative of his 'find'. 'If indeed', he wrote in 1987, 'as some have been kind enough to say, that *Town & Country* has never appeared better, it is no small measure to his presence in its pages ... He is handsomer than ever and his pictures have never appeared more sparkling and vivacious'. Parkinson recognised what was demanded for the Zeitgeist: 'People now they want style, they need romance, they need beautiful women to be in beautiful and provocative surroundings', and his assignments for *Town & Country* greatly fulfilled these expectations. It was 'a good moment', he also added, 'for a return to style'. *Town & Country* was unashamed of its brash promotion of money, style and taste, which had marked out for it a singular niche since 1846. 'Wealth in America', its biographer Kathleen Madden explained, 'has been characterized and qualified, as simply this: "what a bunch of extraordinarily privileged people manage to do with their abundant blessings"'. It was unashamedly the type of magazine 'that has always offered up only those interiors that are splashily, happily unreal. A dance floor that disappeared at the press of a button always carried a certain cachet too ...'.

Parkinson's book, *Sisters Under the Skin* appeared in 1978

and achieved a measure of notoriety matched by that of his final book, *Would You Let Your Daughter?* A portrait of identical twins Amy and Anne McCandless in a naked embrace was used as the jacket image for the former and was calculated to provoke 'the miserable attitude of Mrs Whitehouse' [a campaigner for wholesome family values]. However its impact was superseded by the complaints to the press of subterfuge, by the irate uncle, from one of England's grander families, of a sitter who had appeared naked reading a mocked-up jacket of the finished book, alongside the caption 'Parks, I would like to be in this book'. Parkinson, more aware than ever before of the merits of publicity, good or ill, fanned the flames. His third and final book *Would You Let Your Daughter?* (1985) was billed as a 'unique blend of art, sexuality and drama'. A compilation of photographs created out of my 'fifty year love of, and respect for, women' (featuring some of his photographs for the 1985 Pirelli calendar), the book received a lukewarm response and was noted mainly for the conspicuousness of its art direction. Once again Parkinson was walking the jagged edge between good and bad taste, his amiable maxims, hijacked from popular quotations – 'An intelligent woman is a woman whom one can be as stupid as one wants' and 'My will is strong but won't is weak' – did not endear him to certain reviewers. Calling him 'a lecherous photographer' and his celebrity photographs 'simply silly', one such reviewer castigated Parkinson's American publisher (whose new owner was featured in it) for its 'atrocious price' and for 'bothering to publish such drivel'.

Between the two provocative titles, in 1983, Parkinson published *Lifework*, his photobiography, which reunited him with his former *Queen* art director, Mark Boxer and presented his achievements to a greater audience than that of fashion magazines. For his contribution to just such publications the American Society of Magazine Photographers gave him its Lifetime Achievement Award in 1982.

Kennedy Fraser, Parkinson's most discerning critic in these years offered this coda: that it was tempting to see Parkinson's relentless flattery 'as veiled contempt. It is as if he embraced his starry-eyed subjects and slowly hugged them to a high-camp, Technicolor death'.

Parkinson died in a Singapore hospital on 14 February 1990, having just completed an assignment for *Town & Country*. It appeared posthumously as 'The Mermaid's Tale'. He had hoped that the 'colourful eggs' that he had hatched over the years with *Town & Country*'s editor Frank Zachary, his measure in vitality and charisma, would be 'remembered well after we are both forgotten'.

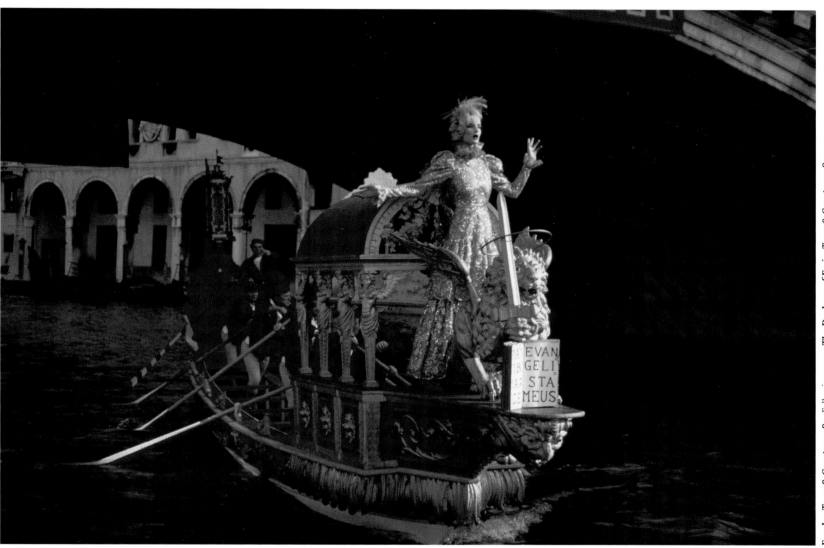

Town & Country, 1984 Following pages:

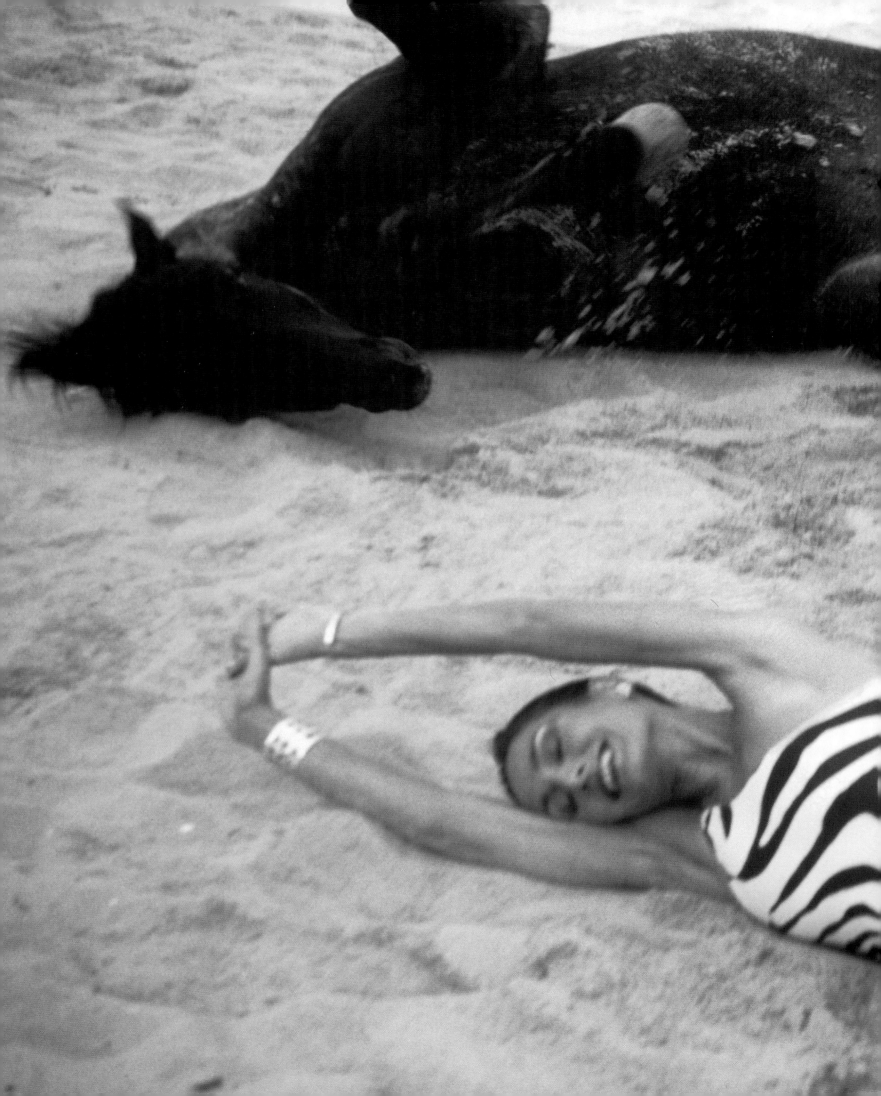

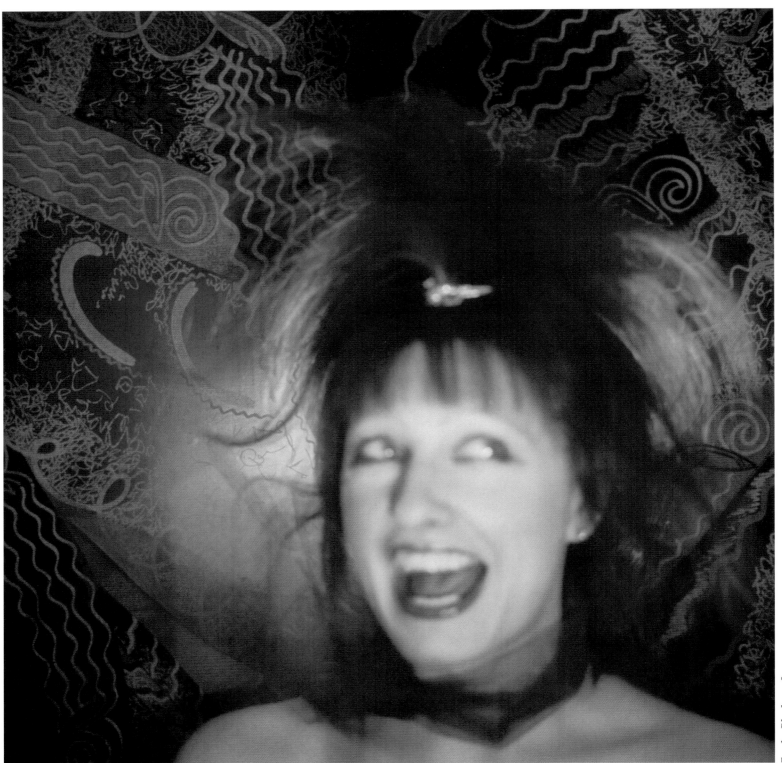

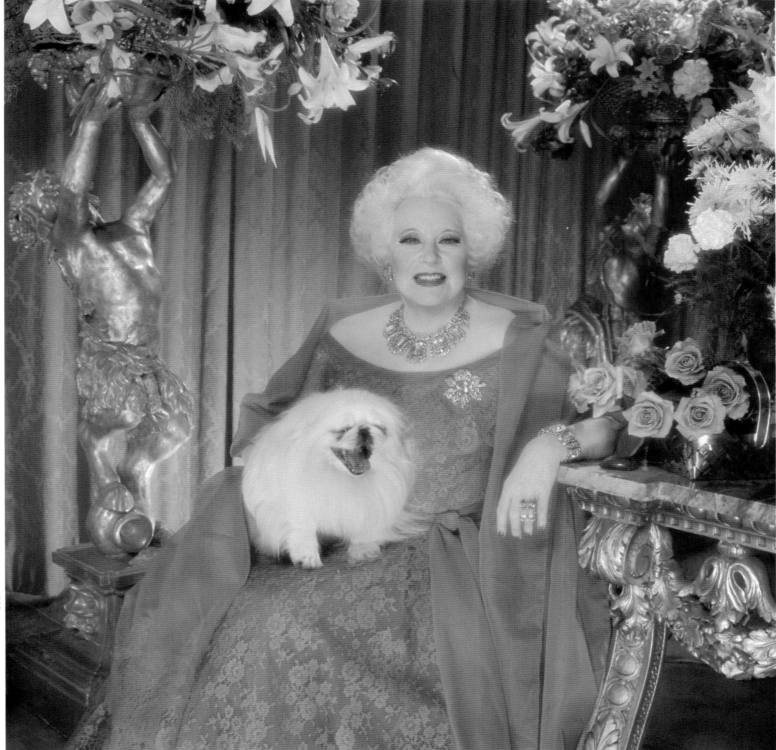

Barbara Cartland and Twi-Twi, 1977

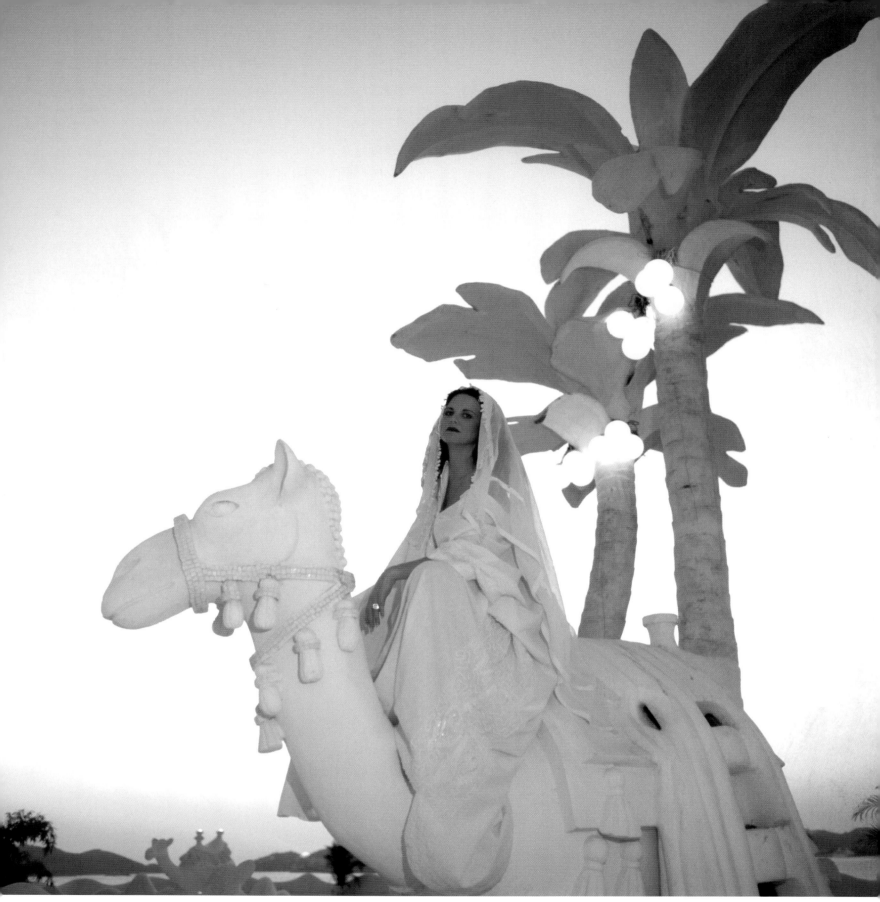

Baroness Sandra di Portanova, *Town & Country*, 1981

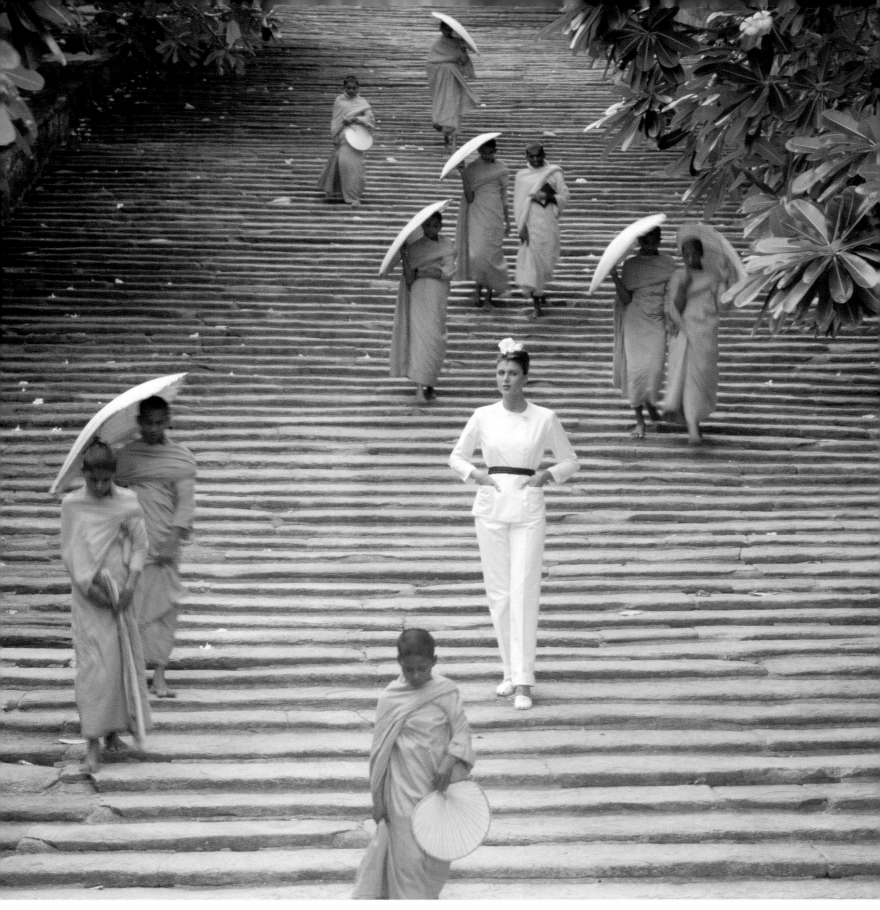

Pilar Crespi, *Town & Country*, 1980

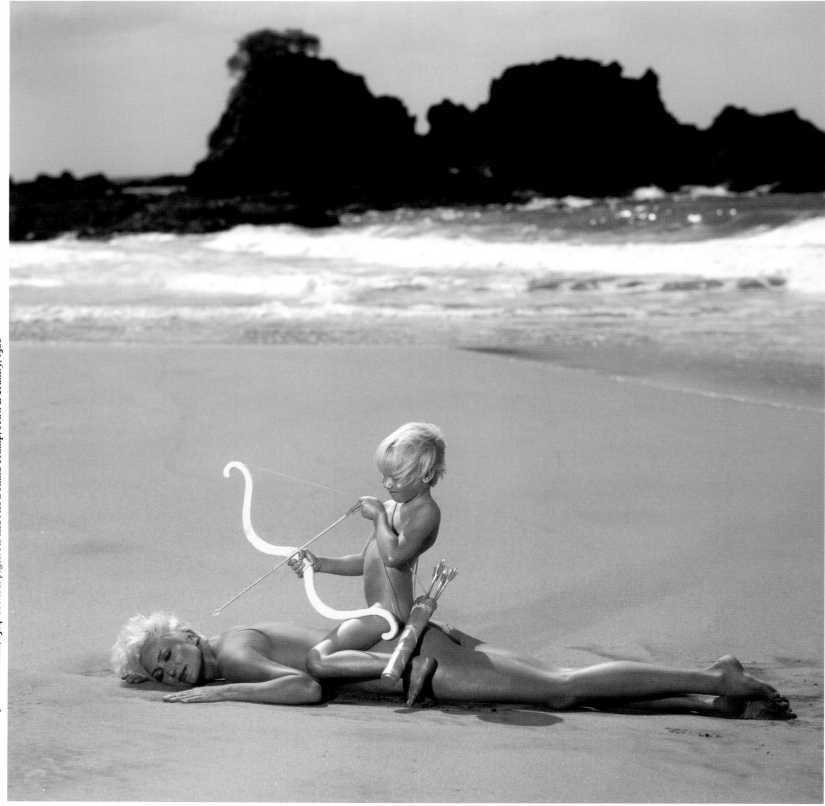

Anna Andersen and Jake Parkinson, 1984 Previous pages: **Mr and Mrs Donald Trump**, *Town & Country*, 1986

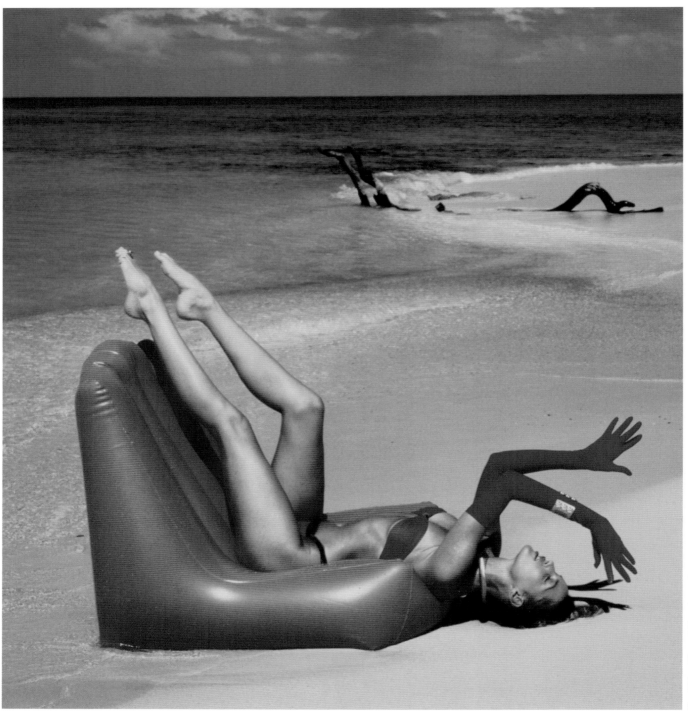

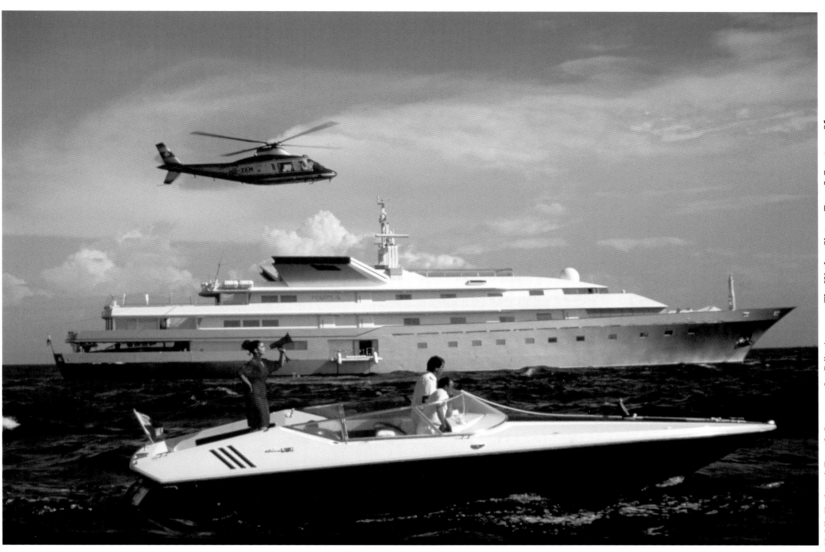

Nabila Kashoggi, *Town & Country*, 1985 Following pages: **The Wathne Sisters**, *Town & Country*, 1986

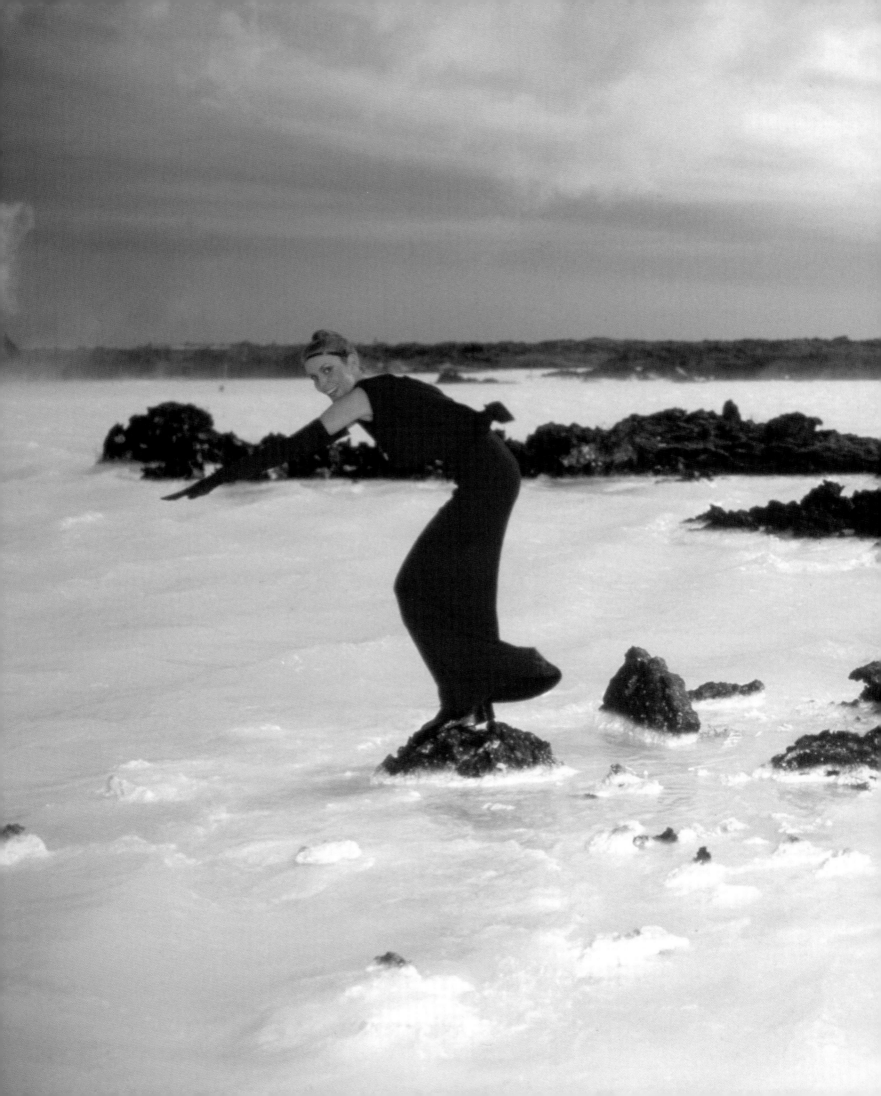

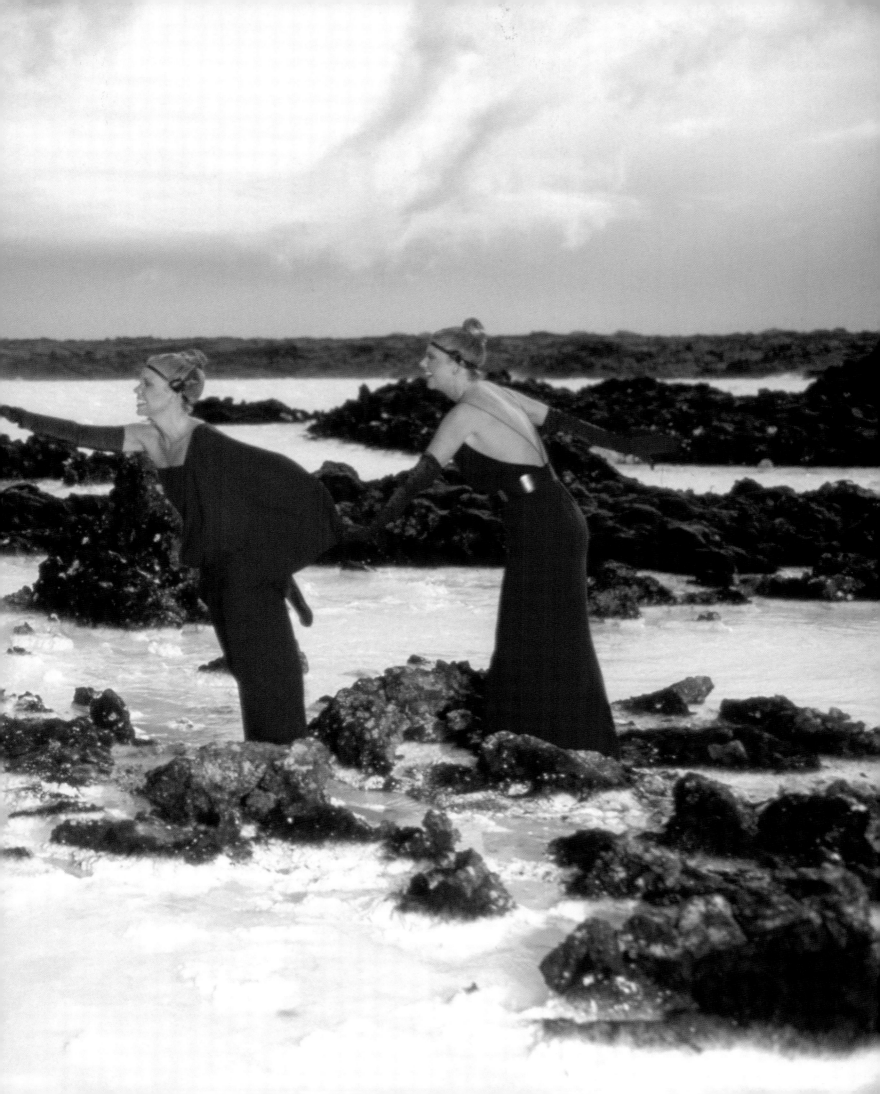

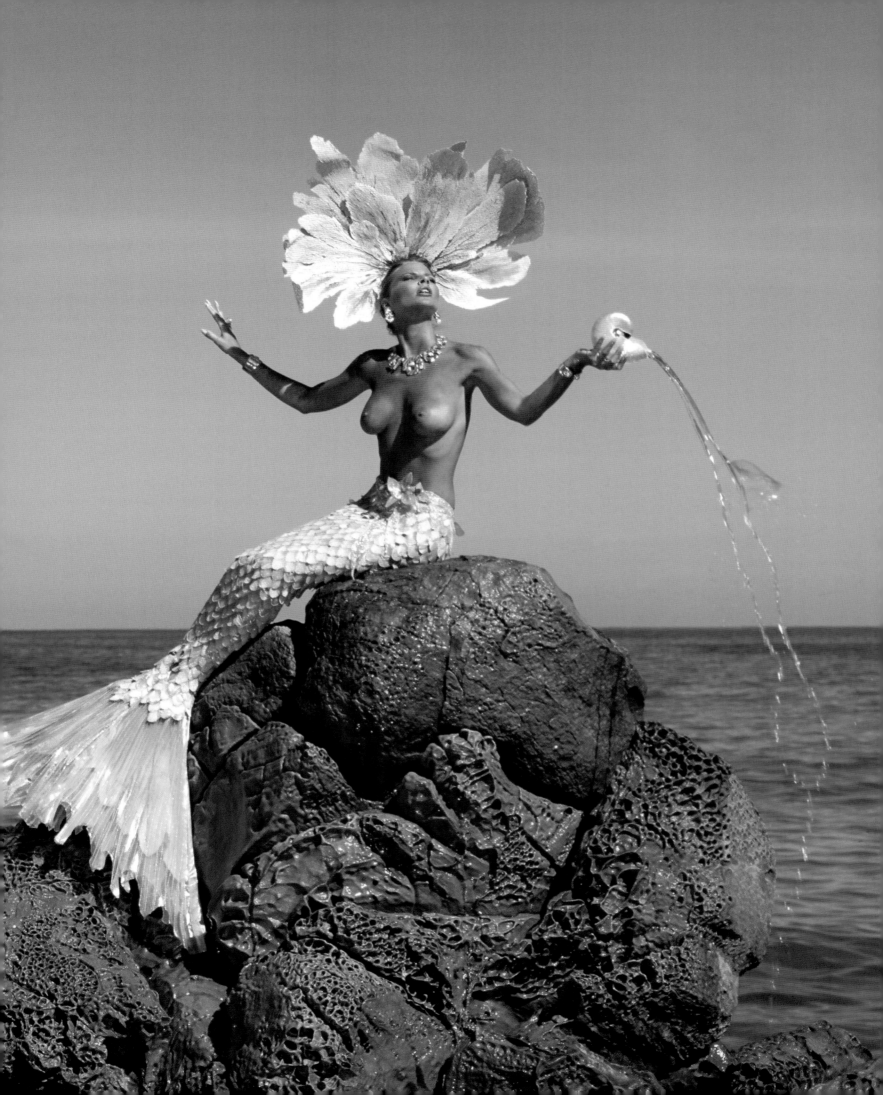

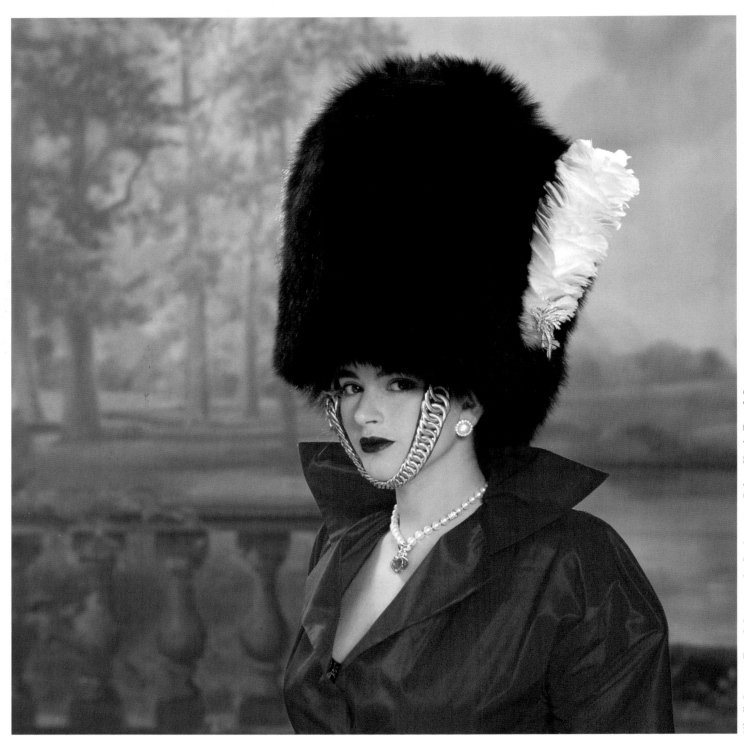

Bibliography

Books by Norman Parkinson

Parkinson, Norman, *The Beatles Book* (Hutchinson, London, 1964)
Sisters Under the Skin (Quartet, 1978)
Snap! Crackle! Pop! (unpublished manuscript, 1983)
Lifework (Weidenfeld & Nicolson, London, 1984)
Would You Let Your Daughter? (Weidenfeld & Nicolson, London, 1985)

Articles and Reviews by Norman Parkinson

Parkinson, Norman, (as 'Ronald Parkinson'), 'The Portrait as a Piece of Furniture', *Photography*, April 1935
Parkinson, Norman, 'Back to the Land', *Vogue*, July 1944
Formula for Success', *New Photograms*, 1962
'Teaching Photography', *Photography*, March 1964
'The Abbey Habit', *Vogue*, August 1981
'The Birthday Circus Comes to Town', (unpublished) *Town & Country*, 1983
'Parkinson's View of Countryside Vandals', *Daily Telegraph*, 23 November 1988
'The Great Aunts', undated, unpublished holograph manuscript
'My Grandfather', undated, unpublished holograph manuscript

Books about Norman Parkinson

Beaton, Cecil and Buckland, Gail (eds.), *The Magic Image* (Weidenfeld & Nicolson, London, 1975)
Coddington, Grace, *Thirty Years of Fashion at Vogue*, Edition 71 2002
Coleridge, Nicholas and Quinn, Stephen (eds.), *The Sixties in Queen* (Ebury Press, London, 1987)
Devlin, Polly, *Vogue History of Fashion Photography* (Thames & Hudson, London 1979)
Garland, Ailsa, *Lion's Share* (Michael Joseph, London, 1970)
Hall-Duncan, Nancy, *The History of Fashion Photography* (Alpine Books, London, 1979)
Harrison, Martin, *Parkinson: Photographs 1935–1990* (Conran Octopus, London, 1994); *Appearances: Fashion Photography Since 1945* (Jonathan Cape, London, 1991)
Howell, Georgina, *In Vogue: Six Decades of Fashion* (Allen Lane, London, 1975); *Vogue Women* (Pavilion, London, 2000)
Kazjanian, Dodie and Tomkins, Calvin, *Alex: The Life of Alexander Liberman*, (Knopf, New York, 1993)
Liberman, Alexander (ed.), *The Art and Technique of Color Photography* (Simon and Schuster, New York, 1951)
Mazzola, Anthony T. and Zachary, Frank (eds.), Madden, Kathleen, (intro.), *High Society: The Town & Country Picture Album 1846–1996* (Abrams, New York, 1996)
Withers, Audrey, *Lifespan* (Peter Owen, London, 1994)
Yoxall, H. W., *A Fashion of Life* (Heinemann, London, 1966)

Articles and Reviews about Norman Parkinson

Anon., 'Advertising Photograph of the Month', *Photography*, January 1939; 'Campaign Commentary', *Art & Industry*, January 1939; 'Norman Parkinson Chose Margaret Philipps', *Vogue*, June 1952; 'Norman Parkinson', *Image*, Vol. 1, No. 6, 1972
Appleyard, Bryan, 'The Mad Master of Illusion', The *Sunday Times*, 18 February 1990
Clark, Roger, typescript for 'Norman Parkinson', *British Journal of Photography Annual*, 1982
Cleave, Maureen, 'The Gentle Giant with an Eye for Women', *Woman*, 9 December 1972; 'Norman Conquests', *Observer*, 26 June 1988
Collins, Nancy, 'Royal Shutterbug', *People*, 18 April 1983
Cowles, Fleur, 'England is My Dish', *Viewpoint*, No. 2, 1961
Curtis, Charlotte, 'Norman Parkinson', *New York Times Magazine*, 20 March 1983
Devlin, Polly, 'I'm the World's Most Famous Unknown Photographer', *Vogue*, November 1973
Donovan, Terence, 'Photographs by Norman Parkinson: Words by Terence Donovan', *Over 21*, September 1981
Forbes, Joanna Gordon, 'Parkinson of *Harper's*, Rawlings of *Vogue*', *Art & Industry*, March 1940
Fraser, Kennedy, 'The Light in the Eye', *New Yorker*, 10 December 1984
Glynn, Prudence, 'Parkinson's Lore', *The Times*, 23 April 1968
Gowing, Mary, 'Norman Parkinson', *Art & Industry*, September 1956
Gross, Michael, 'A Photographer's 50 Years in Fashion: No Still Life', *New York Times*, 15 December 1987
Hadley, Katharine,'Parkinson's Lore', *W*, 7 April 1988
Hancock, Michelle, 'Here's to Eccentrics', *Fort Worth Star-Telegram*, 2 April 1986
Hugh-Jones, Siriol, 'You Can Hold the Light Meter', *The Listener*, 31 October 1963
Jennings, Diane, 'The High Life', *Dallas Morning News*, 23 February 1986
McCooey, Meriel, 'Parkinson's Lore', *Sunday Times Magazine*, 20 October 1984
Menkes, Suzy, '50 Years of Parks', *The Times*, 3 August 1981
Miller, Beatrix (et al.), 'Parkinson in Vogue', *Vogue*, April 1990
Parsons, John, 'Fashion in Fashion Photography', *Penrose Annual*, Vol. 49, 1955
Petschek, Willa, 'Royal Portraits and Bangers', *International Herald Tribune*, 15 October 1979
Vines, Alan, 'Norman Parkinson', *Photography*, March 1964; 'Norman Parkinson Interviewed', *British Journal of Photography*, 12 October 1962
York, Pat, 'A Sort of Talent in a Quirky Trade', *Independent on Sunday*, 1 July 1990
Yoxall, H. W., 'Fashion Photography', *Penrose Annual*, Vol. 43, 1949

Exhibition Catalogues

Davies, Sue (intro.), Boxer, Mark (contrib.), *British Photography 1955–1965: The Master Craftsmen in Print* (The Photographers' Gallery, London, 1983)
Harrison, Martin (intro.), *Outside Fashion: Style and Subversion* (Howard Greenberg Gallery, New York, 1994)
Harrison, Martin (intro.), Bailey, David (ed.), *Shots of Style: Great Fashion Photographs* (Victoria and Albert Museum, London, 1985)
Hugh-Jones, Siriol (intro.), Avedon, Richard (foreword), Penn, Irving (contrib.), *Norman Parkinson* (Jaeger, London, 1960)
Mellor, David (intro.), *Modern British Photography 1919–39* (Arts Council, London, 1980)
Pepper, Terence, *Norman Parkinson: Fifty Years of Portraits and Fashion* (National Portrait Gallery, London/Gordon Fraser, London, 1981)
Zachary, Frank (intro.), *Norman Parkinson* (The National Academy of Design, New York/Hamiltons Gallery, London, 1987)

Acknowledgements

For their help in the research of this book and the shaping of its contents I should like to acknowledge the tireless help of Fiona Cowan and Leigh Yule of the Norman Parkinson Archive. The former allowed access at all times to the considerable archive of Parkinson's private papers, including the original manuscripts for *'Snap! Crackle! Pop!'*, Parkinson's unpublished memoirs. I am particularly grateful for the latter's encyclopaedic knowledge of Parkinson's six-decade oeuvre, for her patient retrieval of prints and transparencies and for meticulously providing details for several of the photographs unpublished since the 1930s.

I am no less grateful to Terence Pepper and Clare Freestone for retrieving cuttings and papers held at the National Portrait Gallery, London. I should like to acknowledge here Terence Pepper's pioneering exhibition 'Norman Parkinson: Fifty Years of Portraits and Fashion' (1981) and its accompanying catalogue. I also extend grateful thanks to his colleagues at the National Portrait Gallery, Robert Carr-Archer, Anjali Bulley, Denny Hemming and their director Sandy Nairne.

I am grateful to Martin Harrison, whose research into Parkinson's life, published in *Parkinson Photographs 1935–1990* (1994), uncovered fresh biographical detail and has acted as a balance (and, in many instances, a corrective) to Parkinson's own photobiography *Lifework* (1983).

For lending several photographs to this book and for providing details of studio life in the 1960s I am very grateful to Angela Williams, of the Angela Williams Archive (AWA) and to Michael Hewett for his research into the fashion magazines of the twentieth century. I thank Philippe Garner for introducing us. I was immensely pleased that Irving Penn allowed the reproduction of his silhouette portrait of Parkinson from 1949 and I am grateful to Leigh Monteville of The Condé Nast Publications Inc. for facilitating this. Jill Kennington, whom Parkinson photographed frequently in her modelling years lent her masterful portrait of Parkinson, taken towards the end of his life and in the new, photographic phase of hers.

I would like to thank my colleagues of long standing in the *Vogue* Library, London: Janine Button, Simone Burnett, Brett Croft and Jooney Woodward for their patient assistance on a daily basis. I acknowledge too the help of Norman Parkinson's grandson, Jake Parkinson, and of Fiona Cowan's son, Tom, in the early preparatory stages of this book.

Mark Thomson of International Design UK has designed the book with great flair, with Annabel Rooker's assistance, and Victoria Webb has edited it with sensitivity. All of us involved in the production of *Portraits in Fashion* are grateful to Mark for conceiving it several years ago. I admire the tenacity and skills of our producer Colin Webb, who knew Parkinson, and I am very pleased he invited me to be one part of a favourite project.

RM